To: Mum & Ji

From: Ian & Gail

Christmas 1989 With Best Wishes
& Fond Love.

Debrett's
Illustrated Fashion Guide

THE PRINCESS OF WALES

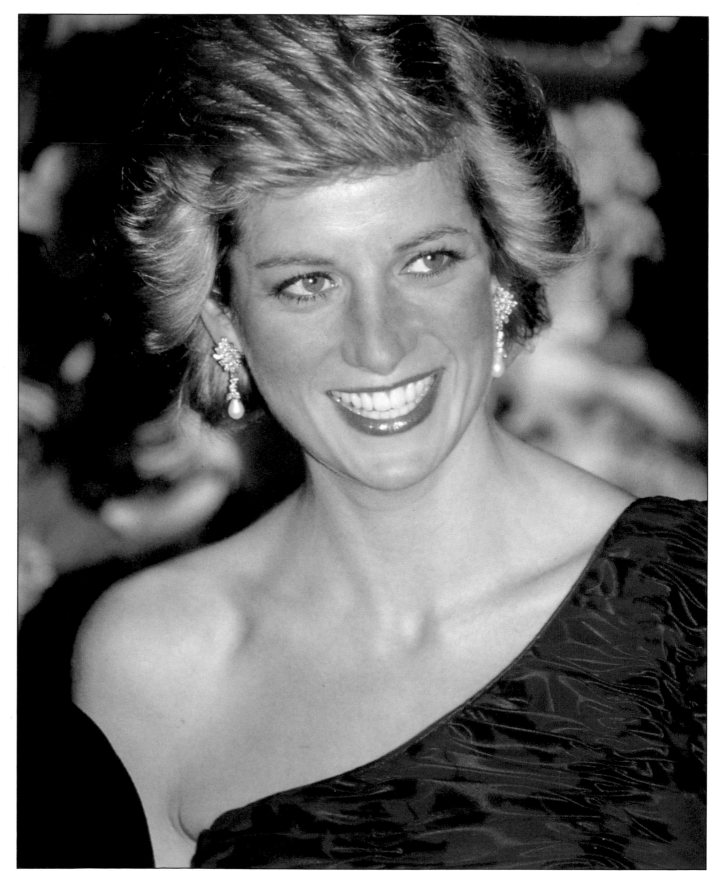

The Princess wears a very unusual one-sleeved evening gown by Catherine Walker to a formal dinner at the British Embassy in Paris in November 1988. The dress, in a bold red and black silk, is heavily ruched from the dropped waistline to the neck.

Debrett's
Illustrated Fashion Guide
THE PRINCESS OF WALES

JAYNE AND TERRY FINCHER

Webb & Bower

MICHAEL JOSEPH

First published in Great Britain 1989 by
Webb & Bower (Publishers) Limited
5 Cathedral Close, Exeter, Devon EX1 1EZ
in association with Michael Joseph Limited
27 Wright's Lane, London W8 5TZ

Published in association with the Penguin Group
Penguin Books Ltd, Registered Offices: Harmondsworth, Middlesex
England
Viking Penguin Inc., 40 West 23rd Street, New York, New York 10010, USA
Penguin Books Australia Ltd, Ringwood, Victoria, Australia
Penguin Books Canada Ltd, 2801 John Street, Markham, Ontario,
Canada L3R 1D4
Penguin Books (NZ) Ltd, 182–190 Wairau Road, Auckland 10, New Zealand

First impression 1989
Second impression 1989

Designed by Vic Giolitto

Production by Nick Facer/Rob Kendrew

Text and illustrations Copyright © 1989 Jayne & Terry Fincher
Debrett Trade Mark Copyright © 1989 Debrett's Peerage Limited

British Library Cataloguing in Publication Data
Fincher, Jayne.
 Debrett's illustrated fashion guide the
 Princess of Wales.
 1. Great Britain. Diana, Princess of Wales.
 I. Title II. Fincher, Terry.
 941.085'092'4

ISBN 0–86350–235–0
Library of Congress 89–83913

Text set in Garamond Original

Typeset in Great Britain by P&M Typesetting Ltd, Exeter, Devon

Colour reproduction by Peninsular Repro Service Ltd, Exeter, Devon

Printed and bound in Great Britain by BPCC Paulton Books Limited

Contents

Introduction

A warm, late summer's day in 1980 and a shy, attractive young woman is sitting in a small London square, dressed simply yet comfortably in a lightweight patterned skirt, an ageing cotton blouse and a soft mauve sleeveless jumper.

Who would have speculated then that within months women around the world would be scrambling for newspapers and magazines, hungrily seeking the means to mimic in their own wardrobes the same look and style as Lady Diana Spencer, the future Princess of Wales and, one day, Queen of England.

It was this very same summer's day that Lady Diana Spencer learnt a very hard first lesson in 'public dressing'.

Her clothes were to her own choice and suited the mood of the day. It was a lonely time for the young girl, with rumours of a royal romance with Prince Charles being denied officially and as yet she had no access to that umbrella of protection which Buckingham Palace can provide. She was not to foresee the mistake of not wearing a slip under her skirt that day, unaware of her oversight until she saw the next morning's editions of every national newspaper.

A group of Fleet Street photographers had persuaded Diana to pose briefly for them in the garden of her place of work, The All England Kindergarten in Pimlico. As the strong sunrays filtered through the trees, Lady Diana was quite unaware that her long shapely legs were clearly visible through the flimsy, and by now transparent, skirt.

Shortly after this Lady Diana ran into trouble again, this time on one of her first official public engagements at London's Goldsmith's Hall. She wore a very low-cut black taffeta gown which revealed a little too much of the future Princess's cleavage and caused great excitement among the daily tabloids.

These were fashion lessons not to be forgotten in the ensuing years. Her wardrobe was at times demure and tame; she favoured high necklines and long, loose-fitting, calf-length skirts and definitely no visible cleavage on evening gowns.

The Princess of Wales has now emerged from that chrysalis to become the most photographed woman in the world. Far more has been written about her wardrobe than that of such celebrated fashion addicts over the years as Jackie Onassis or the late Duchess of Windsor.

The Princess of Wales has a complete sense of style and a natural understanding of fashion; in recent years she has shown a new-found confidence and frequently experiments with new designs.

Her overall look is the envy of many fashion-conscious women and the delight of the British fashion industry, which is currently in the ascendancy largely due to the loyal patronage of the Princess. Her personal list of British couturiers and milliners numbers over twenty-five.

On her engagement day in 1981 the Princess chose an 'off the peg' Cojana suit purchased from Harrods, to launch herself into the public eye and hence on to many royal wedding souveniers. Interestingly, over the years she has chosen quite a number of ready-made clothes. Her wardrobes at Kensington Palace now consist of hundreds of couturier garments carefully selected for every type of occasion and climate, a consideration which has become part of the Princess's everyday life.

While her lavish budget for clothes has made her the envy of millions of women, the demands of royal decorum limit the number of occasions when she can actually dress for fun or fancy. The first major ensemble put together by the Princess in 1982 had to include a vast range of basic garments that no young woman of nineteen or twenty would normally have to contemplate.

The Princess had to start virtually from scratch. Gone were the cotton neckerchiefs, the crumpled white cardigan and the tight-fitting cord trousers; in came formal gowns, smart suits and dresses, shoes, bags, gloves, blouses, belts and, of course, the now famous hats. These were all just part of a working Princess's requirements.

During the course of eight fashion seasons styles have changed. But, as many fashion experts tell us, if something suits you and you like it keep wearing it. And the Princess does just this, with favourites such as the cream, high-ruffle-necked blouses, so often seen in 1982 and 1983 and still regularly worn with many of her current suits. Garments that were once worn on formal engagements now appear as part of a casual ensemble at polo matches.

Just as the Princess had settled into her newly acquired wardrobe, the pattern of her life changed again – she became pregnant for the first time. She now had to make new decisions about clothes she had never before had to contemplate. A maternity wardrobe is not easy to choose for lesser mortals, but for the Princess of Wales, with a high public profile, considered advice must have been greatly appreciated.

At times the Princess's choice of maternity clothes seemed dull and even frumpy. In the past pregnant royal ladies were kept out of the public eye; few undertook public engagements. But the Princess of Wales adopted a different policy. Over the months of waiting she

maintained a steady flow of appointments. Comfortable clothes were essential and the Princess decided almost at once to wear loose-fitting coats and dresses, even in those early months of her pregnancy. Indeed, on the day of the announcement of the forthcoming royal baby, she wore a very loose-fitting multicoloured wool coat by Bellville Sassoon, which, coincidentally, was similar to the one worn by the Duchess of Kent. The pregnancy look was quite exaggerated at this early stage, but the loose coat became a firm favourite through the following months.

The spring of 1983 offered foreign travels for the Prince and Princess of Wales. After the birth of Prince William the Princess quickly regained her shapely figure and it was now time to meet some of the Commonwealth subjects.

New problems loomed: the Prince and Princess would be undertaking a non-stop programme of engagements for a period of over four weeks; when selecting the wardrobe she needed to take into account the variations in climate, from the hot sun of Alice Springs in Australia to the sudden showers of Auckland, New Zealand.

On average two outfits for each day were required and this took months of planning and numerous fittings. It transpired that, at times, the choice was quite tame, but as the Princess walked down the aircraft steps on her arrival in the Antipodes she must have felt confident that within the many silver and black trunks in the luggage hold she had a presentable and suitable wardrobe.

It was during the Princess's first tour 'down under' that the first signs of her growing confidence and maturity became evident. Only a few months later during a visit to Canada her individual sense of style began to assert itself. During these first few years as Princess of Wales it was not only her official wardrobe that attracted comment and influenced buyers in the Highstreet shops. Her casual clothes, worn 'off duty', attracted a special fascination – women love to catch a glimpse of a princess dressed in clothes to which they can more easily relate.

It is refreshing to see her striding out across the polo field dressed in drain-pipe jeans and a 'sloppy joe' sweater. These are the rare occasions when she can almost forget the conventions and restrictions of being a leading member of the world's pre-eminent Royal Family.

Throughout the summer months the Princess spends many a sunny afternoon at Smith's Lawn, Windsor watching her husband play polo. At the very casual matches she usually chooses denim, fun sweaters and pedal pushers. For the more formal matches, at which she may be required to present a prize or attend with the Queen, she presents a crisp, neat image in floral, or patterned silk and cotton dresses or simple skirts and blouses.

Norway was the destination for the Princess on her first solo foreign visit. It was a short visit of only two days and included a gala evening at the ballet. The Princess was well

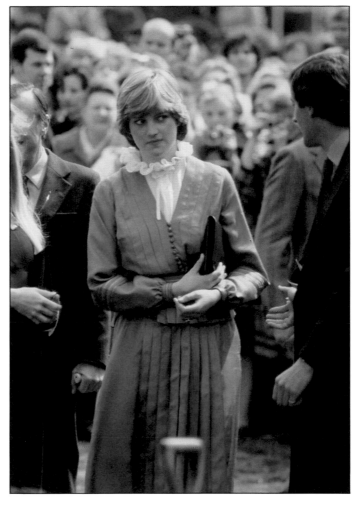

One of Lady Diana's early engagements was a visit to Broadlands in Romsey, Hampshire in March 1981. For the occasion she chose a new suit in a raw leaf green silk. The belted jacket is worn over one of her famous high-necked blouses with a ruffle collar.

dressed against the cold February air when she arrived at Oslo airport in a new suit in cobalt blue. The choice of such a vivid shade of blue marked the start of a very colourful 1984 for the Princess's wardrobe.

The Princess was now expecting her second child and this time her maternity clothes were bolder. A large proportion of the dresses had exaggerated collars, squared and pointed, which added that extra feminine touch to some brightly patterned and striped garments.

During her first pregnancy the Princess's wardrobe boasted a variety of coats but this time the Princess chose to wear only two coats, both of similar design, one in navy and one in red. These were livened up with a variety of coloured stockings and shoes and ribbon bows at the necklines.

After the birth of Prince Henry the Princess returned to her busy schedule of public engagements; her working wardrobe expanded accordingly showing, to the delight of fashion commentators, a great diversity of styles. Velvet in an abundance of colours seemed a popular choice throughout the year: suits and dresses in greens and blues and blacks and several coats finished off with velvet

revered collars. The Princess still enjoys wearing velvet clothes and currently has many such outfits for both day and evening wear.

It is not only the Princess's clothes that make the headlines. During 1984 the Princess's hair had grown out very quickly from the original Lady Diana hair style of the early eighties. Her soft perm had been allowed to run its course and this enabled her to experiment with various new styles that were not too well received by her most ardent fans.

When she stepped out of her car in Ealing in 1984 to visit a Dr Barnado's home she was almost unrecognizable as the Princess of Wales. It seemed that virtually overnight her hair had grown inches longer and become considerably darker. This 'new' look had actually been achieved by blow-drying her hair in a straight style, reminiscent of the look of the forties. The hair was scooped up at the sides with clips and then gently flicked under and on to her shoulders. And the once-heavy fringe had been back-combed off her face to the side. This style reappeared some days later in Newham, but since then she has chosen to revert to her familiar image.

During 1985 the Princess of Wales was seen in a wide variety of styles and colours on the round of public engagements. One day she would wear something approaching a 'French look' with, for instance, the bright, pillbox-red, fitted wool suit complete with a beret worn cheekily to one side in Southampton, only to be followed on the next engagement by a multicoloured loose-fitting check wool suit like the one worn in Wellingborough.

It was at the beginning of the new 1984–85 winter season that we saw the introduction of the 'Cossack' look; this remains a style much favoured by the Princess, and one which has been adopted by the Duchess of York. A high black hat was the first of many hats in this style. They have come in all colours and fabrics, ranging from a version in bright, cornflower-blue suede to one in red edged in black and made to complement a coat with Cossack undertones. This look had its origins in traditional Russian styles, was modified and then given its airing on the Paris catwalks. Very soon it was copied for the rails of dress shops on the High Street. Once again the Princess had successfully judged what were to be the fashion trend setters on the broad scale from the early collections.

In her fifth year as a royal princess, the Princess of Wales was noticeably cultivating a more sophisticated image. Many of her bows and gathers gave way to the sleek tailored styles that were particularly evident in some of the creations from Catherine Walker of the Chelsea Design Company.

After a skiing holiday with Prince Charles in Lichtenstein, during which she had posed happily for photographers in her new pink Head ski suit, she met with her designers to embark on what was described by the Fleet Street press at that time as a £80,000 spend-up. Stories suggesting that she was a 'shopaholic' infuriated the Princess. She had three major royal tours ahead of her – to Italy, Australia and the United States. The speculation, often critical, about a new wardrobe for her visit to Italy, one of the world's most fashion-conscious countries, caused her to rebuke some of the journalists when they jokingly complained that they had not yet seen any of the reported dazzling new outfits. The press corps awaiting the arrival of the royal flight on the tarmac in Sardinia were convinced that she would appear from the aircraft in a sensational new outfit to stun the Italians. They were bitterly disappointed to find she had chosen a lavender and white outfit which had been seen on previous occasions.

And they were disappointed again later on in the tour in Milan, where the royal couple were attending a glittering evening at La Scala opera house. Dense crowds filled every corner of the square and packed the streets surrounding the famous opera house, pushing and jostling each other to catch a glimpse of the English princess. Journalists who were forecasting that she would wear a fabulous evening gown were rewarded instead with what they saw as a 'two-year-old dress'. In fact Diana, who was getting a little revenge for all those stories about her extravagance with clothes, had chosen the pink organza dress by Victor Edelstein that had been part of her 1983 Australian tour wardrobe. Her selection did liven up later in the Italian tour, however, although some previously seen outfits were much in evidence.

1985 was also the year that the Princess discovered the 'coat dress'. This has proved to be a practical and yet extremely smart addition to her working wardrobe. Catherine Walker has designed many of these dresses for the Princess in a variety of colours and fabrics. One great favourite, a cream dress with a fine navy pinstripe running through it, has been worn on many occasions. Originally it was part of her Italian wardrobe and was worn with a jaunty nautical-style hat, appropriately, to the La Spezia naval dockyard.

Bruce Oldfield made the glamorous gold lamé dress that has been seen on so many glamorous evenings, including a gala fashion show held by Oldfield a few years ago. The dress has large padded shoulders and a full pleated skirt that swirls as the Princess walks; a diagonal cut-away section reveals the Princess's very feminine back. This plunged bare-back effect has been repeated in similar fashion for several of her dresses, such as the crushed, plum-velvet dress seen at many formal dinners and film premieres, or the slinky red silk dress, again by Oldfield, with the large 'V' backline.

The shoulder pad was very much in evidence in 1985 and 1986; it gave additional impact to garments ranging from ridiculous oversized styles to the squarer, neater

shape that the Princess chose for many of her new three-quarter length jackets. She combined the longer jackets with skirts which began to get shorter and became far removed from the calf-length dirndls that she apparently favoured in 1983.

In the Autumn of 1985 the Prince and Princess spent two weeks back in Australia before travelling on for a brief visit to the United States. The highlight of this American visit was a glittering dinner at the White House. It was attended by a wide variety of celebrities from politicians to Hollywood stars. As the royal couple were greeted by President and Mrs Reagan the cameramen only had eyes for the Princess, dressed seductively in a new velvet gown. The Princess had displayed uncharacteristic confidence in choosing a dress with a low-cut neckline and bare shoulders. The gown, by Victor Edelstein, fitted perfectly over the hips before flowing into a mermaid-like finish at the bottom of the skirt. It was perfect for dancing, as Princess Diana discovered later that evening when she was swept around the dance floor, to the delight of the media, by John Travolta. She chose accessories for a dramatic effect – a seven-strand pearl choker with a large sapphire

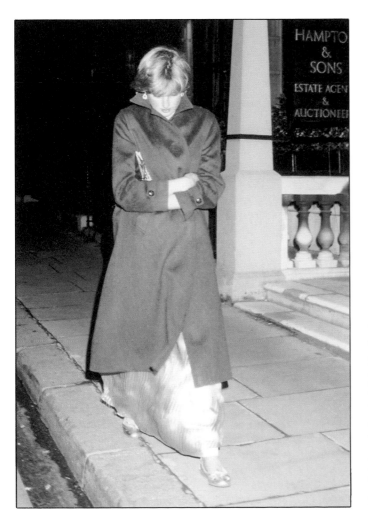

clasp adorned her neck, while a bracelet in similar style was worn on her wrist. The Princess had always been fond of pearls but this choker bore little relation to the single-strand necklace which was her trademark during her days as a kindergarten teacher.

The choice of jewellery available to the Princess is the envy of women the world over. Occasionally she requires formal jewels for such events as state dinners or the State Opening of Parliament; the Spencer family tiara, originally worn on her wedding day, is a popular choice. She finds it light and far more comfortable than some of the more heavy and ornate tiaras which are available to her from the royal collections.

The Princess loves casual costume jewellery and has a lot of 'paste' in her jewel case. These items range from the Butler and Wilson heart-shaped ear-rings to a snake *diamanté* brooch. Among some of her most treasured possessions are the personal pieces of jewellery given by the Prince of Wales to commemorate special events in their life together – such a gift was the gold and pearl necklace with the heart clasp given to her on the birth of Prince William. Heads of State frequently make gifts of priceless jewellery; the collection contains magnificent pieces from the Sultan of Oman and the Saudi Royal Family.

The Princess is fortunate to be blessed with a long slim neck and has always looked good in a high neckline. Those ruffled Edwardian-style blouses from Laura Ashley were gradually replaced by others with equestrian undertones which were particularly effective when worn with neckties and cravats. Many of these blouses were finished off in 'hunting stock' style, neatly held down with a small brooch or pin. These blouses were in vivid colours and usually made from expensive, feminine fabrics such as silk or satin.

Polka dots was a dominant theme in many wardrobes in 1986; the Princess had championed the craze long before she left for a three-week visit to Canada and Japan. She had chosen dots as the theme for a variety of styles and garments ranging from the ankle socks worn regularly at polo matches, to a stunning Victor Edelstein dress worn at the Epsom Derby.

In Japan 'Di' mania had reached fever pitch long before the Prince and Princess touched down in Osaka. The women's magazines had filled every possible page with features and fashion spreads on the Princess, and photographs appeared everywhere, even on Tokyo phone cards. Short, dark Japanese women longed to look like the tall, cool, blonde English Princess. In one Tokyo department store a Princess Diana look-alike competition was held, and half a dozen petite Japanese girls paraded, rather self consciously, in white ruffle-necked blouses and pearls.

The Princess turned to Tatters, a small shop in London's Fulham Road, for an outfit to wear on her first day in

One of the press's first glimpses of Lady Diana was her departure from a birthday party in London in December 1980. She is huddled into a serviceable green wool coat over a pink chiffon evening gown.

Japan at a traditional tea ceremony. The fabric design was remarkably like the Imperial Japanese flag, large red circles on a plain white background, pure coincidence, or a mark of respect for her hosts? The dress was in a soft cool silk with large shoulderpads and a tight cummerbund.

The Princess is given many gifts as she travels around the world, and on this particular occasion the Japanese presented her with two kimonos, one made in cotton and the other in the finest Italian silk and reported to be worth over £15,000.

The Japanese saw many of her favourite Catherine Walker outfits but there were a few new suits and dresses with labels not previously worn such as Anouska Hempel and Yuki.

Anouska Hempel, actress, interior designer and a personal friend of Prince Charles, had started out in the world of fashion a few months earlier. The Princess had liked some of her collection, particularly a grey and black cocktail skirt and blouse which she wore in Tokyo for an evening at the sumo wrestling.

Up until now the Princess had not shown any overt preference for sequins. However, this all changed when she appeared in two dresses, both bedecked in green sequins but of different designs. Sequins were also worked on to her shoulders and bodices in tandem with small glass and pearl beads.

After the successful low neckline at the White House the Princess chose a striking selection of evening gowns all revealing, if somewhat discretely, her pretty cleavage. An assortment of boned dresses were seen at banquets and premieres but these had to go to the back of the wardrobe towards the end of the year, for a planned visit to the Middle East called for modesty at all times.

Western women visiting the Middle East must be extremely careful over their choice of dress. They must show respect for local and religious customs. It would have appeared extremely disrespectful if the Princess, as an honoured guest in an Arab country, had appeared in short skirts and bare-shouldered dresses. Saudi Arabia is the most restrictive for choice, and the Princess was probably advised, as were the women journalists travelling with the royal party, to cover her arms and legs and keep garments loose-fitting to conceal any figure-hugging waists or generous bosoms. When the Queen visited Saudi Arabia in 1976 she wore full-length gowns for day and evening wear. The Princess of Wales, however, did not wear full-length clothes during the day. She chose instead a selection of soft-falling, calf-length skirts and dresses.

Throughout the ten-day tour, that included visits to Oman, Bahrain, Qatar and Saudi, we saw a lovely array of new gowns. The Emanuels were well represented in both day and evening wear, including the black and white taffeta gown worn in Riyadh. Catherine Walker designed what must be one of the loveliest dresses in the royal wardrobe –

a soft, pastel-blue evening dress in lace and chiffon.

The Princess of Wales chose a Catherine Walker outfit for the finale of the Gulf tour. A spectacular desert picnic had been prepared for the royal visitors and their entourage at a remote spot some two hour's drive from Riyadh. Among the sand dunes the scene was likened to a desert mirage, with countless luxurious carpets bedecking the dark Bedouin tents that were being prepared for the picnic. Camels and beautiful white Arabian horses galloped past as men in long, white flowing robes prepared the feast of roast lamb.

The royal convoy arrived and out stepped the Princess dressed impeccably for such an occasion. The sun was burning but her cool silk tunic and baggy trousers were the perfect choice to allow the Princess to relax and enjoy herself. The trousers were an inspired selection as, in keeping with tradition, the guests had to sit cross-legged on the carpets and sip Arab coffee. Diana had yet again displayed mature judgement in her choice of outfit for what was potentially a difficult engagement.

The Princess started 1987 in casual clothes. Dressed very much as just one of the mothers, she took Prince William along for his first day at his new school in London's Notting Hill. It was a freezing snowy day in January and Prince William looked very much the 'new boy' dressed in his grey school cap and coat. The Princess was dressed warmly in a large casual wool jacket with collar and cuffs of striped elasticated shearing, a red, pleated wool skirt and flat knee-length boots. As the Princess walked up the school steps the back view of her jacket revealed a colourful appliqué design showing a polo player on a horse. We had been given a glimpse of the young mother's wardrobe, kept under wraps for those many happy hours spent in private with her children.

During the summer months the Princess favours fun sweat-shirts embossed with cartoon characters (Mickey Mouse is a particular favourite) and both she and the children are often seen in T-shirts given as mementos from charity fund-raising events, such as pop concerts, or from organizations of which she is patron.

In the spring of 1987 the Princess wore a new, pale blue coat edged in white; nothing out of the ordinary about that, except for the fact that she had an identical one made for Prince William. They were first seen in their 'mother and son' coats at the traditional Easter service at Windsor.

1987 was the year of the 'puff-ball' skirt, it was a short-lived fad that was greeted with mild derision by the clothes-buying public. Not to be outdone the Princess wore a Catherine Walker version of the puff-ball on the last day of a short tour of Portugal.

The Princess seems deliberately to wear particularly stunning or unusual new garments on the last days of foreign tours; the press have been caught off balance on a number of occasions and missed a good fashion picture in

the closing hours of a tour. As so often happens, the travelling media party usually departs ahead of their Royal Highnesses in order to cover their arrival at the next point on the tour. On the final day of that first Australian tour back in 1983, ninety-nine per cent of the press had flown ahead to New Zealand, they were all awakened early next morning by their irate editors asking why they hadn't stayed on to photograph the Princess in an amazing new one-shouldered evening gown by Hachi or the blue Australian digger hat which she wore at the airport.

History repeated itself on this Portugese trip when the Princess chose a blue and white puff-ball on her last morning before flying off for a brief visit to Bordeaux. That particular puff-ball has only appeared once since then – it is obviously a style which has been deemed unsuitable for public functions.

There were a number of new coats on view during 1987; they came in a variety of colours but one colour, ochre blue, was dominant. The coats were all generous in the length and a few still displayed that large padded-shoulder look from the previous season. One coat that was totally different from the previous styles seen was a lemon, black and white coat by Escada, first seen in the latter part of the year in Berlin. It looked bright and warm on a grey, dismal winter morning and was complemented by the turban-style hat in contrasting colours by Philip Somerville.

There were several foreign visits during 1987, including a trip to Spain when the Princess enjoyed an elaborate fashion show in Madrid. As the Princess joked and chatted with the girls after the show she could easily have been mistaken for one of the professionals. Dressed in a new turquoise silk suit, Diana looked as tall and as slender as any of the models.

That evening she wore an unusual jacket with heavy braiding sewn on to the lapels and the back, a little addition that has come to the fore on a couple of outfits since then, such as the cream drum majorette suit worn a month later during the State Visit of King Fahd to London.

In the latter part of the year the Princess had a new robust glow. Although still slender, she appeared to have gained a few pounds and it suited her well, giving her a softer shape which was preferable to her painfully thin figure of a few years before.

In September the Prince and Princess visited the French town of Caen for a one-day engagement. The French onlookers loved her chic sense of style. She chose a red and black two-piece suit, which was complemented by an eye-catching Spanish-style hat with a black scarf tied at the chin – this was the first time she had been seen in public with all her hair taken off her face and completely covered. It gave a totally different shape to the Princess's face and certainly accentuated those huge blue eyes.

The Spanish theme reappeared in a number of garments

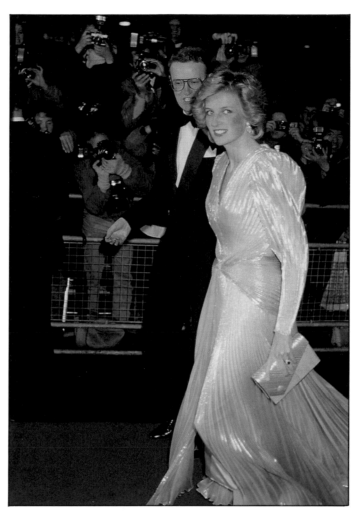

One of Princess Diana's most glamorous evening gowns is this gold lamé dress by Bruce Oldfield, worn to a gala dinner at London's Grosvenor Hotel in March 1985.

in the 1987 wardrobe, including the dark-mauve, velvet dress with a taffeta flamenco-style skirted hem, which she wore to the opera in Munich.

Throughout 1988 there was more foreign travel for the Prince and Princess, including a visit to Australia for the Bicentennial Celebrations. The Princess had to collate her third Australian wardrobe; she chose a wide variety of styles and designers that included old favourites such as Catherine Walker and Bruce Oldfield plus some new blood such as Alistair Blair.

Throughout 1988 Catherine Walker dominated the Princess's preference for clothes. Many new designs were interspersed with the ever-popular coat dress, which was much in evidence during the Paris visit in November.

Victor Edelstein also featured highly in 1988 and one of his most stunning creations was surely the regal satin gown and bolero jacket worn by the Princess in Paris to a formal dinner.

At the beginning of the year the Princess was seen in many wide-brimmed hats by Philip Somerville, particularly during Ascot week.

Favourite colours for 1988 were red, black and blue. We

During a visit to the Atlantic College, Wales in June 1985 the Princess wore one of her smart Jan Van Velden coats over a polka dot Catherine Walker dress. Both these garments had been seen on prior engagements but in a different combination. The hat is by John Boyd.

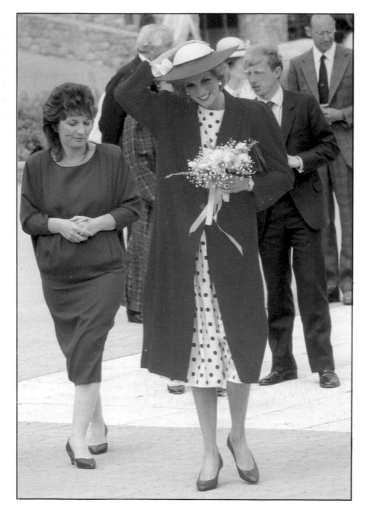

Looking back over the past eight years we have seen a remarkable change in the character and personality of the Princess of Wales and we have enjoyed her choice of glamorous, unusual or simply practical clothes. An enormous amount of hard work is required to compile a wardrobe fit for a Princess. All those endless fittings with designers, the hours of skilled work spent on the finishing touches to gowns and accessories and, last but not least, the care and cleaning of the clothes.

The Princess employs two personal dressers, Fay Marshala and Evelyn Dagley. These meticulous two ladies are responsible for the loving care, the cleaning, pressing and storing of the Princess's wardrobe. They travel the world with the Princess, ensuring that her clothes are always ready and laid out for a quick change between engagements. They keep a record of which outfit has been worn to each engagement in order to avoid duplication the following season.

The Princess has over seventy-five hats, each of which has to be stored in appropriately sized hat boxes to protect them from dirt and damage. It is difficult to imagine the amount of storage space that is required to cope with a wardrobe of this size. How many rails would one need for at least twenty-five coats, fifty evening gowns, ninety day suits and countless other items such as separates, dresses, capes and a personal 'at home' wardrobe? To say nothing of the shoes, jewels and other accessories.

Many of the Princess's critics are unhappy with the image she projects to the world; they fear that she has become a slave to the extravagant world of high fashion and is losing touch with reality. But perhaps her detractors are missing the point: the Princess is, to a large extent, out of touch with reality, if reality is accepted as the life-style of the ordinary man and woman. She is no ordinary woman, as a senior member of the British Royal Family she is automatically on a different plane. But Diana, Princess of Wales, has added an extra dimension – she is the first member of the Royal Family to become an international media star. Her figure, clothes and personal likes and dislikes are an integral part of her job – even her most vociferous critics admit that she has done much to invigorate Britain's sagging image abroad and has played her part in boosting the domestic economy.

Just a brief glimpse of the future queen can give enormous pleasure to so many people; when, for instance, the Princess sits down on the edge of a bed at an old people's home or a hospice, those few precious moments bring immense joy. Her choice of outfit is invariably the topic of conversation long after she has departed. People expect a royal princess to stand out in a crowd, and by wearing bright colours and distinctive hats the Princess is instantly recognizable through the mêlée of officials and security men.

Before each official engagement the Princess and her

saw day and evening dresses, coats and suits all in these three bold shades. Red and black were often combined together to great effect as in the unusual one-sleeved dress by Catherine Walker seen at the British Embassy dinner in Paris. The most talked about 'red' garments were the Chanel red coat and hat chosen by the Princess to wear for her arrival in Paris.

Throughout 1988 women were still being encouraged to show off their knees and legs with the aid of the short hemlines. The Princess continued to champion the cause and wore many tailored short skirts and dresses.

The Princess's confidence continued to shine through during the year, never more so than when she wore jeans, a sloppy sweat-shirt and an old baggy tweed jacket to a polo match in the summer.

As the year drew to a close thoughts were already turning to 1989. Once again, early in the year, she would be flying off on official overseas tours to New York and then the Gulf. The meticulous planning required to select a wardrobe for a Princess was well underway. The fashion world was gearing up for yet another year when the Princess of Wales would exert considerable influence.

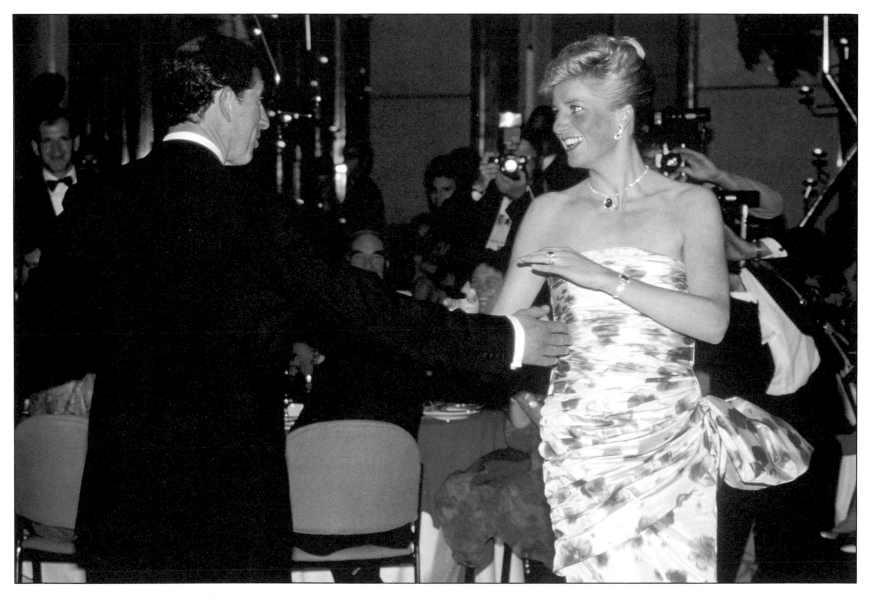

ladies-in-waiting will study the itinerary – the requirements of the visit will influence the choice of clothes. The Princess may have to bend down to plant a tree, climb high steps or stand on a windy runway – the outfit must be chosen for comfort and to avoid possible embarrassment. One of the ladies-in-waiting will usually visit the location prior to the Princess's appointment, thus ensuring that the final choice is appropriate.

The Princess and her clothes – magnificent obsession or an essential part of the job? The answer probably lies somewhere between the two points of view. Over the past eight years few can dispute the fact that, at the very least, our future queen's chic sophistication and acute eye for stealing the fashion headlines has provoked comment and inspired an ailing British fashion industry. The story unfolds in the chapters of this book; it is a unique chronological catalogue of many of the outfits worn by a woman whose impact on international fashion circles can be likened to a minor revolution.

Dancing the night away in Melbourne, Australia in January 1988 the Princess shows off her new evening gown in pastel pink and blue silk. This gown, by Catherine Walker, accentuates her elegant shoulders.

From private person to royal princess

In November 1980, on a freezing winter night, the future Princess of Wales walked along a London street huddled in a green woollen coat. Lady Diana Spencer, as yet unknown to the world's press, had just attended the fiftieth birthday party celebrations held for Princess Margaret at the Ritz Hotel. The well-worn coat covered a pink and gold evening gown, and Lady Diana looked just like any one of the so-called 'Sloane Rangers' who had been among the party-goers.

Over the following weeks, as rumours about a royal romance began to spread, the press showed early signs of what was to grow into an obsession – an interest in the style of clothes that Lady Diana liked to wear. As a part-time kindergarten teacher she dressed for the most part in very casual clothes. Trousers were frequently seen: jeans, cord drain-pipes or knee-length knickerbockers were worn with coloured sweaters and cardigans.

The Princess liked to shop in many of the popular Knightsbridge shops – Harvey Nichols, Laura Ashley and Fenwicks were particular favourites. For a special occasion Diana would drive herself down to Harrods to browse through the vast selection of clothes. Only a few weeks before her engagement she was seen doing exactly that; indeed she may well have spotted then the blue off-the-peg suit by Cojana, purchased from Harrods, which she wore on her engagement day.

Now that Lady Diana Spencer was about to enter public life she was faced with the task of collating a wardrobe that would be appropriate for her new role. Britain's top designers provided many of the couturier garments, but Diana still liked the freedom to choose from some off-the-peg designs. Shopping expeditions, however, became increasingly more hazardous as speculation about a royal romance grew to fever pitch.

Designers such as Bellville Sassoon, Jasper Conran and Jan Van Velden introduced Diana to a wide range of styles, although some of her personal preferences, such as ruffle necks and sailor-style blouses, were incorporated. Donald Campbell and Bill Pashley were names with which Diana was already familiar, as her mother, Mrs Shand Kydd, and sisters had patronized them over the years.

The Emanuels' name came to the Princess's attention when she took a liking to a blouse they had designed. She borrowed the blouse for a pre-wedding official photographic session with Lord Snowdon. Diana decided to commission them to make her magnificent wedding gown. The Emanuels were also responsible for the very low-cut black evening gown that Diana chose to wear on her first official engagement – a reception at London's Goldsmith's Hall in March, 1981. In retrospect it was probably unwise to have worn a dress that was bound to provoke comment, thus causing great embarrassment to a young girl who was still ill at ease with publicity.

That same month Diana flew by royal helicopter with the Prince to the West Country town of Cheltenham. She looked shy and nervous as she greeted local well-wishers, dressed in a Bellville Sassoon navy and white sailor suit. Later that same day, back at Buckingham Palace, the engaged couple posed for the first time with the Queen for an official photograph – Diana was still wearing her sailor suit.

During the run-up to the wedding Prince Charles showed his fiancée off to the world in a sudden rush of public engagements. Her choice of clothes for these appointments conformed to quite traditional style – two-piece suits in wool and silk and simple dresses, in fact nothing too out of the ordinary.

In June, with only one month to go before the wedding, Diana attended her first Royal Ascot race meeting with the royal party. This four-day meeting, which is world famous for its overt style and sophistication, requires an appropriate wardrobe. There was nothing extravagant, however, about Lady Diana's four outfits for Ascot; she also kept to tradition by wearing gloves – in subsequent years she has defied convention and gloves are rarely seen.

As the royal party moved through the crowded Royal Enclosure to the paddock Diana kept in step behind the Queen, looking very self-conscious in her new outfit and matching accessories. The four days revealed two suits by Bellville Sassoon, both in silk: the first suit was in a pale peach worn over a ruffled blouse; the second, a red and white Andy Pandy-style skirt, was worn with a plain blouse and sleeveless coat. David Neil made the lilac, banana and white striped silk suit worn on the third day. The final Ascot outfit was a grey and white check dress with a Peter Pan collar. All the Ascot outfits were finished off with hats made by the Scottish-born milliner John Boyd. John Boyd was also responsible for the slanted red hat worn to the wedding of Prince Charles's close friend, Nicholas Soames, at St Margaret's, Westminster, in late June.

On 29th July 1981 Lady Diana Spencer married the Prince of Wales at St Paul's Cathedral – it was a unique event which was seen by millions both at home and

abroad. The wedding dress was designed by David and Elizabeth Emanuel; it was a romantic reincarnation of every girl's dreams. The twenty-five-foot long train sparkled with mother-of-pearl sequins and tiny pearls, and was finished in lace. The dress itself was made in ivory pure silk taffeta, overlain with pearl-encrusted lace. Lady Diana wore delicate silk slippers with tiny heart motifs made from pearls and sequins by Clive Shilton. The fairy-tale had come true: the dashing Prince had married his beautiful Princess and we were all able to share in the excitement of a truly splendid occasion.

A few months later the hat that was worn to the Soames' wedding was seen, slightly altered, with a green edging to match a red and green suit made by Donald Campbell. The Princess wore the suit in the Welsh national colours as a tribute on the first day of a mini tour of Wales in October 1981.

The weather was bad throughout the visit. It was cold and frequently rained. A celebration service was held in the historic St David's Cathedral; the Princess was dressed warmly in a camel wrap overcoat but she was soon to learn the importance of dressing for the elements. John Boyd had designed the small beige velvet hat with veil that complemented the camel coat. The large ostrich feather looked fluffy and full during the visit to St David's but, by the time the Princess had finished her drenched walkabout in the main street of Carmarthen, the hat was suffering badly from the rain, with the feather limp and soggy. Despite the near fatal debut the hat recovered well and kept its shape, for it was seen looking as good as new in 1983 when the Princess visited Christchurch in New Zealand.

The future Princess notched up two important firsts during this year – the annual Braemar Gathering and the State Opening of Parliament. At the Braemar Gathering, held near Balmoral, Scotland, the Royal Family are always dressed in traditional Scottish tartan, or alternatively country tweeds. The Princess wore a new check suit made by Caroline Charles and, for that added Scottish flavour, a black tam-o'-shanter that had been specially made for the occasion by John Boyd.

For the State Opening of Parliament in November a more regal style was *de rigueur*. As the Princess rode in one of the state coaches to the Houses of Parliament accompanied by Princess Anne, the passing crowd caught

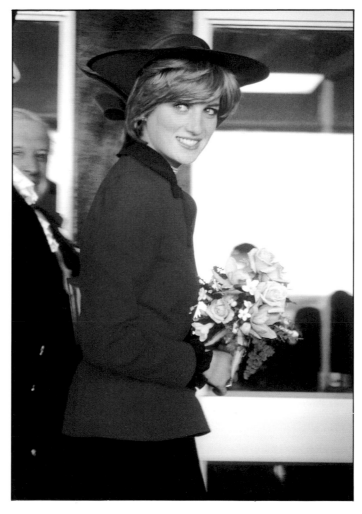

In November 1981 Princess Diana chose a suit in the National Welsh colours by Donald Campbell for a three day tour of Wales. The red wool jacket contrasts boldly with the dark green pleated skirt. The hat by John Boyd echoes the patriotic colour scheme.

a brief glimpse of a white fur coat and the Queen Mary tiara.

In the final months of that exciting year, 1981, Buckingham Palace announced that the Princess of Wales was expecting her first baby. A new maternity wardrobe would have to be chosen. In December, and only three months' pregnant, the Princess was seen in looser styled clothes such as the red coat and dress worn for a visit to Guildford Cathedral for a carol concert. On Christmas day at the family service held in St George's Chapel at Windsor, the Princess's pregnancy was becoming more evident in a turquoise-blue maternity coat.

This practical green coat that here is worn over Lady Diana's pink and gold evening dress was worn for day and evening wear in 1980. Diana is seen leaving Princess Margaret's fiftieth birthday party.

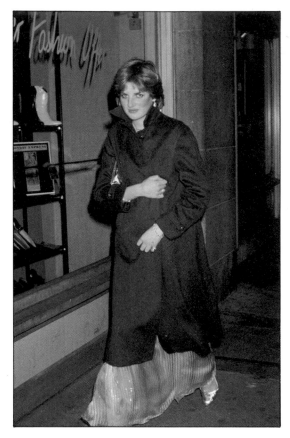

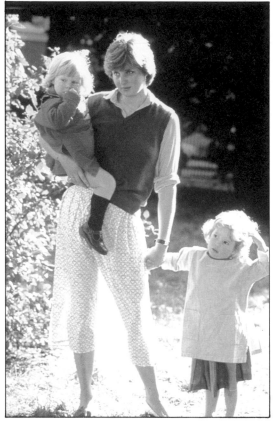

This was typical of the style of day dress preferred by Lady Diana in 1980. The lightweight skirt caused the young teacher some embarrassment as she posed for the cameras, unaware of its transparent qualities.

Lady Diana Spencer strolls through Eaton Square in London in 1980 pushing a friend's baby. She is dressed in comfortable cord trousers, an old cardigan over a cotton blouse, plus her warm coat.

For day-to-day visits to friends and family Lady Diana often preferred to dress casually, in a soft wool cardigan, a coloured blouse, trousers and a neck scarf. She is seen here outside her London flat in 1981.

Returning from a day's work to her London flat, the future Princess of Wales looks like any ordinary working girl dressed in her navy check skirt and green sweater. Her taste for coloured tights is evident at this early stage, for she has chosen a shade of tights which match her sweater.

This colourful hand-knitted sweater was worn before and after her engagement. Lady Diana teams it up with jeans and a ruffle-necked blouse to wear to work at the All England Kindergarten in Pimlico. Here she is seen returning from an outing with some of her young pupils. The sweater came from the London shop Inca.

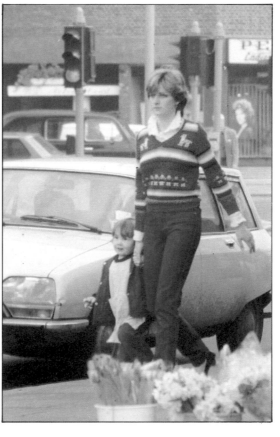

Lady Diana leaves her London home for the weekend in 1981 with her overnight case. She is dressed in a Victorian-style cotton blouse with a ribbon tied at the neckline, a casual cardigan and a grey pinstripe skirt.

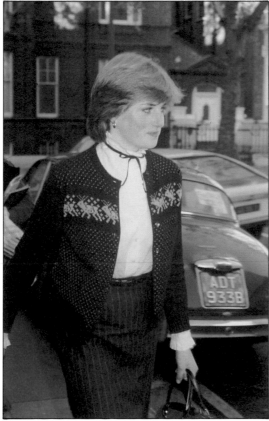

The Prince of Wales and Lady Diana stroll in the gardens of Buckingham Palace on their engagement day in February 1981. Diana wears a blue suit by Cojana, purchased from Harrods, and a blue and white blouse with a tie neck.

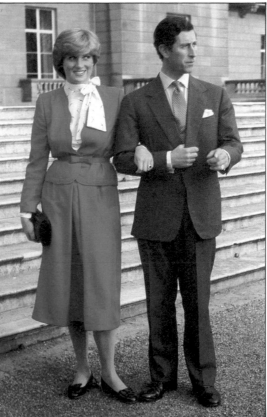

This low cut black dress by the Emanuels caused much comment when the young Lady Diana chose to wear it to Goldsmiths' Hall in March 1981. The dress, in a heavy black taffetta, was not to be seen worn again in public.

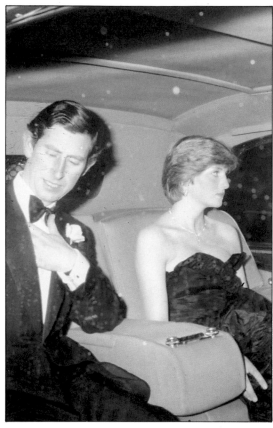

One of the first day suits in Lady Diana Spencer's 'official' wardrobe was this emerald green silk suit, chosen here for a visit to Romsey, Hampshire. The suit, worn over a cream ruffle-necked blouse, sports a cummerbund belt in the same fabric.

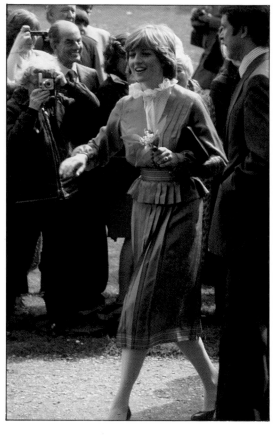

Bellville Sassoon designed this smart, navy wool sailor suit and crisp white blouse. Diana wore it in March 1981, to visit Cheltenham. She also wears her simple, single-strand pearl necklace and carries a navy clutch bag.

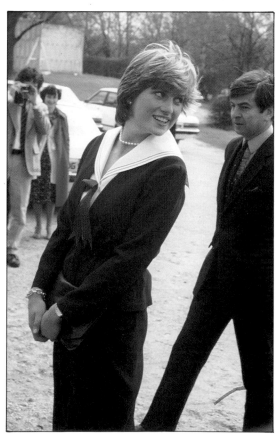

A shy Diana peeps out from under her felt hat in the paddock at Sandown races in March 1981. She is most definitely dressed to suit the occasion in a country brown suit by Bill Pashley. The favourite cream blouse is seen yet again.

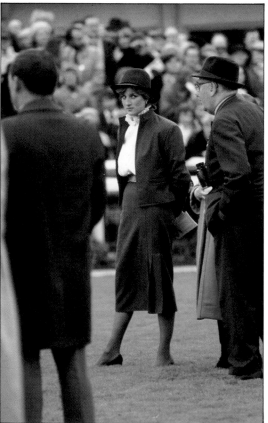

Jasper Conran can take the credit for this cheerful red and white polka dot suit seen here in Tetbury in March 1981. The jacket is held with a wide leather belt and is worn over a high ruffle-necked blouse. The skirt, in plain red, is kept to a simple straight style.

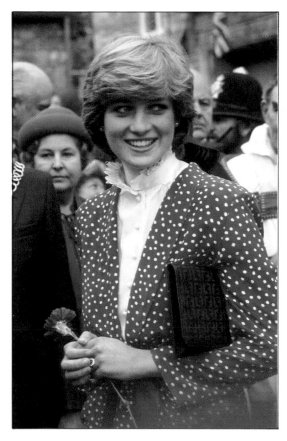

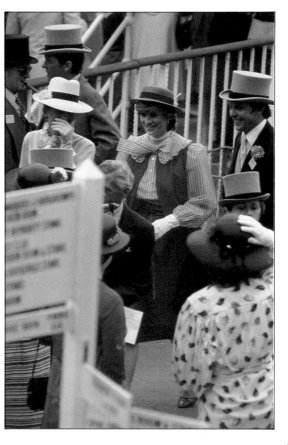

This red and white Andy Pandy style suit stood out in the crowd at Ascot races in June 1981. Bellville Sassoon designed this suit in three pieces: a skirt, sleeveless coat and a bold, striped organza blouse.

This pale apricot silk suit was worn to Royal Ascot in 1981, and came in useful on the Princess's honeymoon. It was also worn without the ruffle-necked blouse, as seen here on the last day in Egypt before departing for England.

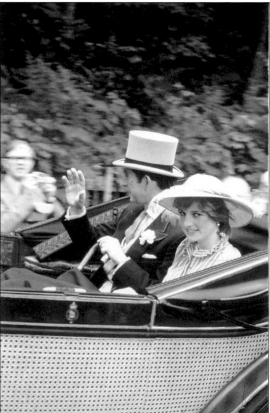

David Neil designed this three-piece suit, worn to Ascot in 1981, in lilac, white and banana stripes. The outfit consisted of a camisole top, pleated skirt and loose jacket. A large-brimmed hat in a matching shade of lilac creates the ideal outfit for a day at the races.

The finishing touch

In the early part of the eighties hats had become a forgotten fashion accessory for the vast majority of women. The floppy felt hat of the seventies had long been hidden at the back of the wardrobe. Elaborate hats were mostly confined to the pages of glossy fashion magazines and 'society' events. The favoured hat for most women, dragged out for those family weddings, was limited to a dusty old straw hat with a dull band around the crown.

For the royal ladies however, hats had never become unfashionable. They were still seen as an indispensable item to complement or formalize a complete outfit.

The Queen, Queen Mother and the Princess Royal have each established their own style in their choice of hats, patronizing such established names in the world of millinery and fashion as Frederick Fox, Norman Hartnell, Hardy Amies and Aage Thaarup. The Scottish-born milliner John Boyd had supplied the occasional hat to a royal client but it was not until the new Princess of Wales appeared in public in so many of his creations that he became prominent among British milliners. The Princess chose to wear hats at almost every public event when she first attracted public attention, unlike the present day when she prefers to keep them for more formal or colourful occasions, such as overseas tours, Royal Ascot and formal state events.

The revival in the popularity of hats in the early eighties was certainly fuelled, in part at least, by the Princess of Wales's personal interest. At this time she favoured John Boyd's small skull cap styles. Many of these were included in her Australian and New Zealand tour wardrobe in 1983. The hats were decorated and trimmed in with a variety of fine face veils, silk flowers and flowing ostrich feathers.

The problem with hats, whether large or small, is keeping them in position. Everyone has suffered the embarrassment of a fly-away hat at the most inopportune moment. For the Princess of Wales, so much in the public eye, this is a situation which simply must not happen. John Boyd introduced the Princess to a clever spring-like clip that fits snugly inside the hat and keeps the item on firmly. Mr Boyd discovered these useful combs while on a trip to Thailand. He was in a small village market near Bangkok when he discovered them set on springs. He purchased 150 of these, much to the delight of the locals. It is a rare sight to see the Princess of Wales spoiling her hats with old-fashioned hat pins.

In the Princess's wardrobe there are approximately

Above right
For a visit to London's University College Hospital in December 1982, the Princess chose a John Boyd creation. This small cap is covered in blue-grey velvet and is decorated with a large, softly dyed ostrich feather. A delicate spotted face veil is sewn into the brim and this cascades down around the Princess's head to her jaw-line.

Below right
This hat had to do battle with the wind when the Princess wore it for her arrival at RAAF Fairbairn in Canberra, Australia, in 1983. The pretty turquoise silk cap was secured tightly as the Princess walked about the blustery runway. The instantly recognizable style of John Boyd was evident again with the fine veil, this time swept back off the face and secured with a ciré flower at the back. The hat is covered with silk that matches the suit by Catherine Walker of the Chelsea Design Company. The hat is finished off around the edge with two rolled ropes of silk.

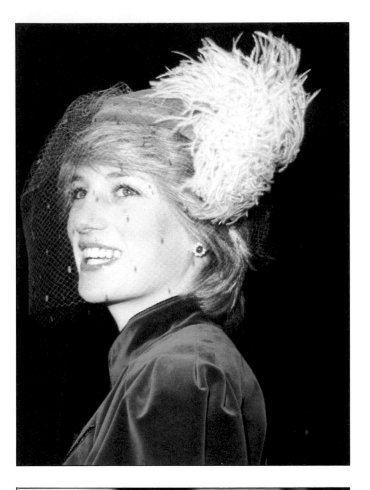

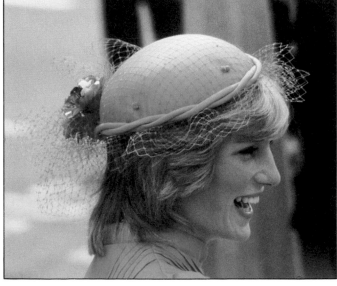

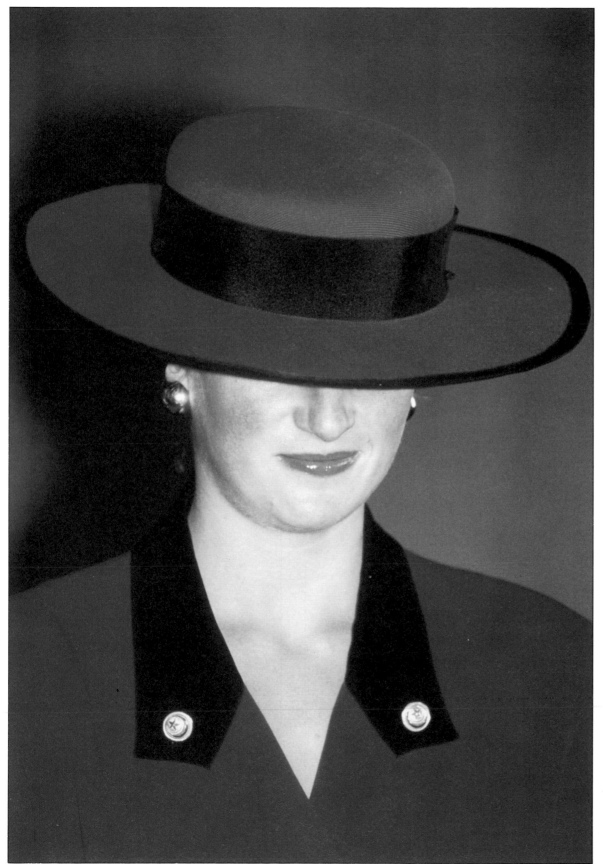

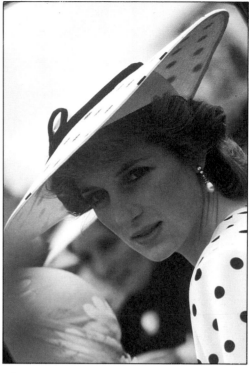

Above
Hats are *de rigueur* in the Royal Enclosure at Royal Ascot and the Princess always enjoys the fashionable fun at this particular race meeting. But she has chosen an unusual hat for an afternoon on the Epsom Downs to attend the running of the world famous Derby in 1986. It was made in two separate pieces: a small tightly fitting skull cap in white straw was overlain by a polka dotted wide flat brim, tilting over the right eye. The polka dots matched a black and white polka dot dress by Victor Edelstein.

Left
This tailored red boater was made by Philip Somerville for the Princess in 1987. Worn with an elegant red and black suit during a visit to the French city of Caen, it caused a flutter in fashion circles. The hat appears quite simply styled from the front but from the side and back the attached black 'snood' is clearly visible. The snood completely covered the Princess's hair and accentuated her face. The fabric was tied behind her neck and the long ends trailed down her back. The more formal part of the boater at the top has a black silk band and edging.

Right
This small skull cap, complete with a delicate face net, is typical of the 'Boyd' style. The ivory-coloured hat has silk flowers attached to one side and was worn with a suit in a similar colour when the Princess visited Tasmania in 1983.

Far right
Back to John Boyd, but this time a different style. This feminine shell pink hat was chosen for a visit to an orange grove near Catania in Sicily in 1985. The large floppy brim was turned back at the front and secured by a decorative feather made in the same straw as the hat. This floppy cloche style was repeated by the Princess at the wedding of The Duke and Duchess of York in 1986, but since then the style has not been seen again in public.

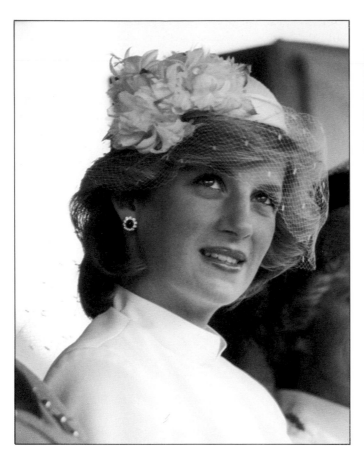

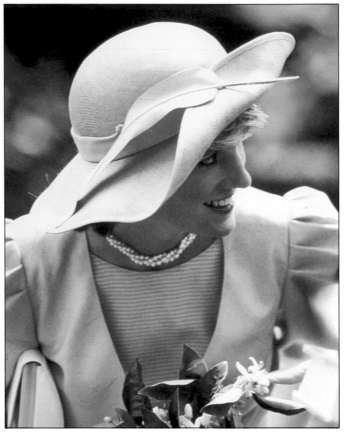

Right
This simple pillbox in dark plum wool has made use of a wide piece of fabric from the Princess's suit by Bruce Oldfield. The material has been gently pleated and sewn at an angle from the crown of the hat to the side. It has been worn on a number of occasions including the dedication of HMS *Cornwall* at Falmouth, Cornwall in April 1988.

Far right
John Boyd introduced the Princess to the spring comb to secure her hats firmly. Here the Princess has got into trouble and is showing her clip. The Princess had just driven around a sports stadium in an open-topped car during her visit to Perth, Australia, in 1983. The unusual drape cap was designed by Boyd.

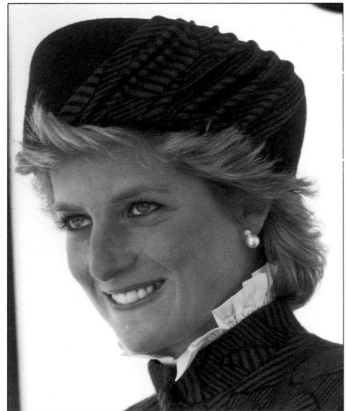

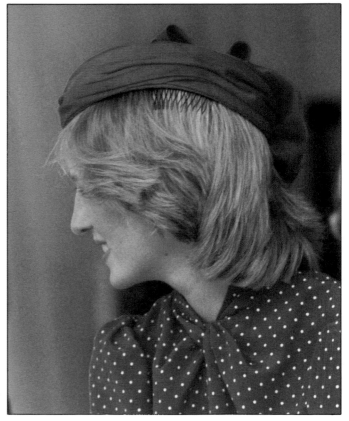

seventy-five hats. These are all meticulously kept, wrapped in tissue paper and stored dust-free in hat boxes. Many of the Princess's hats have to endure typically British weather and consequently they often get extremely wet. Little can be done to restore a badly soaked hat but it is surprising how resilient to rain some of them can be. One such hat was a small coffee-coloured velvet 'Boyd' hat worn during a walkabout in a heavy Welsh downpour in Carmarthen in 1982. The hat looked ruined as the ostrich feathers hung down miserably over the Princess's face. The following year, however, the hat appeared totally revitalized in New Zealand.

The Princess continues to patronize John Boyd but she has also expanded her list of milliners to include Frederick Fox, the Queen's milliner; Graham Smith, who has been the design director of Kangol for over six years and who is responsible for many of the nautical designs; and Philip Somerville, the New Zealand-born milliner who has created many of the larger, more sophisticated hats chosen by the Princess over the last couple of years.

Recently the Princess has chosen hats with cleaner, sharper lines with little or no trimming. She seems to enjoy wearing the large-brimmed picture hats, but still some of those favourites, such as small natty pillboxes, berets and jaunty nautical styles, appear in her ensembles. During her visit to Berlin in November 1987 the Princess appeared in a turban reminiscent of a favourite style of the forties. The turban was cleverly draped in yellow and black wool by Philip Somerville.

Hats will continue to play an important role in the Princess's wardrobe. She is extremely lucky in that the style of most hats suit the shape of her face, drawing attention to her large blue eyes. She chooses her hats carefully, usually in consultation with the milliner. The nature of the occasion and the style of colours of an accompanying outfit will obviously influence the final decision. Periodic fittings are normally essential. It can take up to three days of meticulous work to craft a hat fit for a Princess. Silks and nets often have to be hand dyed to match a garment and small lengths of material from a garment are frequently incorporated into a hat to ensure perfect cohesion.

Many women wear hats with self-conscious determination; the Princess of Wales, however, wears her hats with consummate ease. This *pièce de résistance* of accessories has found the perfect champion.

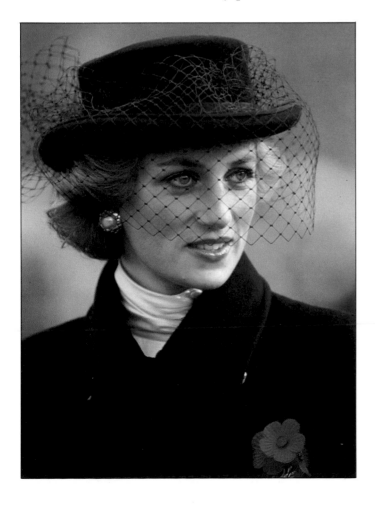

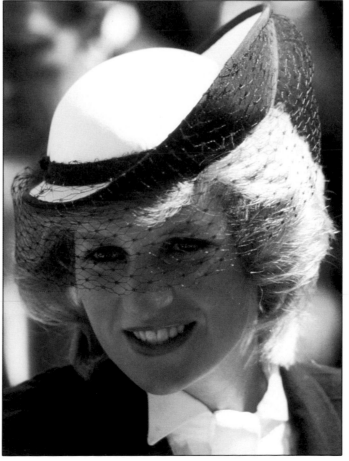

Far left
This black hat with a long face net exuded an appropriate air of solemnity when worn at the 'Celebration of Armistice' in Paris in 1988. Viv Knowlands was the designer back in 1986 and it has been seen on a number of occasions since then.

Left
Frederick Fox is the designer responsible for this hat with the upside-down-brim. This small neat hat in navy and white has a brim that rolls up on the left side. Into the tiny band around the hat a navy face veil is attached, ending just below the eye line. This hat was worn during the Princess's visit to Warrington in May, 1984.

For her first 'James Bond' film premiere in London in 1981, the Princess dressed in a vibrant red and gold silk chiffon gown by Bellville Sassoon. The boned top has tiny shoe-string straps and is worn with a necklace of gold, rubies and diamonds that matches the Princess's bracelet and ear-rings.

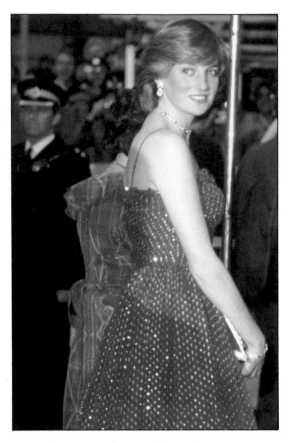

Red again: this dress by David Neil in lightweight silk is shot through with a white, blue and green pattern. The dress, with a tie belt and high ruffled neckline, was worn to the wedding of Nicholas Soames and Catherine Wetherall in July 1981.

Lady Diana keeps cool during those nerve-wracking days immediately before her wedding in a simple, patterned silk suit. The loose-fitting pale pink and white blouse is worn tucked into the skirt and has full elbow-length sleeves.

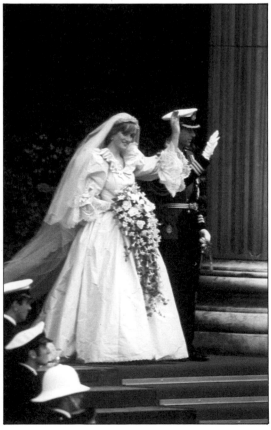

The *pièce de résistance* of a woman's wardrobe – her wedding dress. The Princess wears the dramatic ivory silk dress designed by David and Elizabeth Emanuel. The Spencer family tiara keeps the veil securely in place as she waves to the crowds on the steps of St Paul's Cathedral.

As the newly wed couple arrive in Gibraltar to embark on *Britannia* for a honeymoon cruise, the Princess looks fresh in a white floral faconne silk dress and jacket by Donald Campbell. The short jacket ties simply at the front.

Looking fit and bronzed, the Princess arrives back at RAF Lossiemouth in Scotland after her honeymoon in 1981. She is dressed in a white double-breasted cashmere coat over a thin silk suit. White shoes emphasize her tanned legs.

This brown and white check suit by Bill Pashley was the perfect choice for a stroll by the River Dee at Balmoral in August 1981. A white blouse with a mandarin neckline is worn underneath, and soft cream leather pumps are the sensible choice of footwear. The Prince looks happy and relaxed in a kilt and casual sweater.

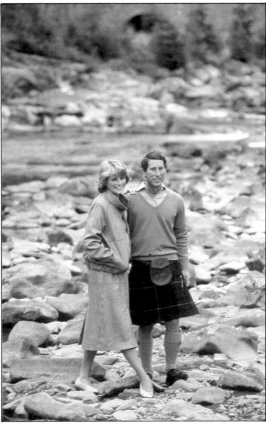

Caroline Charles designed this woollen dress in a rust, brown and black plaid. The Princess chose it in preference to a kilt on her first visit to the Braemar Highland Games in September 1981. To complete the Scottish theme, she wears a black velvet tam-o'-shanter.

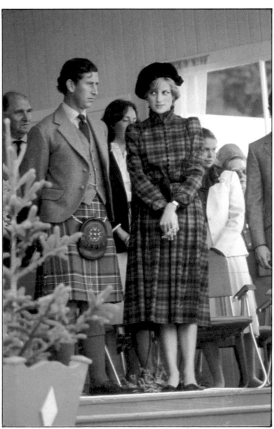

Front to back

July 1981, and twenty-five feet of ivory-coloured silk make a spectacular back train to the Princess's wedding dress designed by David and Elizabeth Emanuel. The dramatic design was greatly appreciated by the congregation in St Paul's while the Princess stood at the altar.

The Princess of Wales, while having one of the world's most recognizable faces, has another side to her character that is not so obvious. A clear back view of the Princess is often blocked by a number of dignitaries, security or personal entourage, but once in a while we have a chance to glimpse the back view of the Princess, and, at times, this can reveal her personal taste for fashionable finishing touches.

In 1981 on the Princess's wedding day, we saw evidence that the Princess liked to consider her appearance from the rear. She surprised everyone with the endless veil and train that flowed behind her as she ascended the steps of St Paul's Cathedral. In more recent years, however, the effect has been rather more subtle, and her choice has included small buttons, feminine bows and exotic embroidery.

For those not fortunate enough to come face-to-face with the Princess the backs of many of her day and evening clothes can prove almost as captivating. For instance, the choice of a long, plain, ivory-coloured strand of pearls accentuated the clear 'English rose' skin that was left exposed by a deep plunging V-shape cut in the back of an evening dress by Catherine Walker. The pearls hung simply around the Princess's throat and fell behind her neck, in preference to wearing long-stranded necklaces to the front. The pearls were cleverly knotted half-way down to enhance the shape. This combination of pearls and a simple and yet elegant dress could not have been bettered by the most elaborate array of glittering jewels.

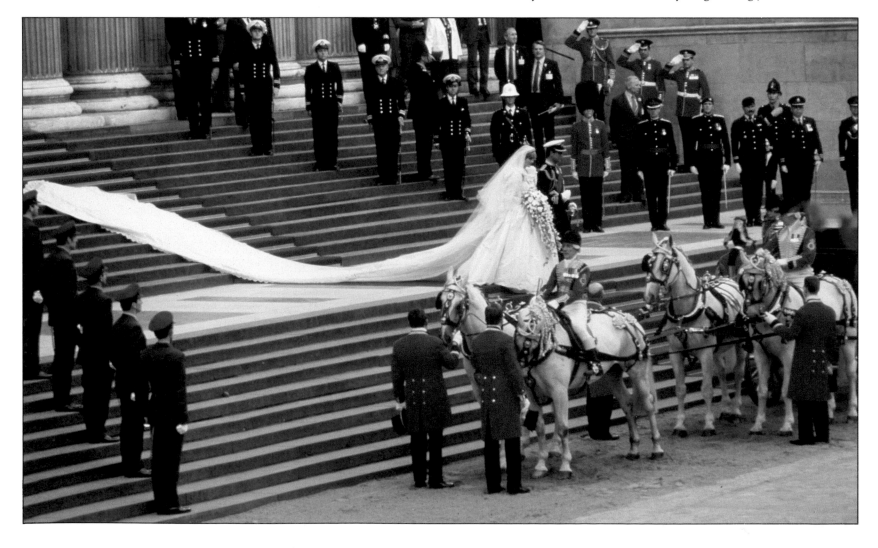

The same crushed-velvet dress also provided a second focal point for 'back detail'. At the base of the spine hung a large satin bow; this had proved uncomfortable for the Princess while sitting down for a long dinner or film premiere.

Another of the Princess's successful backs was the revealing design of the Bruce Oldfield gold lamé dress. A very large, bare triangle was shaped from the waistline almost to the nape of the neck. This dress has a tendency to reveal small red marks or blotches caused by sitting in a car or being pressed into a chair.

It is not just the glamour of evening wear that provides the successful back detail. The Princess has several warm woollen cardigans and jackets that are usually seen during her casual or private hours. When the Princess joined other parents to watch the school nativity play at Mrs Mynor's kindergarten, it was easy to spot the royal mother in her vivid pink cardigan. This colourful knitwear was edged in black with an elaborate swirl of black knitted into the back section.

It was another school occasion which provided the

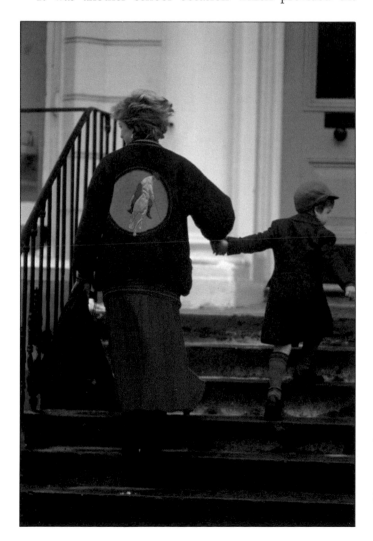

Above
The Princess, with her hair swept up, wears a large *diamanté* paste hair clip to a fashion show held in Sydney, Australia, in January 1988. Her outfit is by Bruce Oldfield.

Far left
In January 1987 Princess Diana accompanied Prince William to Wetherby school. She is wearing an over-sized cardigan with polo-player motif by Mondi and pleated red wool crêpe skirt by Jasper Conran.

Left
The Princess attended a British fashion show in Madrid during her short Spanish tour in 1987. Rifat Özbek designed this dramatic turquoise-blue moiré silk suit emblazoned with gold braid.

Right
To attend the film premiere of Steven Spielberg's *Back to the Future* in London the Princess wore this rich panne velvet plunge-backed evening dress by Catherine Walker, with a long strand of knotted pearls hanging down her back – simple but very effective.

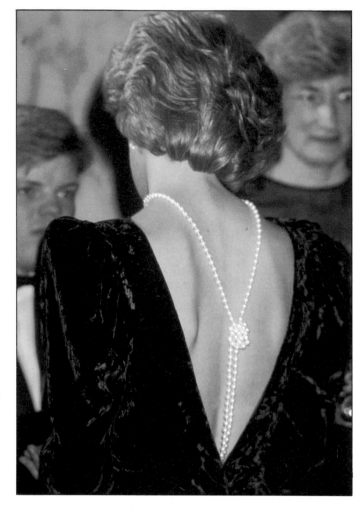

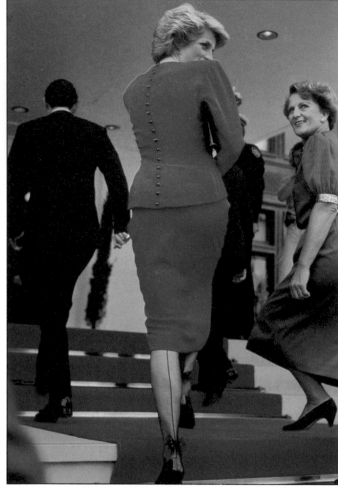

Far right
As the Princess climbed the steps to Government House in Canberra, Australia, in 1985, seventeen shiny round black buttons fastened the back of her red silk crêpe dress by Victor Edelstein. At the base of the Princess's seamed tights was a decorative net butterfly bow with red polka dots.

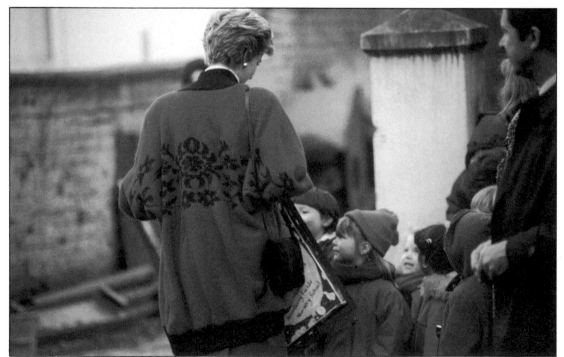

Right
This heavy knitted cardigan-jacket in a deep pink has a black swirling pattern knitted into the back for added interest; it was worn 'off-duty' to watch Prince William's school play in 1986.

opportunity for wearing a casual item of clothing. The Princess chose a long, dark navy jacket when she accompanied Prince William on his first day to Wetherby school. The jacket, with striped elasticated cuffs and collar, had distinctive appliqué work on the rear in the shape of a polo player on a pony.

As the Princess has excellent legs she can enjoy the luxury of wearing a high slit in the back of some of her skirts. These slits can emphasize the colour of her tights or accessory details such as seams or ankle bows.

There are at least four evening gowns in the Princess's wardrobe that feature a very low plunging back. Two of these have a row of small, dainty buttons for fastening or decoration. One dress, in a deep navy velvet by Catherine Walker, also has a lace panel sewn into the cut-away 'V'-shape. The lace is dyed to the same shade as the dress and a row of at least twenty small buttons follow the line of the spine. Her other low-backed dresses rely simply on a clear cut or dramatic colour for effect.

In Spain in 1986, the Princess wore a suit designed by Rifat Ozbek – the young Turkish-born designer who was voted the Best British Fashion Designer of 1988. The two-piece suit had a very long jacket with a full peplum. Although the jacket sported heavy gold appliqué designs on the lapels, Ozbek had also paid attention to the rear view with a finishing touch of appliqué work at the base.

In Portugal the same year, we saw the Princess wearing a very unusual and somewhat unflattering black bustle-style evening skirt. The bustle looked a bit too full with the swaggers of taffeta.

The Princess also uses her hats and hair styles to create a 'back feature'. Many of her hats are finished off with bows or feathers, but one of the most unusual styles to create a good back view, was the red felt hat made by Philip Somerville and worn in Caen in 1987. Attached to the hat was a large black rectangle of fabric, in a bavolet style. The fabric was pulled back in a scarf-like fashion and secured in a tie.

For back of the head detail when not wearing a hat the Princess is able to wear her hair swept up and fastened off with a decorative clip.

Included in her choice of day wear is a suit in deep purple wool. The suit, in the Cossack style, has heavy embroidered detail on the front and back.

Below
One of the more revealing back styles worn by the Princess was the bare triangle created by Bruce Oldfield in this gold lamé dress, seen here in Melbourne in 1985.

Right
Philip Somerville's dramatic Spanish hat had the unusual back feature of a bavolet-style scarf.

Below
A high-cut slit in the back of this black satin skirt emphasizes the black seamed tights worn to a sumo wrestling bout in Tokyo in 1986.

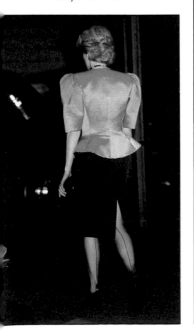

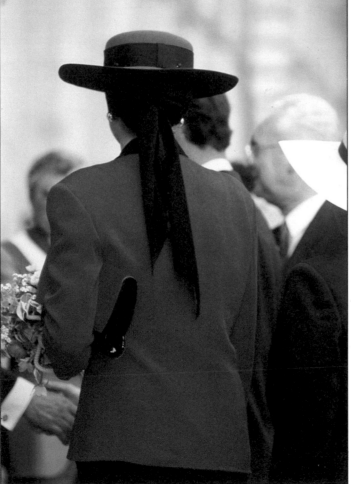

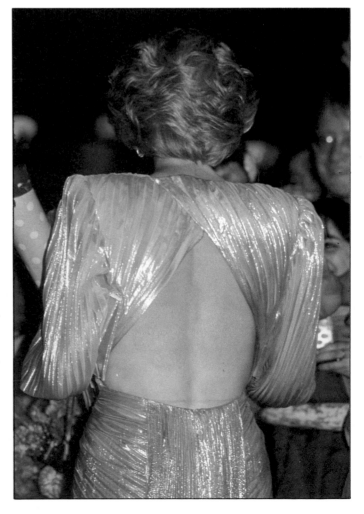

The Princess dressed in Welsh national colours on the first day of her visit to Wales in November 1981. The woollen suit was designed by Donald Campbell and is worn with a large-brimmed hat by John Boyd. Red shoes and a suede clutch bag complete the theme.

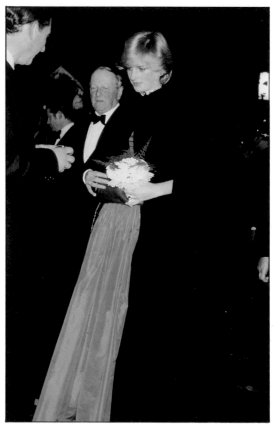

The emeralds in this splendid choker contrast well with the full taffeta gown designed by Graham Wren. The Princess, seen leaving a concert in Cardiff, Wales, in November 1981, also wears a heavy black velvet evening cloak.

This suit in a deep plum velvet is an off-the-peg design from Jaeger. The suit, worn on numerous occasions, is usually worn with a cream ruffled blouse, as seen here in Wales in 1981. The hat is by John Boyd.

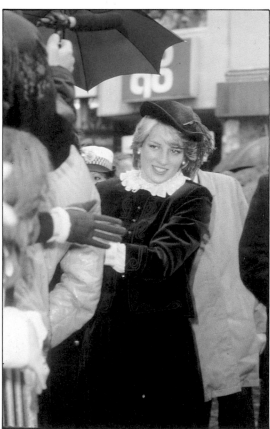

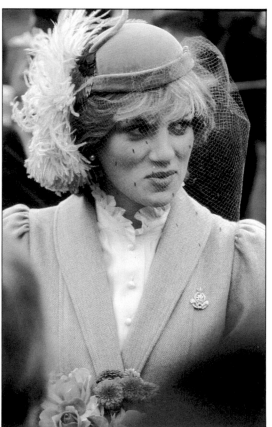

This feathered Boyd hat and beige tweed coat by Caroline Charles had to endure heavy rain during a visit to St David's and Carmarthen, Wales, in 1981. The cream silk blouse was the only item of clothing to keep dry during the walk-about. The hat, with a fine face veil, recovered well and was spotted again several years later.

This dark, bottle-green wool cape-coat is worn over a multicoloured printed dress by Donald Campbell, worn on a visit to Chesterfield in November 1981. Accessories include a black felt boater and black patent court shoes.

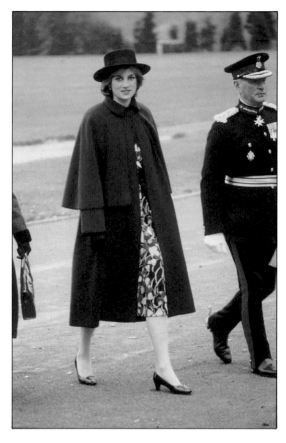

This romantic chiffon dress by Bellville Sassoon, seen here in London in November 1981, has been a favourite over the years. In feminine pastel shades of blue, pink and white, it has an off-the-shoulder neckline edged in satin bows. A wide sash is worn. Small silver beads are intermittently sewn on to the dress to create a subtle shimmer.

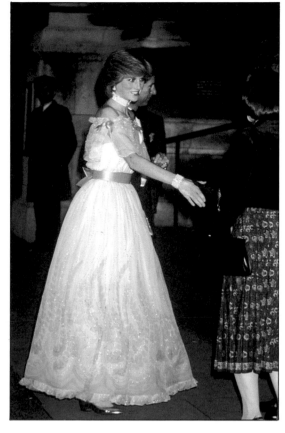

Gina Fratini designed this dark-green velvet dress in the puritan style. The wide lace collar matches the long petticoat which is deliberately worn longer than the dress. A tight satin sash in a lighter green matches the evening shoes. The Princess is seen here on a visit to the National Film Theatre in 1981.

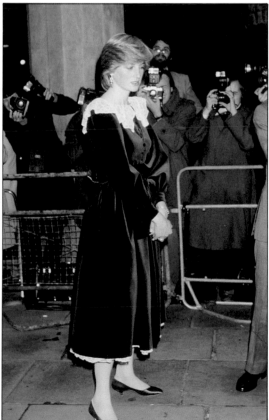

This heavy velour coat by Bellville Sassoon has an unusual fringed collar and hem. The loose-fitting coat was worn for the first time here at a luncheon at the Guildhall in London in November 1981.

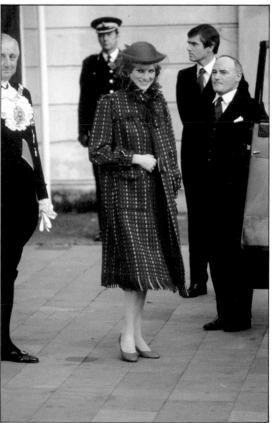

This lace-edged blouse with a wide collar by Bellville Sassoon has been worn with many outfits over the years. The blouse is worn under a black crêpe woollen suit at the Remembrance Service at the Cenotaph in London, in November 1981.

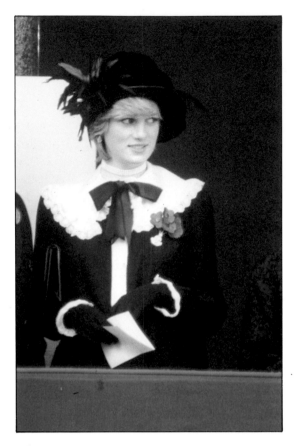

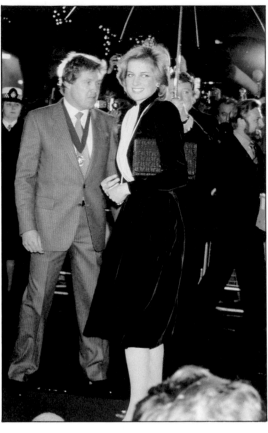

The first solo engagement for the Princess was to turn on the Christmas lights in London's Regent Street in December 1981. The Princess wears a rich blue velvet suit by Bruce Oldfield with a full gathered skirt. A pale pink crêpe de Chine blouse can just be seen under the jacket.

The Princess's first pregnancy was only in its early stages when she visited Guildford Cathedral for a carol concert in December 1981. The three-quarter-length coat is worn over a straight skirt and a patterned blouse. In line with the seasonal colour theme, the Princess wears red shoes and a red hat.

On Christmas Day at Windsor the Princess is seen in one of her new maternity coats by Bellville Sassoon. The soft coat, in a flattering turquoise velour, hangs gently from a yoke. It has a mandarin-style neckline. A small pillbox hat completes this 1981 Christmas outfit.

A pregnant pause

Because of the Princess's pregnancy no official royal tours were undertaken in 1982. But at the beginning of the year, the Prince and Princess flew off for a private holiday to the island of Eleuthra in the Bahamas. After a few weeks of sun and rest and, despite the upsetting ordeal of being photographed while pregnant in a bikini by press photographers hidden in bushes, the Princess returned to London to a relatively busy schedule of official engagements.

By the end of January the Princess could no longer wear her fitted clothes so she turned to her new maternity wardrobe. Bellville Sassoon was a major contributor, with his very feminine, flattering coats and dresses.

The royal couple attended a concert at the newly opened Barbican Centre in London in February, and it was apparent that the Princess's pregnancy had not detracted from her stunning looks. Dressed in a deep wine-red taffeta lace gown she showed that pregnant ladies can still look elegant. The magnificent diamond necklace that she was wearing added that extra touch of glamour, and perhaps successfully shifted the emphasis.

Despite almost certainly feeling immensely tired during this stage of her pregnancy, the Princess continued to travel around Britain; she seemed to prefer one-day flying visits to major northern cities such as Leeds, Huddersfield and Liverpool. On most of these visits the Princess was wrapped up against the chill spring air in a warm maternity coat worn over soft, loose dresses. These coats were usually matched with one of John Boyd's delightful hats. The Princess was still wearing her sensible flat pumps, which proved ideal footwear for those weary walkabouts.

In April, the Prince and Princess, as Duke and Duchess of Cornwall, visited the Scilly Isles for four days of appointments. As the spring comes early to this idyllic group of islands, the Princess could discard her heavy coats and we saw, for the first time, those maternity day dresses that, until now, had only peeped out of a collar or the top of a coat. In St Mary's, the Prince and Princess were greeted by a large crowd when they went on walkabout. The Princess looked extremely comfortable in a loose-flowing dress in a pale blue and white polka dot fabric, made by Catherine Walker.

During the final months of her pregnancy the Princess attended a number of polo matches to watch her husband play. These matches were usually at Smith's Lawn, Windsor, but in May the royal couple drove down to Brockenhurst in the New Forest for an afternoon of polo. The setting is less formal than that of Smith's Lawn. The Princess sat under a sun shade to watch the match, looking cool in a blue check dress with a crisp white collar and cuffs.

The Princess decided to attend only one day of racing at the Royal Ascot meet. Being heavily pregnant, her choice of outfit was extremely limited but she still looked radiant in a pretty pale peach silk dress and small netted hat. Obviously feeling rather self-conscious on this overtly public occasion, the Princess decided to avoid the route to the paddock which winds its way through the Royal Enclosure and passes immediately under the press photographers' balcony. Instead, she quietly slipped down the front exit of the spectator stands with some friends and into the paddock.

Later that day, however, she was not so lucky in escaping press attention when she stopped for tea and a spot of polo watching at Smith's Lawn, a tradition that members of the Royal Family enjoy after a day at the Ascot races. Feeling the cold as the day progressed, the Princess put on a soft white cardigan over her maternity dress, and appeared a little irritated at being photographed as she walked around the pony lines.

Only a short time after Ascot, the Princess was admitted to St Mary's Hospital in Paddington for the birth of Prince William. Her hospital stay was kept to a minimum and the Princess departed down the hospital steps less than twenty-four hours after the birth. Dressed in a green and white polka dot dress, she posed patiently on the steps for photographers with her husband and new son. While she wore little make-up and still appeared tired, her hair was as immaculate as ever.

In July, the Queen and members of the Royal Family attended the Falklands War memorial service at St Paul's Cathedral. It was the Princess's first official public engagement since the birth of her son. The Princess was perhaps a little over optimistic in wearing a tightly belted dress only a month or so after having a baby. The black cummerbund worn over a blue and black silk dress only emphasized the few excess 'baby' pounds that the Princess was still carrying. She also had a little trouble that day with one of her famous pearl chokers. When she arrived she was wearing her three-strand pearls, but as she departed from St Paul's it was missing. It was later reported that the choker had embarrassingly broken during the service, spilling pearls all over the floor.

In April 1982 Princess Diana, despite being nearly seven months pregnant, visits Liverpool and wears a bright pink velour coat by Bellville Sassoon with a hat in matching colours by John Boyd.

As late summer approached, the Princess flew with the Royal Family to Aberdeen for the start of the Balmoral holidays. The fresh air and exercise encouraged the Princess to lose the last of her pregnancy weight gain and by early September, when she attended the Braemar Games, she looked as healthy and slender as ever in a new black and brown check dress.

Over the next few months there was much speculation as the Princess continued to lose weight. At a fashion show held at London's Guildhall, she appeared in a blue one-shouldered dress by Bruce Oldfield. The dress accentuated her very slight shoulders and rumours that she may be suffering from the slimming disease, anorexia, appeared in the newspapers.

Being back in shape meant that the Princess could start to wear some of her more fitted clothes again, including the floaty pale blue sequinned evening gown that was tied off at the waist with a pink silk ribbon which was worn to a concert in Cardiff in November.

That same month, the Princess joined the Royal Family to welcome Queen Beatrix of the Netherlands to London for a four-day state visit. The welcoming party gathered on the red carpet at the landing stage at Westminster Bridge to receive the Dutch monarch who was travelling up the Thames in a royal barge. The Princess was dressed against the damp chill in a new pink, quilted suit and felt hat. The skirt length was still long in that 'Sloane' Lady Diana style and the ruffle neckline was still evident.

Also in November another short visit was planned to Wales and this time the royal couple started off in the tiny fishing port of Barmouth. It was here that we saw one of the early coat dresses that have since become so popular with the Princess. Arabella Pollen designed this particular dress in a tan and brown check wool. The length was long and the collar and cuffs were finished off in a soft leather. To keep out the cold, the Princess chose also to wear brown boots, a suede beret and leather gloves. Also seen on that particular visit to Wales was one of the maternity coats designed by Bellville Sassoon in a red and multicoloured wool. This eminently sensible idea of reusing maternity clothes did not receive popular acclaim on this particular occasion.

As Christmas approached the Princess made public her passion for velvet – it is a fabric she continues to favour. The navy velvet suit by Caroline Charles worn to the University College Hospital in December was finished off with a small blue hat with a very large ostrich feather trim and fragile face net by John Boyd. This style of hat would continue to be popular with the Princess as she entered the New Year.

The Princess steps out of the royal car as she arrives at the Barbican Centre in London to attend a gala evening in aid of the Order of St John. The Princess, by now three months' pregnant, wears a loose claret empire-line silk taffeta gown by Bellville Sassoon.

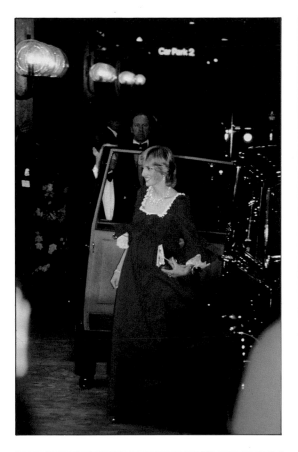

Huddersfield received a visit from the Prince and Princess in March 1982, and to keep warm the Princess wore a fluffy woollen coat by Bellville Sassoon in a deep shade of pink. The neckline has a wide collar with fringe edging.

A strategically placed bunch of spring flowers disguises the expanding royal midriff during her visit to Leeds in March 1982. The dark green Bellville Sassoon coat has a velvet collar and cuffs and appliqué patterns across the bodice. The boater-style hat is worn in a similar shade of green.

The Princess accompanied her husband and friends to the Grand National race meeting at Aintree, Liverpool in April 1982. Now seven months' pregnant, the Princess chose to wear a loose-fitting woollen coat in a deep, wine red. A hat worn jauntily to one side added the customary hint of style.

In pink again, this time for a visit to the West Country in April 1982. The woollen coat, by Bellville Sassoon, has a mandarin-style neckline and matches the small pillbox hat; it is worn over a pastel blue maternity dress.

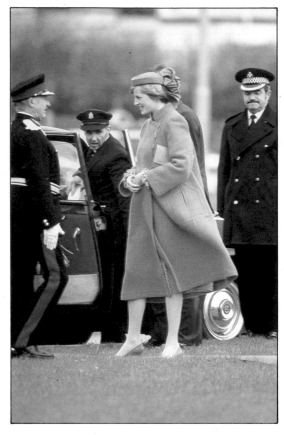

The Princess walks among the crowd on St Mary's, the Isles of Scilly, in April 1982. Sensible flat black pumps are worn by the pregnant Princess. The dress is by Catherine Walker in a pale blue and white polka dot fabric which hangs generously from a ruffled neckline.

The young mother-to-be keeps cool in her blue and white check maternity dress by Catherine Walker at a weekend polo match at Windsor in May 1982.

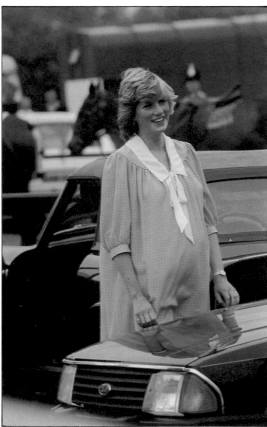

One of the most frequently worn maternity dresses, in blue cotton by Catherine Walker, is seen again here at a polo match, this time in Brockenhurst, Hampshire.

After a day at the Ascot races the Princess joins her husband for tea at the Guards Polo Club in June 1982. Only a short time before the birth of her baby, the Princess wears a loose maternity dress in a pastel peach silk. A casual warm cardigan has been added after the racing.

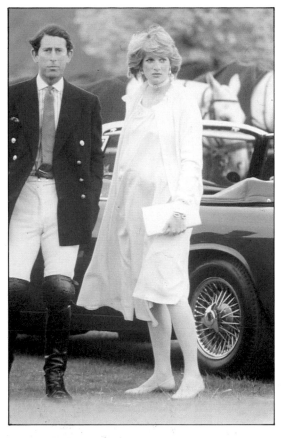

This belted dress in black and blue silk did not do justice to the Princess when she attended the Falkland Memorial service at St Paul's in London only a month after having Prince William in 1982. The dress by Catherine Walker is complemented by a small netted hat.

Arriving at Aberdeen airport on the Royal Flight in July 1982, the Princess wears a high-waisted polka dot dress with a wide, white collar. She carries a warm knitted cardigan in preparation for the family holiday at Balmoral.

The Princess's figure has regained its slender form after her pregnancy and here she wears a fitted suit at Heathrow airport in August 1982. The wine-coloured suit has a peplum jacket and is worn with a white blouse by Bellville Sassoon.

Hair Styles
Crowning glory

The Princess of Wales's hair has always been one of her most prominent features without being outrageous or extravagant. Over the years she has tended to prefer a more classical shoulder-length style, but once or twice she has been a little more daring.

A characteristic of the Lady Diana Spencer of 1980 and 1981 was the famous original layered bob. The style was casual and unfussy and simply blown dry. It was a most fitting hair style for the young Princess but as she matured she began to develop a more sophisticated and elegant look.

One of the new-found pleasures for the new Princess was the advantage of a personal hairdresser. The man who fulfilled this role was Kevin Shanley from the London salon Headlines. Shanley was to remain in this position until late 1984. During this period he travelled on many engagements and, of course, the official overseas tours to Australia, New Zealand and Canada. Shanley kept the Princess's hair to just about shoulder length and was also responsible for the unusual swept back styles in November 1984. This new look was rather reminiscent of the styles which were popular in the forties. At this time the colour of the Princess's hair underwent a radical change; the subtle highlights of 1983 became a total overall blonde look in 1984.

Richard Dalton, a stylist who was also originally from Headlines, took over Shanley's role late in 1984 and as we headed into 1985 a very definite change in style was beginning to take shape.

After the Christmas and New Year holidays at

Right
The original 'Lady Diana' hair style. The Princess-to-be is seen here in March, 1981, during a walkabout at Broadlands, at Romsey in Hampshire, the home of the late Lord Mountbatten. The hair is only very slightly highlighted. The short layers are swept across the forehead in a heavy fringe. The hair lies naturally flat on the top as little or no lacquer has been used on this occasion.

Far right
Trying to keep a royal princess's hair neat and in place can be difficult on a gusty day in London. Princess Diana got into trouble with her hair as she left the Capital Radio building in London in November, 1982.

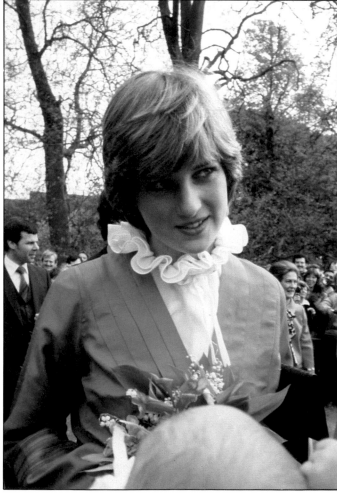

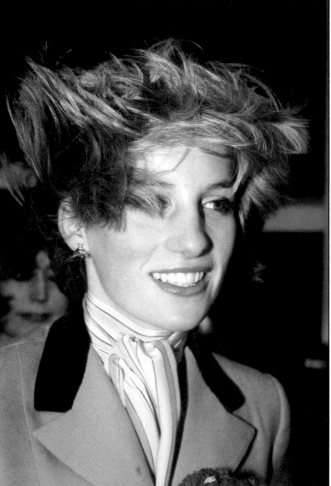

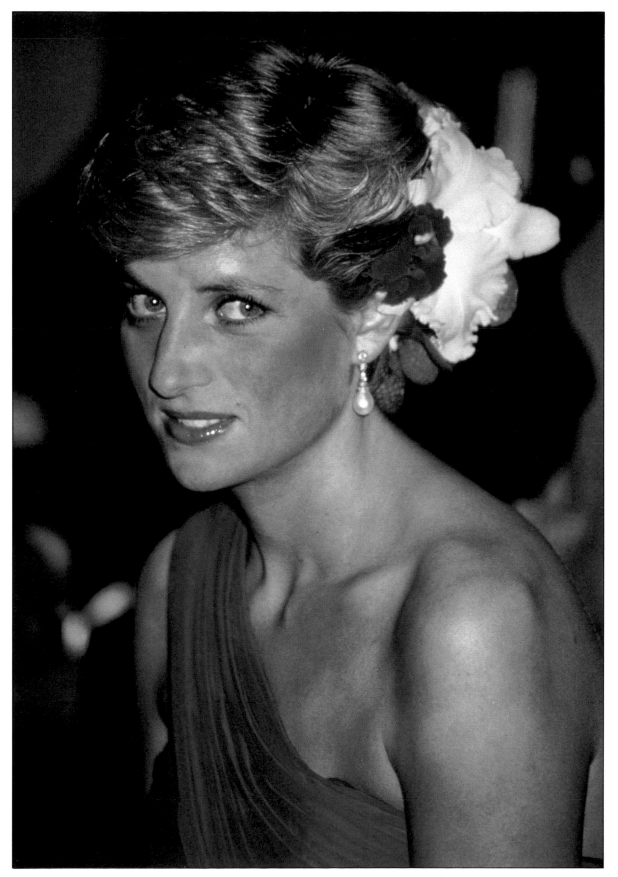

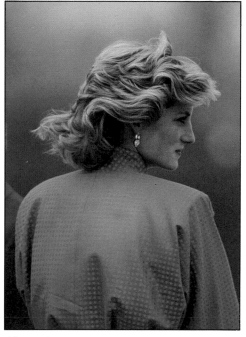

Above
This second attempt at letting her hair grow longer is given its first airing by the Princess when she visited Milan, Italy in 1985. The hair, although quite long, remains in short layers on the top.

Left
This hair style looked very exotic, particularly when finished off with coloured silk flowers, when the Princess visited Thailand in 1988. A formal dinner in Bangkok gave the Princess the opportunity to complement the colours of her dress with that of her hair, which was neatly pinned up behind the hair accessory.

Right
The Princess had grown her hair to shoulder length by the time she embarked on the long tour to Australia and New Zealand. At this stage her hair was still fairly natural and cut to a heavy wedge across the fringe and into the back of the hair, the style was fairly easy to manage. The colour still has only faint traces of highlights. The Princess is seen here in the Australian outback town of Alice Springs in March 1983.

Far right
Shortly after the birth of Prince Henry, the Princess grew her hair to its longest length yet seen. Kevin Shanley swept her hair off her face and clipped it back quite severely. The style was reminiscent of those popular in the forties. It was the first time that we had seen the Princess without her heavy fringe and it took some people by surprise. On some occasions this style would be worn curly at the back and at other times it was blown dry to achieve the very straight look.

Sandringham the Princess appeared with a very sophisticated swept-back style as she posed for photographers on the ski slopes of Lichtenstein. The colour had been toned down and the new fuller style was probably aided and abetted by a soft perm.

It was not until 1986 that we saw any dramatic change in the Princess's hair style, but just after the summer holidays at Balmoral she appeared with a very short creation similar to the style usually known in England as a 'DA' from the 'teddy boy' era of the fifties. The hair was very short all round, especially over the ears. The back was blown back almost into a wing at the nape of the neck. This cool hair style was the perfect choice for the coming visit to the Gulf States with their hot and sticky temperatures.

Although the short style looked simple to manage, the essence of these styles is the blow drying; if not dried correctly the top can appear shapeless and the back flat and wispy. It was noticeable that when the Princess had an overnight stop on the Royal Train before undertaking engagements, her hair was obviously self-styled and looked a little flat. Her hair at this stage was still highlighted, although at times darker shades returned.

Dalton works on a freelance basis for members of the Royal Family and at times this can mean irregular hours and fairly long periods away from home. On a normal day of engagements in the United Kingdom the Princess will need her hair styled before travelling; this usually means a very early start for both client and hairdresser as most of the engagements start around 10.30 am. On the tours, when time can be of the essence, Dalton often has to re-style the Princess's hair from a day look to a more glamorous, formal evening style.

Many of the female members of the Royal Family wear their hair up gracefully in 'rolls' and 'pleats'; the Princess first attempted one of these styles in 1984 when she attended the State Opening of Parliament. It was not, however, until more recently, in 1987 and 1988 that she decided on the elegant style which took the hair off the face and neck. This style suited her and worked particularly well when worn with a tiara. Although not over generous in length, Richard Dalton was able gently to roll the Princess's hair over the Spencer family tiara.

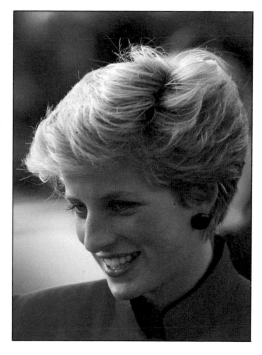

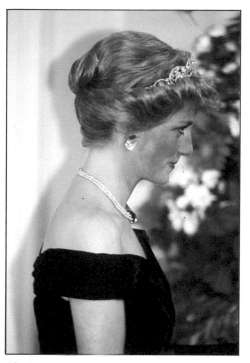

On other occasions the hair was scooped back into a pleat or into a small twist, with the pins cleverly disguised by a silk flower or a hair clip. Perhaps under the influence of her sister-in-law, the Duchess of York, who is a great lover of hair accessories, the Princess of Wales has started to incorporate these pretty items into her hair styles – the 'paste' *diamanté* star hair clip worn in Australia was a great success.

The hair styles worn more recently by the Princess have looked full of body and bounce. Her hair has been cut to a boxier shape and swept back off the face in a more classical style. On occasions it can appear quite curly at the back, probably when it has been tonged or dried with a hot brush. The Princess seems to have settled for a sensible length; this enables her to have the best of both worlds in that she can wear it scooped up, blown dry, curly, sleek or just hanging loose, according to the dictates of the occasion or mood. Whatever style she seems to choose the Princess's hair always looks shiny, healthy and clean and will remain one of her best attributes.

Above
Another variation on the 'hair up' theme is this gentle roll, styled for the Princess when she attended a formal dinner in Bonn, West Germany, in November 1987. The tiara is the Spencer family tiara which was first worn at her wedding.

Above left
In Wellingborough in late November 1984, the Princess's hair seemed very blonde and, at an awkward length, it looked a little windswept. All the shorter top layers had grown out to one length.

Above centre
The back view of the 'DA' was not seen to best advantage here when the Princess stepped off the Royal Train after an overnight trip – the overall effect is a little flat. The Princess was visiting Giggleswick in Yorkshire in September 1986.

Above right
Still wearing her hair short, the Princess is photographed during a visit to Littlehampton in December 1986. The hair colour has been changed to a more 'ash blonde' from the golden tones of a few weeks earlier.

This pretty, pink sailor-style dress was worn to the wedding of the Princess's former flatmate, Carolyn Pride, in August 1982. The drop elasticated waist of this dress by Catherine Walker enabled it to be easily converted to maternity wear.

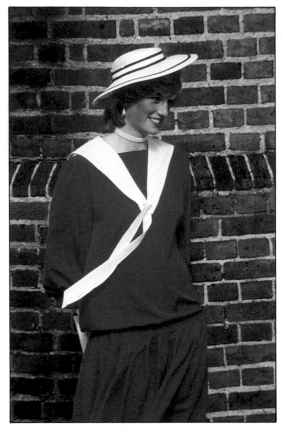

Attending her second Braemar Games in September 1982, the Princess chose another Caroline Charles dress. The dress, in black and brown check, has a fitted waist and button detail up the front, plus white collar and cuffs. The Scottish-style hat is reminiscent of the one worn by Prince Charles when he dresses in the uniform of the Gordon Highlanders.

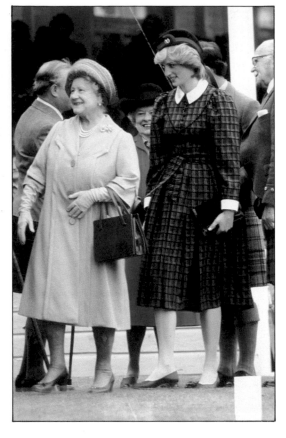

This overtly feminine dress in pale blue silk chiffon with a pastel pink satin sash emphasized the Princess's slender waistline. The neckline in a deep 'V' shape has a frothy ruffle edging. The dress, by David and Elizabeth Emanuel, has been seen on many occasions including here on a visit to Cardiff in October 1982.

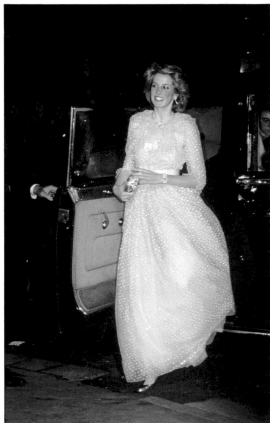

To attend a concert with Prince Charles at London's Barbican Centre in October 1982, the Princess chose an emerald green taffeta gown by Graham Wren. The diamond and emerald choker once belonged to Queen Mary. It has matching ear-rings.

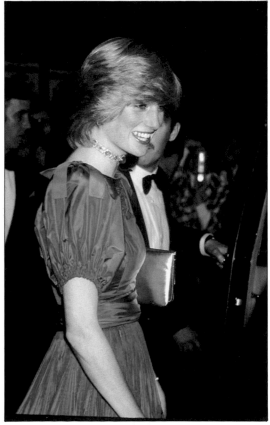

The Princess is often called upon to attend an evening reception when a long dress would not be appropriate. On these occasions cocktail calf-length dresses come in handy, like this one in blue silk chiffon by Donald Campbell, seen in November 1982 at a reception in London.

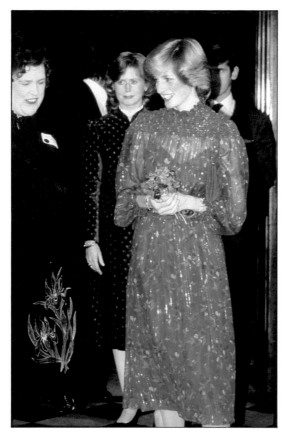

This creation was one of the first Bruce Oldfield evening gowns to be worn by the Princess. The electric-blue frilled crêpe de Chine dress, daringly cut with only one shoulder, has a deep ruffle around the dress top. The skirt, falling generously from the hips, was cut with an unusual asymmetric hem.

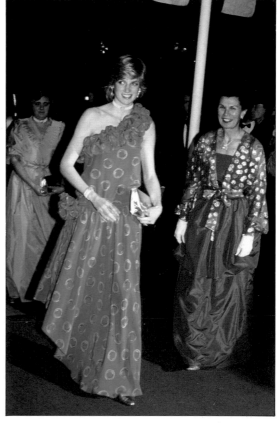

Amid growing rumours that the Princess has contracted anorexia, she still manages a smile while greeting Queen Beatrix of Holland, in London for a state visit in November 1982. The pink quilted suit is worn with a felt boater in a matching shade. Drop pearl earrings and one of her favourite pearl chokers complete the effect. The hat is by John Boyd.

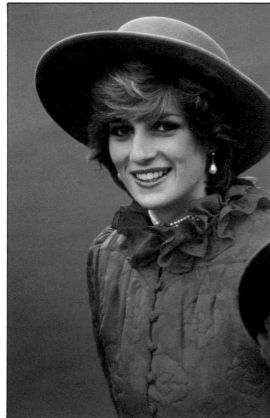

Peeping out from one of the state coaches, the Princess rides to the State Opening of Parliament in November 1982. We can just see her soft white jacket in real fur. She is also wearing the Spencer family tiara.

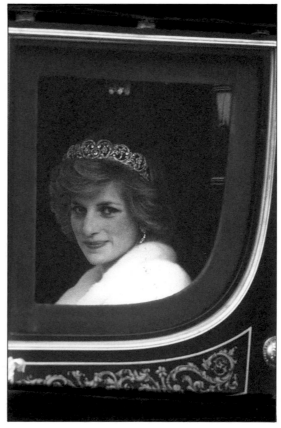

This suit by Caroline Charles has been worn continuously over the years. Here we see it during a visit to Cirencester in November 1982. A white polo neck is worn under the suit on this occasion. Also clearly visible is the Princess's gold charm bracelet, a present from Prince Charles.

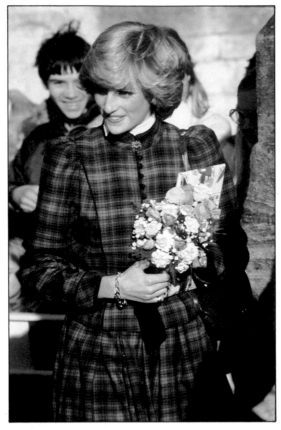

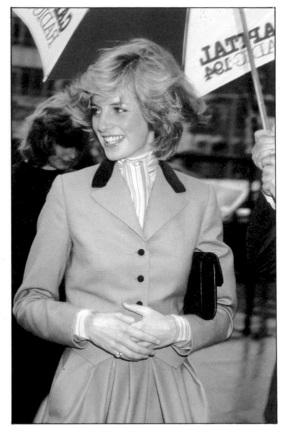

This smart hunting-style suit by Catherine Walker is in a plain light coffee coloured wool. The stepped lapels and buttons are in a deep brown velvet. A high cravat necktie blouse is worn to complete the look when visiting London's Capital Radio in November 1982.

Arabella Pollen designed this warm coat dress in a tan check wool. The drop waisted garment has brown leather cuffs and collar, and the buttons are also covered in soft leather. The Princess wore this to visit Barmouth in Wales in November 1982, complete with cheeky suede beret.

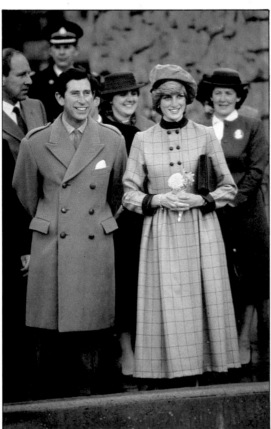

The heavy tweed coat by Bellville Sassoon first seen in 1981, is seen here in Wrexham, Wales in 1982. A small blue hat matches the multi-coloured coat.

This dark green suit was seen on only a couple of public engagements. The jacket has a small shawl collar and fastens to one side. Light green piping decorates the suit. Plain brown shoes and handbag are the preferred accessories for this visit to Catford in 1982.

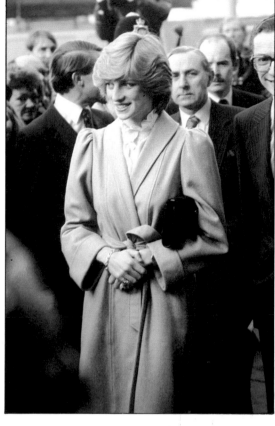

The camel-coloured tweed coat by Caroline Charles that was soaked with rain back in 1981 seems to have recovered well enough to be worn here in November 1982, to visit the DHSS Offices in Wandsworth. Under the coat, the Princess wears a shell pink blouse.

This red woollen coat dress, seen in London in November 1982, has a very full calf-length skirt. The fitted top has large gathered sleeves. A row of small buttons decorates the front of the bodice up to a mandarin-style neckline. Caroline Charles was the designer.

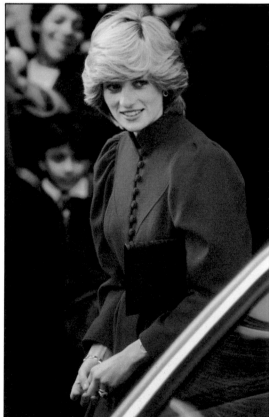

The Princess visited the Royal Marsden Hospital in December 1982, and for the occasion wore a printed silk suit. The pattern is shot through with a dominant turquoise blue and the silk blouse echoes this same colour. The neckline sports a small John Wayne-style necktie. Donald Campbell designed the suit.

Catherine Walker designed this double-breasted woollen coat in tomato red. The collar, cuffs and buttons are in black velvet. The coat is worn over a white cotton blouse for a visit to Kennington, London in December 1982.

The Princess is seen leaving a London cinema after attending the film premiere of *ET* in December 1982, dressed in a boned gown in deep plum velvet and striped taffeta. The dress has an optional bolero jacket which is not seen on this occasion. It was designed by Gina Fratini.

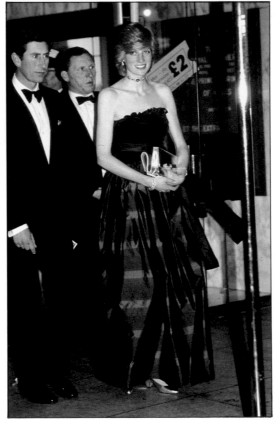

Velvet has been popular with the Princess over the years, especially for suits in this style. The fitted jacket fastens at the front and has three-quarter-length sleeves. The skirt is very full. A cummerbund belt in the same deep blue velvet completes the outfit by Caroline Charles. The suit is seen here in December 1982, when the Princess visited the University College Hospital in London.

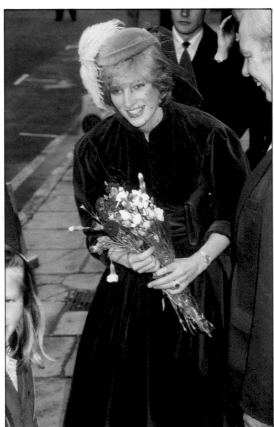

On Christmas Day at St George's Chapel, Windsor, in 1982, the Princess wore her heavy quilted pink suit. The neckline has a ruffle finish and the jacket is tightly belted. A felt boater matches the suit.

1983
Making Commonwealth connections

In 1983 the Prince and Princess of Wales undertook a gruelling six-week tour of Australia and New Zealand. For the Princess it was a particularly demanding task as it was her first official, overseas tour. The prospect of having to organize a wardrobe for a long tour was a daunting task, especially while at the same time coping with Prince William who was still not a year old. The Princess relied on the expertise of the growing band of British designers whom she had come to use frequently over the past couple of years.

Her style and taste at this point had hardly developed from the time when she preferred small feathered hats, long, full dirndl skirts and floaty, full evening gowns. The selection of suitable clothes started months in advance of the March departure date. In January the Prince and Princess travelled to the tiny principality of Lichtenstein for a short skiing holiday and, by the time they returned, work on collating the wardrobe was well underway.

An odd assortment of clothes was required to cope with drastic weather changes, ranging from the extreme heat of the outback to the wet, gusty days expected in Christchurch, New Zealand. The wardrobe, of necessity, therefore, had to be vast; it could not be streamlined to a few dresses and suits.

Throughout the tour their appointments included such contrasting visits as a formal state dinner to a late-afternoon climb of Ayers Rock. The final choice of clothes, hats and shoes was transported in large metal trunks aboard the royal aircraft which flew the arduous thirty-hour flight from London to Alice Springs.

The royal couple were due to stay part of the time at official residences and partly at the luxurious homestead 'Woomarga', where Prince William was to remain with his nanny. The Princess's dressers had to ensure the correct clothes were taken to the right location.

Due to the extreme heat of the outback, the Princess had to rely on more than one change of clothes each day to remain looking cool and crisp. During the visit to Alice Springs, Ayers Rock and Tennant Creek, cool silk dresses were chosen in soft summery colours. Hats would have been too sticky and inappropriate at this stage of the tour.

Despite a sudden flash flood in Alice Springs only hours before the arrival of the royal couple, the sun soon regained its strength; the Princess, to her cost, underestimated its power when she took a few hours off to relax and sunbathe. When she appeared later that day at a reception she looked red and sore.

When the entourage travelled on to Canberra the mood became more formal and, as the Princess emerged from the plane at RAAF Fairbairn, she was wearing a hat and a new turquoise silk suit. From that point etiquette required formal attire, and nearly all were new apart from the pink, white and blue floral dress worn in Sydney that had been worn originally for Prince William's christening the previous year.

During the tour the Princess would need her formal jewels for state receptions and dinners. A tiara was required on many occasions and so the Princess took both her Spencer family tiara and the diamond and pearl Queen Mary tiara. Several diamond necklaces and the small ivory miniature of the Queen that makes up the Queen's Family Order were also part of the travelling collection.

The last two weeks of this marathon visit were spent in New Zealand. Here the weather decided to be difficult as summer slipped into autumn. The Prince and Princess had to contend with a lot of heavy rain and consequently some planned outdoor visits were cancelled.

On the first full day in Auckland the Prince and Princess visited the Pupeke school; it poured with rain from the time they alighted from the car. Dressed in a pale primrose dress the Princess, although under an umbrella, had to call for her beige raincoat to drape over her shoulders. Underfoot, however, not much could be done to stop the Princess's ivory-coloured tights from being splattered with mud.

The rain continued to dampen other events, including a garden party at Government House in Auckland. Guests huddled under trees and umbrellas. The royal couple tried to cheer up some people as they picked their way around the soggy garden. The Princess looked a little damp in a black and white Van Velden blouse and skirt and a white boater-style hat.

The New Zealand visit ended on a fine sunny day when it was the Maoris of Waitangi's turn to welcome the royal visitors. The Prince and Princess were taken in an historic war canoe to a welcoming ceremony at the Bay of Islands. It was a strange sight as the bare-chested men in full tribal dress rowed the Prince and Princess, who were formally dressed in lounge suit and a yellow dress. The Princess's hat looked out of place next to the Maori headdresses.

A formal state reception in Hobart, Tasmania in April 1983 gave the Princess an opportunity to wear the Spencer tiara and a new evening gown by Bruce Oldfield; a red silk dress speckled with gold glitter with a deep ruffle neckline.

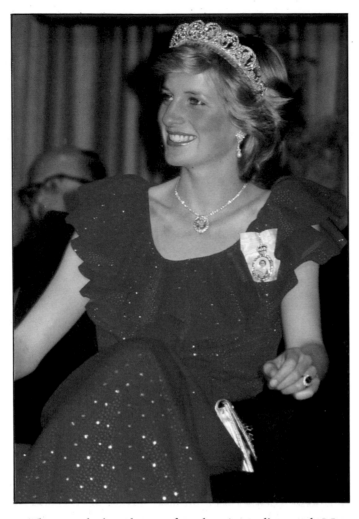

The wardrobe chosen for the Australian and New Zealand visit threw up few surprises, except for the stunning one-sleeved gown worn to a dinner in Melbourne on the eve of their departure. The slinky, white-beaded dress was designed by the British-based designer Hachi. The dress was in complete contrast to those rather formal conventional gowns seen previously. This dress oozed film-star glamour. The Princess looked wonderful and,

unknown to avid royal watchers, this was a taste of slinkier styles to come.

In May, after a two-week holiday with the Prince in the Caribbean, the Princess resumed her diary of domestic engagements sporting an impressive suntan. But the break from foreign travel was not to last long as the Prince and Princess had soon to travel to Canada for another official tour to a Commonwealth country.

The Princess's Canadian wardrobe consisted mostly of clothes taken to Australia and New Zealand, although there were a couple of new suits which included a dress worn on the first day of the visit to Nova Scotia in the colours of the Canadian flag – red and white.

One outfit carefully packed for the visit was a Victorian-style costume borrowed from the BBC wardrobe department to wear at a traditional barbecue at Fort Edmonton. The dress was boned, in pale peach with cream lace. It looked a little uncomfortable for the Princess as she contemplated the steps of the reconstructed fort. Prince Charles did not escape this piece of make-believe and looked splendid in a long coat, top hat, and cane.

The polo season was in full swing again by the time the Prince and Princess returned from Canada and this meant many a weekend as a spectator for the Princess. She regularly appeared at matches in casual, 'fun' clothes; one afternoon, she arrived dressed in a pair of white cotton trousers and a hand-knitted red sweater from Warm and Wonderful, with a sheep motif. Large, white sheep appeared on the back of the sweater, but its charm lay in the one lone black sheep which adorned the front. This sweater was copied worldwide as the craze for 'sheep' jumpers became insatiable.

Towards the end of the year the Princess's appearance was undergoing a very subtle change. She grew her hair much longer and started wearing it in a slightly more coiffured style with the help of hair spray. The long dirndl skirts, usually worn for day wear, were eased out in favour of a more tailored style, and shorter in length. The sleek tailored look was just beginning to attract the Princess's eye.

Pink was a popular colour with the Princess in 1983 and this two-piece suit in wool was designed by Jasper Conran. The jacket is in a double-breasted style and has turned back cuffs and a high-standing collar. The skirt swings generously as the Princess departs from the Royal College of Music in London in January 1983.

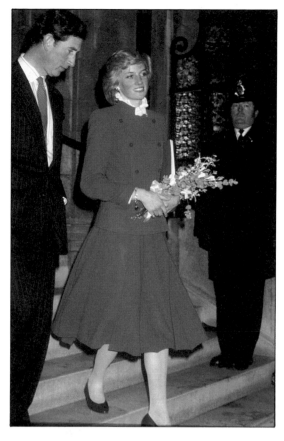

This blue wool coat dress had a high mandarin neckline edged in black piping. The sash tie belt and accessories are all in black. A small velvet bowler hat by John Boyd is in a matching shade of blue. The dress is by Catherine Walker and was worn to Reading in February 1983.

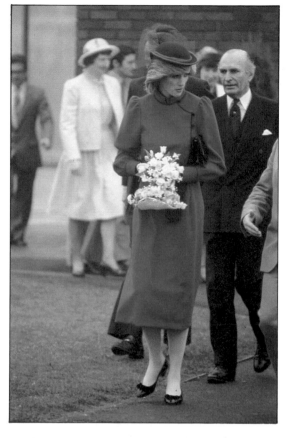

This sunshine yellow and white crêpe de Chine dress was designed by Jan Van Velden and was taken on the Australian tour in 1983. The Princess, seen here in Alice Springs, wears it belted with a white sash and shoes.

The Prince and Princess climb Ayers Rock in Australia in March 1983. The Princess wears very flat leather pumps and a white cotton jacquard dress by Benny Ong. A white leather belt and handbag are matching accessories.

The Princess wears a bright turquoise silk two-piece suit by Catherine Walker when she arrived in Canberra, Australia in March 1983. The blouse has tiny pin tucks on the bodice and a mandarin collar. The skirt is full. The small skull cap is by John Boyd.

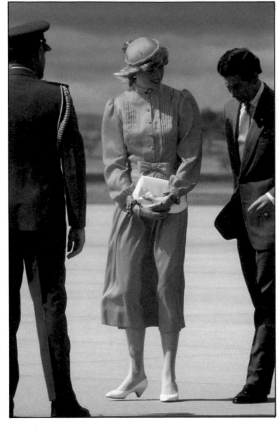

This pretty pink and white silk crêpe de Chine dress was first seen at Prince William's christening, but here we see it in Sydney, Australia in March 1983. The dress has a small battle-dress tie jacket and is designed by Bellville Sassoon. The wide-brimmed hat is by John Boyd.

Another Bellville Sassoon design for the Australian tour in 1983. This three-piece outfit, worn in Hobart, Tasmania, has a candy striped organza blouse with a large collar and bow. The skirt is slim, and a sleeveless three-quarter-length coat completes the rather unusual design. A red boater with white silk daisies at the back completes the overall effect.

In Adelaide, Australia in March 1983, the Princess is seen visiting the Parks Community centre dressed in a yellow, coffee and white striped silk two-piece suit. The loose-fitting jacket has a ruffle neckline. The straw boater is by John Boyd and the suit designed by Arabella Pollen.

This lightweight cherry-red silk suit by Jan Van Velden is worn over an unusual blouse with a jagged collar. The jacket hem also features the unusual design. A white and red straw hat by John Boyd was chosen for this visit to Port Pirie in Australia, in April 1983.

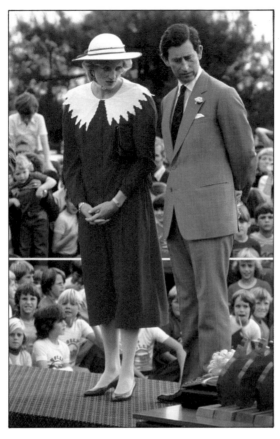

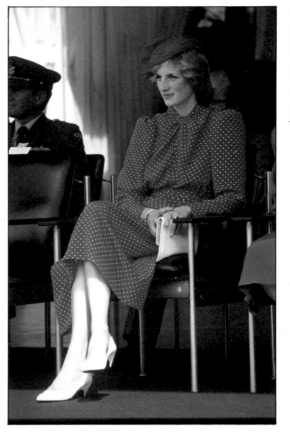

The Princess sits in the shade during her visit to Perth, Australia, in April 1983. The fuchsia and white spotted dress, by Donald Campbell, has a wrap-over skirt. The pretty organza hat is by John Boyd.

The Prince and Princess attend a garden party at Government House in Perth, Australia, in April 1983. The Princess wears an ice-blue sailor suit by Catherine Walker; it has only been seen once in public. The boater is trimmed with a ribbon.

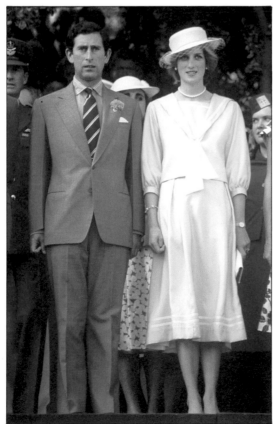

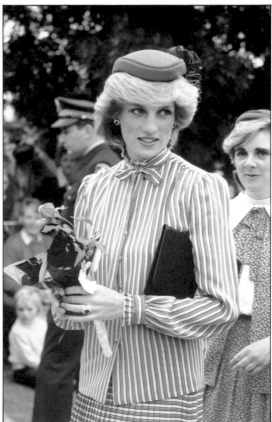

In Bunbury, Australia, in April 1983, the Princess wore the striped silk suit originally seen at her first Ascot meeting in 1981. The three-piece suit by David Neil consists of a camisole, pleated skirt and loose-fitting jacket. The hat is by John Boyd.

Sportswear and the Unusual
Casual chic

The Princess of Wales is a keen fitness fan and enjoys dancing, swimming, skiing and tennis. Taking part in these sports gives her the chance to wear casual clothes which are, however, no less fashionable than the tailored outfits she chooses for public duty.

The Prince and Princess take an annual skiing holiday in the early months of the year. The Princess has a number of ski outfits from which to choose and an assortment of warm accessories.

In 1983, when the Princess was still reluctant to be photographed during her holiday, she wore a very simple suit – plain red salopettes and a red, white and blue jacket. It was practical and warm, rather than fashionably chic.

In recent years ski-wear has become big business. Competition on the slopes is intense – and that's relating to the most fashionable outfit, not the ability to ski the most terrifying black runs. The Princess has two padded suits, usually worn over a plain polo-neck sweater. The first suit to be seen in public was a plum-coloured jump suit made by Head; her most recent suit is in a vivid mauve with pink and green stripes and star appliqué work emblazoned on the front.

The Princess has not changed her comfortable ski boots – a white pair made by Nordica. She does not always wear a hat but on some occasions we have seen a wool headband or a fluffy white head tube. Sunglasses are worn in preference to ski goggles to keep out the glare of the sun and snow.

Tennis, in recent years, has become one of the Princess's

Right
Lech, Austria in 1983 and the Princess of Wales is dressed in a practical, and rather patriotic, red, white and blue ski suit. Eager to avoid the press photographers, she nestled her face into the high, zipped neckline.

Far right
The 1985 skiing season and a more confident Princess poses in her all-in-one-jumpsuit by Head. She still wears her comfortable Nordica white ski-boots but has decided against a hat.

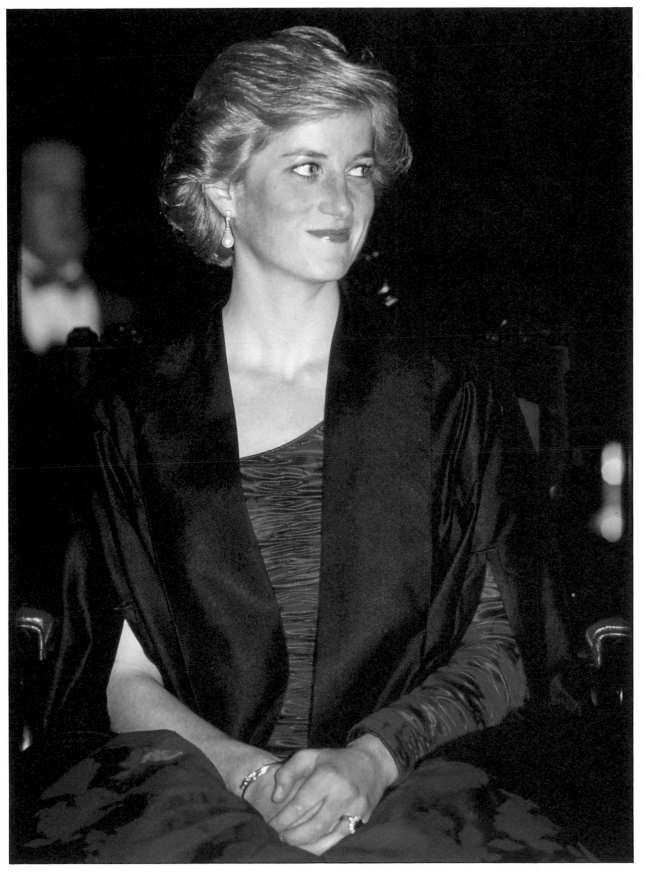

Above
By 1987 the Princess has woken up to the fact that ski slopes during the season are the most fashionable place in Europe. The all-in-one purple ski suit by Kitex sports elaborate pink and green stripes and lone star appliqué work on the front. A simple white polo neck is worn underneath and trendy mirrored sunglasses and snood add a touch of *je ne sais quoi*.

Left
This simple slit black gown toned in well with the stunning Catherine Walker dress. The Princess was dressed for the ceremony in which she was made an honorary barrister at London's Inner Temple.

Right
The Princess of Wales spends a little time in 'tennis' talk with the 1988 Grand Slam champion Steffi Graf. The Princess, who is wearing a favourite blue and white tennis dress and a baggy pink cashmere cardigan by Jasper Conran, played the world number one in a friendly match at the Vanderbilt tennis club in 1988.

Below right
The new recruit in her army-green 'denims' during a visit to the Royal Hampshire Regiment at Tidworth in 1988. The Princess's name has been embroidered above the left breast pocket.

Below left
The Princess of Wales as an honorary dentist had to wear the traditional red and black robe during her inauguration ceremony in London 1988. The black mortar board was *de rigueur* and looked rather fetching.

favourite sports. Not only does she love to watch as much of the Wimbledon Championships as time permits, but she is now a member of the exclusive Vanderbilt Club in West London. She tends to wear a short tennis skirt which emphasizes her long, slender legs; one of her favourite tennis outfits is an all-in-one dress in a white and blue cotton stripe. In wearing white ankle socks and tennis shoes she prefers to keep to tradition. To keep warm between the courts and the changing rooms, the Princess often throws on a soft, pink cardigan.

Horse riding, although popular with many members of the Royal Family, is not one of the Princess of Wales's favourite sports. Occasionally she enjoys a country hack, particularly when staying at Sandringham with the Queen. The Queen dresses quite formally for riding, and is invariably seen in a tweed hacking-jacket and head scarf. The Princess chooses the more casual style of a warm, knitted sweater, beige jodhpurs and black riding boots. On her head she sticks to the traditional, regulation velvet riding hat.

Being 'on duty' does not necessarily mean back to couturier clothes. Sometimes the Princess undertakes an engagement that requires her to visit a submarine or drive a tank. Obviously, in this instance the choice of dress is very important and it is usual for the prospective hosts to liaise with a lady-in-waiting or a secretary to discuss the appropriate details.

During many of the Princess's visits to regiments of the British army, she has had the opportunity to take the wheel of a tank or armoured vehicle. A skirt would be most unsuitable for clambering in and out of a driver's seat. In Berlin, in 1985, the Princess had a brief drive in a fifteen-ton tank around the parade-ground of the Royal Hampshire Regiment. She was dressed in a black and yellow track suit and training shoes.

In Tidworth, Hampshire, in 1988, however, the Princess was even more suitably dressed for a day out with the army. The visit was to include sitting in a trench during a mock battle and driving an armoured vehicle across Salisbury Plain. When the Princess alighted from her helicopter to begin her day with the army she was already dressed in her version of green army fatigues. These consisted of an all-in-one jumpsuit identical to those worn by the soldiers; the Princess's name was embroidered above the top pocket. These green 'denims', as they are commonly known in the army, can look unflattering but, due to the Princess's height and slim shape, she made them look extremely attractive, especially as they were tightly belted with a standard issue webbing belt. The army had not subjected her to heavy marching boots. She had chosen to wear her own pink canvas boots. It was a good thing that the Princess was suitably dressed for this visit as, after she climbed out of one of the trenches, her rear was covered with white chalky dust.

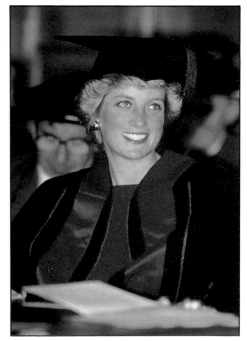

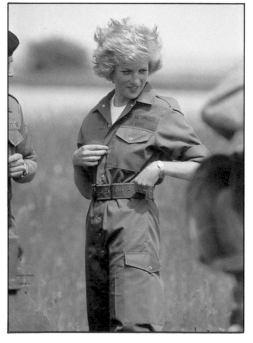

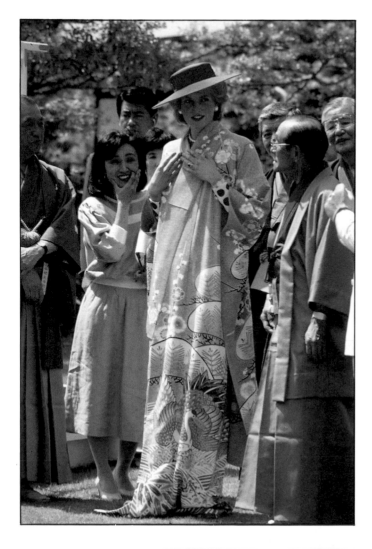

Something completely different was presented to the Princess during her visit to the Japanese city of Kyoto in 1986. After a traditional tea ceremony a cotton kimono was given as a gift, a memento of the visit. At first the Princess seemed a littly shy but, after some encouragement from her hosts, she agreed to try the lavish garment on over her dress. She was completely swamped in its long, wide arms and very generous length. The Princess chuckled with laughter because she did look a little out of place, especially as she was still wearing her red felt hat.

During the endless rounds of visits, the Prince and Princess often tour factories or industrial sites. Despite being royal visitors, safety regulations still have to apply and the royal couple are required to don hard protective helmets. This always brings a smile to the Princess's face as she glances over at her husband and entourage, all similarly clad. Just in case any one forgets just 'who is who' the royal helmets often have the appropriate name inscribed on the front. In some cases the royal couple are required to wear plastic goggles to protect the eyes. Protective white coats are also worn when the occasion demands, especially during a tour of a food factory or dairy. In 1988, the Princess was made an honorary dentist at the Royal College of Dental Surgeons. A black mortar board and black and scarlet gown were worn as tradition dictated. Another event which called for the wearing of ceremonial garb was held at London's Inner Temple in the same year. The Princess, on this occasion, was made an honorary barrister. The simple black gown looked quite fetching over her red and black evening dress.

Far left
This exotic orange kimono was presented to the Princess after a ceremony in Kyoto, Japan in 1986. It was hand-painted with traditional Japanese cranes.

The Princess looked just like one of the floor workers when she visited the Westway Dairy in London in September 1987. A protective white coat and mesh hat were required to comply with hygiene standards.

Safety not fashion was the order of the day when the Princess visited the new Shell terminal in Chester in 1988. The Princess, in a spotless white hard helmet, stands in front of her lady-in-waiting, who is wearing a similar hat.

This dress was made from two different patterned silks in blue and white, and is neatly sashed. Designed by Donald Campbell, it is worn here in Australia in 1983. A John Boyd ostrich-trimmed hat is a most elegant accessory.

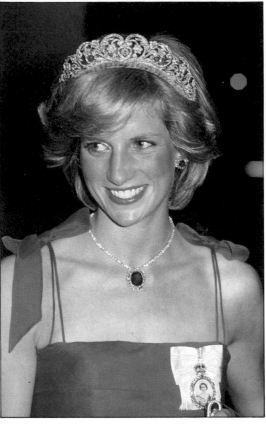

One of the early Edelstein dresses, this pink organza evening gown, was seen in April 1983, in Brisbane, Australia. The bodice has deep tucks and spaghetti straps that tie into wide bows on the shoulders.

This pale rose-pink and white striped suit was later altered from the full dirndl skirt seen here in 1983, in Australia, to a shorter pleated style. Catherine Walker designed the suit that consisted of a short jacket with puffed sleeves over a simple blouse and skirt. The shapely skull cap with a large bow at the back was designed by John Boyd.

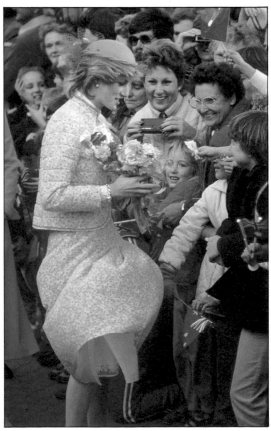

This quilted cardigan-style jacket and front pleated skirt in a turquoise patterned silk is an off-the-peg design by Miss Antoinette. The Princess chose it for a windy walkabout in Ballarat, Australia, in April 1983.

This cream woollen coat dress by Catherine Walker has a high waistline and a gathered calf-length skirt. The wide collar and cuffs are edged in tan. It fastens with a double row of buttons at the front. The residents of Auckland first saw this outfit in April 1983. The matching hat is by John Boyd.

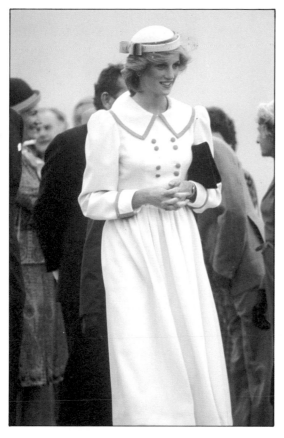

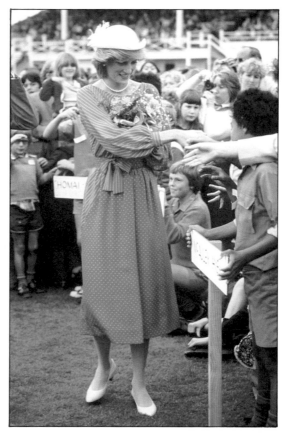

Donald Campbell again makes use of two contrasting patterned silks in similar shades of green and white. This dress, worn in Auckland, New Zealand in April 1983, has a wrap-over skirt tightly sashed and the neckline is kept to a simple slit. The hat is by John Boyd.

This very glamorous off-the-shoulder gown was a perfect choice to wear to a ballet gala in Auckland in 1983. Designed by Donald Campbell, it is in a shimmering vibrant lilac raw silk. The skirt is full length and hangs full from the waist.

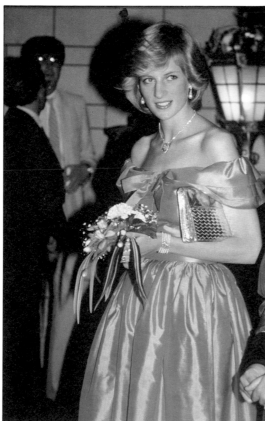

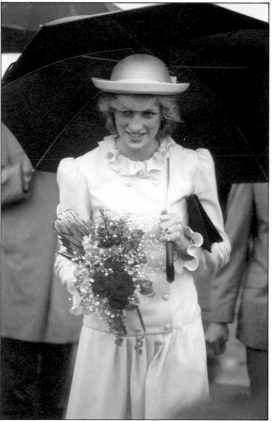

The primrose yellow coat dress by Catherine Walker is worn with a straw hat by John Boyd. Seen here in Auckland, it has not made many reappearances since.

The navy and white crêpe de Chine suit worn to the Auckland Fire Station in 1983 has the same patterned design as a yellow dress seen in Alice Springs some weeks before. Both are by Jan Van Velden. The suit is worn here over a cotton blouse. The large white hat is by John Boyd.

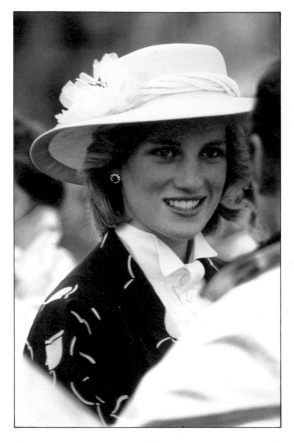

Attending a charity ball at Sydney's Wentworth Hotel in 1983 the Princess wears a new gown by Bruce Oldfield. The fabric, in a light turquoise, shimmers with tiny silver threads; a wide silver belt and silver shoes enhance the theme.

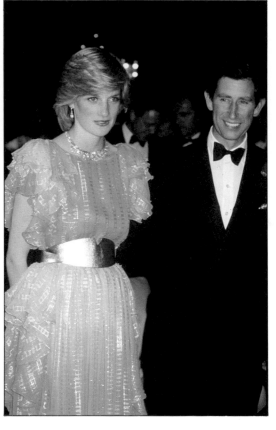

Despite heavy rain the Princess wears a high-crowned white straw hat by John Boyd to a garden party at Government House in Auckland. The hat has a deep black satin band and a perky bow at the back. A striking black and white blouse by Jan Van Velden is just visible.

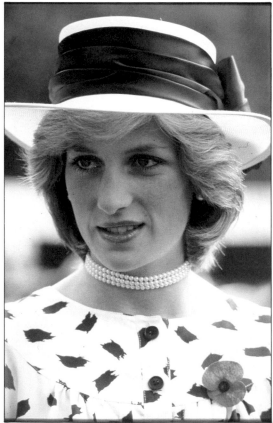

Jasper Conran designed this two-piece suit which was worn in Tasmania in 1983. The white suit has a long jacket with a high mandarin collar, the skirt is a simple straight cut. The decorative hat with face veil is by John Boyd.

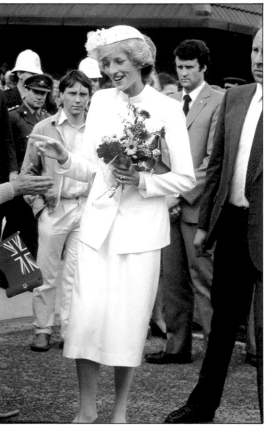

This double-breasted coat in peacock blue has a black velvet collar, cuffs and covered buttons. It was worn with a small hat by John Boyd on a visit to a boys' school in Wellington, New Zealand in 1983.

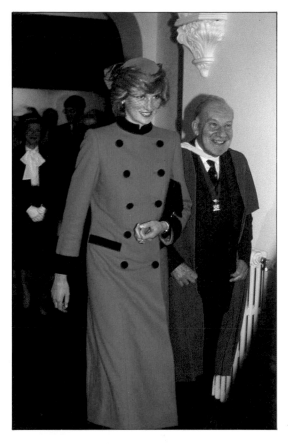

The beige tweed coat by Caroline Charles that was so badly soaked two years prior to this visit to New Zealand in 1983, is still looking shapely, as is the little velvet feathered hat by John Boyd. The original ruffle blouse from 1981 is also worn.

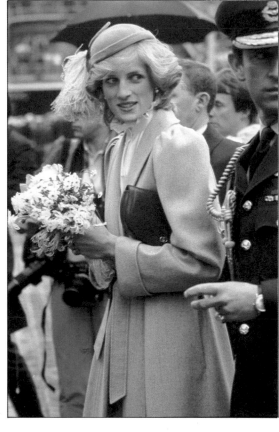

In the Bay of Islands, New Zealand in 1983 the Princess wore this quilted jacket over a bright yellow calf-length dress. Around her neck hangs a gift from her Maori hosts – a fertility symbol carved in a green stone. The small hat with veil is by John Boyd.

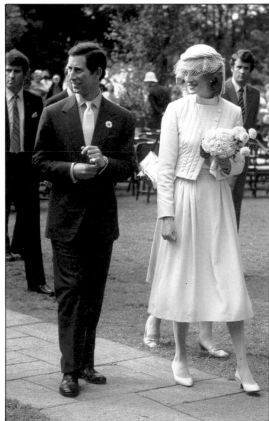

Gina Fratini designed this creamy satin gown seen at a banquet in Auckland in 1983. The dress has transparent organza sleeves and delicate lace detail on the front of the bodice and the neckline. The Queen Mary tiara and the Queen's Family Order are the dazzling choice of jewellery.

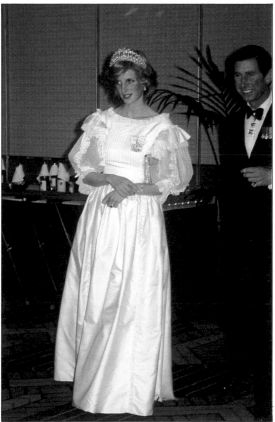

Mother and Sons
Sons and Mother

In past generations, royal children's clothes were predictable and formal. For the Prince of Wales and his brothers and sister, public appearances as children usually meant smart wool coats, short trousers or a school uniform. For the new generation of royal children, however, a new freedom of style is evident and none more so than in the clothes worn by Prince William and Prince Henry.

The Princess's good taste is mirrored in her children's clothes, both for formal and casual wear. As very small babies the two boys were dressed in traditional style – smocked romper suits with white 'Peter Pan' collars. As the Princes have grown older tradition has given way to contemporary fashion, and they now dress in styles that have become popular in the eighties.

For schoolwear, Prince William wears the grey and red uniform of the Wetherby school. This consists of a wool blazer, short trousers and a traditional cap. It is a more casual look, however, for Prince Henry who spends his mornings at Mrs Mynor's Nursery School in London's Notting Hill. Brightly coloured sweat-shirts, cotton shorts and corduroy trousers are more suitable for the Prince as he plays in the school's small garden or sandpit.

The children spend many of their weekends with their parents at polo. Here they are dressed casually, just like any other children who play on the side lines. They are often seen in T-shirts or sweat-shirts that bear the name of a charity or recent charity event – gifts from charity organizations. The Princess is herself fond of wearing a Mickey Mouse sweat-shirt with her drain-pipe jeans. For

Right
At a polo match at Smith's Lawn, Windsor, in June 1987, Prince William wears a red 'Ham Polo Club' sweat-shirt with his knee-length cotton trousers. The Princess chooses a casual lemon cotton suit by Bruce Oldfield worn over a silk blouse by Jasper Conran.

Far right
Majorca, 1987, and the two royal princes are in their summer holiday wear. For Prince William this is a red and white short-sleeved shirt and white elasticated shorts. For Prince Henry it is a loose red T-shirt worn under a pair of red and white candy-striped cotton dungarees. Prince Henry shows off a Snoopy motif on his cotton shoes, while Prince William keeps comfortable in blue canvas shoes.

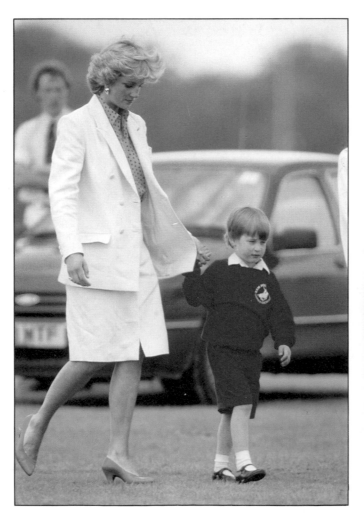

Above
August, 1988, sitting in the shade from the hot
Majorca sun. Prince William and Prince Henry are
dressed in matching ensembles. They wear
Lacoste sportshirts in white cotton tucked into
knee-length pale blue cotton shorts. Prince
William wears one of his first watches on his right
wrist.

Left
Princess Diana, Prince William and Prince Henry
enjoy a moment together in the garden of their
country home, Highgrove, in August 1988. The
Princess, dressed in a cream silk shirt and pleated
skirt, dresses the boys in smart pinstripe shirts,
ties and grey wool trousers in preparation for a
formal family photograph to celebrate the fortieth
birthday of the Prince of Wales.

Right
Prince William wears his
winter school uniform to
attend the Wetherby
school in London. Here
he wears a warm, grey
wool coat over his short
trousers and sweater. The
uniform would not be
complete without a
schoolboy's cap!

Far right
The Princess dresses in a
striped cotton shirt and
taupe skirt when she
visited Mrs Mynor's
Nursery School in
September 1987. She was
accompanied by Prince
William who wore one of
his many striped T-shirts
and cotton trousers.

Right
Prince William has several
sleeveless 'puffa' jackets
and is seen here wearing a
navy version. The
Princess, dressed in jeans
and a tweed jacket, wears
a baseball cap to keep the
wind out of her hair. For
footwear, the Princess has
chosen a tan pair of
cowboy boots and for
Prince William a very
comfortable pair of
training shoes.

Far right
The Princess and her son
Prince William
complement each other in
matching coats by
Catherine Walker. Both
coats were a bright choice
for the Easter Service at St
George's Chapel,
Windsor in April 1987.

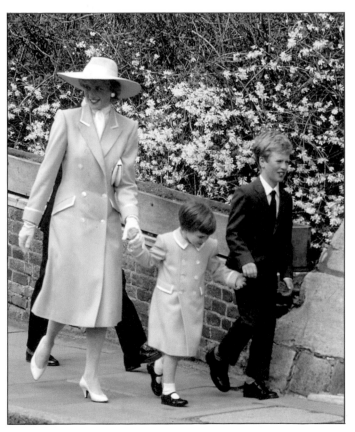

both the Princess and her sons a padded sleeveless 'puffa' jacket is ideal for wearing to polo, school or shopping; the Princes have their own waxed, green 'Barbour' coats, thus furthering the trend set by most adult members of the Royal Family.

For those lazy days spent on holiday in the sun the Princess chooses cool cotton clothes for the boys. Very bright striped T-shirts or trendy Lacoste sportshirts are worn with knee-length shorts or candy-striped, cotton-drill short dungarees. The vivid-coloured hessian espadrilles keep the Princes' feet cool and are also suitable for the beach.

The children rarely attend public occasions as they are still a little young, but occasionally the Princess has the opportunity to take her two sons out on the town. One such occasion was the matinée performance of the Royal Tournament in 1988. Prince William and Prince Henry were among several royal children that were taken on the outing with the Prince and Princess. Dressed in matching green, short wool trousers, blue and white pinstripe shirts and navy bomber jackets the two boys looked very smart, especially as they also wore their first 'grown up' ties in blue silk. Another occasion to glimpse the children is the annual family service at St George's Chapel, in Windsor at Christmas and Easter. All the royal children attending these services are smartly dressed. Prince William is usually seen in a neat tailored coat, rather similar to those worn by his father as a boy. These coats, in a variety of colours, are usually double breasted.

The ultimate in 'mother and child dressing' came to the fore when the Princess asked Catherine Walker to make two coats for the boys to match one of her own. These coats, in a pale, powdery blue wool, were identically finished with white edging and large pearl buttons. Only the style of collar differed; the boys' coats had high-necked collars whereas the Princess's coat sported a classic V-neck and long revere.

Far left
Mother and son seen leaving St George's Chapel, Windsor after attending the Christmas Day Family Service in 1987. Prince William is dressed in a smart burgundy double-breasted coat worn over a formal white shirt and a blue and burgundy silk tie. The Princess wears a taupe two piece suit with a short serrated-edged skirt.

Left
Prince William and Prince Henry are dressed in identical soft white sweatshirts from Benetton, and short lemon cotton trousers when they travelled to Aberdeen with their mother in August 1986. The Princess is dressed in a warm, long sweater over one of her famous ruffle-necked blouses, with a pleated white silk skirt.

Dressing up for fun at the traditional Edwardian barbecue held at Fort Edmonton in Canada in June 1983 for the Prince and Princess. The Princess is in a peach boned dress edged in lace and a small dainty hat. The clothes are reported to have been loaned from the BBC's wardrobe department.

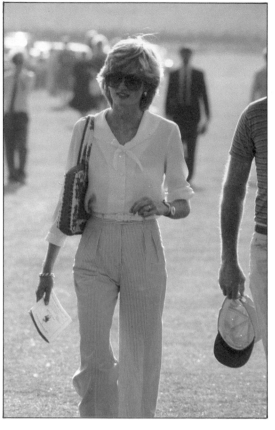

On a warm sunny afternoon at Cowdray Park in Midhurst in July, the Princess is dressed in cool blue and white striped trousers and a light cream blouse.

At the international polo match at Windsor in July the Princess watches the game from the Royal Box dressed in a neat cotton dress in a white, red and green polka dot design.

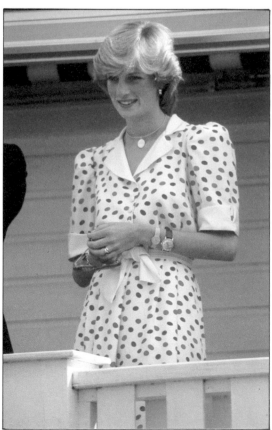

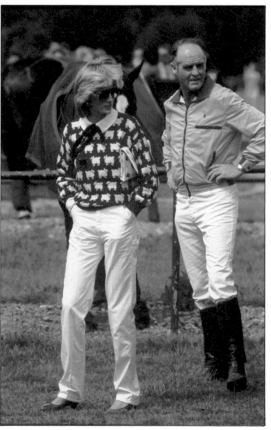

An informal polo match at Smith's Lawn gives the Princess the opportunity to wear casual trousers and a hand-knitted sweater that started off a great craze for 'animal' jumpers. The decorative jumper, with rows of white sheep and one lonely black sheep, came from Warm and Wonderful in London.

This grey silk dress by Catherine Walker has been seen on very few occasions, such as here in King's Lynn in 1983. The dress, edged in pink satin and complete with a tie sash belt, appeared in official photographs taken by Lord Snowdon the same year.

The Princess visited Brixton in October 1983 and wore this two-piece suit by Jasper Conran in a bright pillbox red. The jacket is three-quarter length and worn over a silk blouse in black and white polka dots.

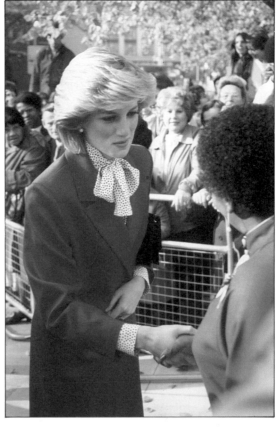

Jaeger's off-the-peg velvet suit first seen in 1981, is still being worn two years later in St Austell in Cornwall. The original ruffled blouse worn under the suit is now replaced by a satin tie-neck blouse. The John Boyd hat, decorated with a large feather, remains the preferred accessory.

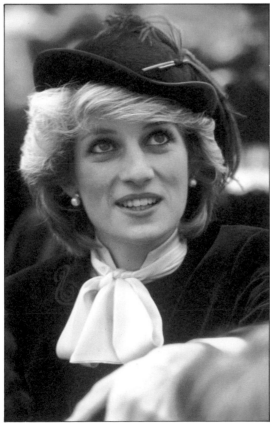

The small bowler hat with a large satin band and back bow matches the shade of this heavy velvet suit worn to the Guards Chapel in November 1983. The jacket is fastened with small buttons and has a wide matching cummerbund belt. The suit was designed by Caroline Charles and the hat by John Boyd.

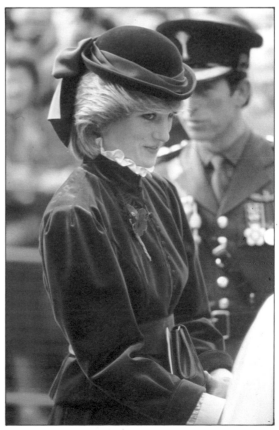

As a young mother the Princess must have found this cream knitted suit exceptionally practical. Seen here in December 1983, the Princess leads Prince William to a photocall at Kensington Palace. The cowl-neck top is belted, the skirt fully pleated.

As the Princess stepped out of the car in London's Park Lane in December 1983, she looked stunning in a new aquamarine blue organza and silk dress by the Emanuels. This daring one-shouldered design was an instant success; the skirt falls from a dropped waist. Small silver beads sewn into the skirt catch the light as the Princess walks.

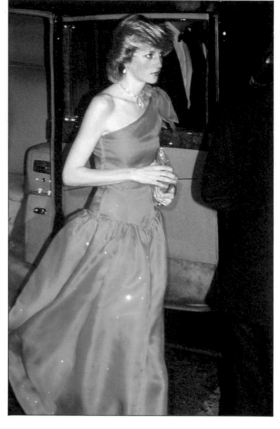

The white cotton blouse by Bellville Sassoon, worn under this dress, has been seen on many occasions before this outing to Brixton in December 1983. The dress by Donald Campbell is in a bold black, red and white fabric.

As the Princess strides across the tarmac of Aberdeen airport, she wears a warm red, woollen coat dress. The dress is fastened at the front with a long row of small buttons, and shows the favourite mandarin-style collar. The skirt falls full from the waistband. It was designed by Caroline Charles.

Enter Prince Harry ... and a new image

In the early part of the year the Prince and Princess returned to the slopes of Lichtenstein as guests of Prince Hans Adam for a skiing holiday. It was a rather brave decision for the Princess who was in the very early stages of her second pregnancy. At that time, the world was not aware that the Princess was to have her second baby later that year; it was not until the Princess returned from her first solo foreign tour in February that the announcement was made.

This mini tour was to the snow-bound city of Oslo in Norway. The Princess, in her role as patron of the London City Ballet, was to attend the world premiere of the ballet company's new production of *Carmen*.

Crown Prince Harald and his wife Princess Sonja took great care of their special guest who looked a little pale as she arrived in freezing temperatures at Oslo's Fornebu airport. The Princess was dressed in a warm three-quarter-length coat in cobalt blue wool, a matching skirt and a high-necked bold blue and white striped blouse. This coat was to come in very handy over the next few months as it was roomy and comfortable – essential requirements for maternity clothes.

For the special gala evening at the City Concert Hall the Princess decided to wear a bright-red satin and lace gown. To keep out the cold air a full-length black velvet cloak was worn over the dress. This cloak has been seen on numerous occasions; it is such a useful item that combines well with most styles of evening dress.

On the second day in Norway the Princess had to brave the cold weather and perform a tree-planting ceremony in the snow at the British Embassy. The Princess had, rather unwisely, chosen not to wear any gloves and, despite wearing a heavy green velvet suit, she looked cold as she clasped the spade.

Diana decided in the early stages of this pregnancy not to rush into wearing very loose-fitting garments – she would make the most of a streamlined figure while she could. We did not see the re-emergence of many of those loose-fitting Sassoon coats; instead there were more tailored styles, usually double-breasted coats with dark velvet lapels and collars.

In Birmingham the Princess surprised everyone when she attended a rock concert. Obviously feeling that a formal evening dress would be inappropriate, she experimented with a completely new suit – a white tuxedo jacket, black trousers and a man's black bow-tie. The ensemble was a success and, subsequently, the Princess has shown the confidence to choose a variety of tuxedos and ties.

By April the Princess had to resign herself to maternity wear again, although she did it with a new eye for colour and detail. Being pregnant and fashionable became quite the vogue at this time, as the Princess, by her example, encouraged future young mothers to change from boring old smocks to such items as pedal pushers, coloured baggy sweat-shirts and drop-waisted dresses with exotic necklines.

This second maternity wardrobe included a lot of vibrant colours, particularly reds and blues and shocking pinks. Clip-on shoe bows became a popular accessory for bringing added zest to tired shoes. The shoes were changing too from those flat pumps to higher heels and two-tone styles.

It was not only the Princess's baby that was growing; her hair was by now shoulder length and getting progressively lighter. By the time the Princess celebrated her twenty-second birthday that old 'Lady Diana' haircut had disappeared completely.

The Princess still chose to wear some of her older yolk-style maternity dresses, designed by Catherine Walker for her first pregnancy, but she also showed a preference for flattering drop-waisted styles and décolletagée evening wear. Much of the fabric chosen for evening wear was shot through with silver or gold thread. One such dress was the white and silver gown worn at an evening with Pavarotti at the Royal Opera House, Covent Garden.

Jan Van Velden's navy and red wool coats proved most useful. They were loosely gathered on to the shoulders and generous in length. It was one of these coats that the Princess wore as she left St Mary's Hospital with Prince Harry in September. In contrast to her last hospital departure, the Princess was quite heavily made-up and had spent some time styling her hair. In October, Lord Snowdon took the official photographs of the Princess with her new son. The heavily made-up face that posed for the camera was far removed from those young looks of Lady Diana Spencer only three years before. Her looks continued to change over the following months and in November it was the Princess's hair that became a target for experimentation.

The Princess dressed in a regal cream gown by Gina Fratini and wore her hair rolled up and pinned around her tiara to attend the State Opening of Parliament. The style, although undoubtedly elegant, was in such contrast to the

A totally different look for Princess Diana on a visit to Ealing in December 1984. Her hair is swept back off her face in a forties style. The pink two piece suit by Jasper Conran is worn over a satin blouse.

familiar soft layers that it appeared quite severe. As her hair was now quite long and straight, she was able to wear it pulled back off the face in a forties bob, fastened back with tortoiseshell combs. The Princess appeared twice with her hair in this style but obviously had a change of heart, for she has not chosen to repeat the look since.

The Princess visited Southampton to launch the new luxury liner *Sea Princess* in November 1984 and looked fetchingly chic in a new red wool suit. The suit was similar to those being worn at the time by Princess Caroline of Monaco – a short jacket, brass buttons and a tailored skirt. The Princess of Wales had added a 'French' touch of her own by wearing a red and black beret into which she had tucked her hair.

The winter wardrobe of 1984 included a number of tailored coats in tweed or plain bright colours and we also saw the Princess wearing a number of warm wool suits – a particular favourite was in a black, blue and pink check. This suit was worn on numerous occasions with a variety of blouses in pinks and blue.

In Shrewsbury, in December, the Princess wore a new black mock fur Cossack-style hat. This new shape was to be repeated in many of the new hats which the Princess would wear during the forthcoming year; it also signalled the demise of the small feather-and-net hat – in the world of high fashion, styles which are deemed *passé* quickly become yesterday's news.

Arriving at Oslo airport in Norway in February 1984, the Princess wears a new royal-blue woollen coat, designed by Bellville Sassoon, over a straight skirt. A striped blouse in blue and white with a high tie neckline, also by Sassoon, is seen under the coat.

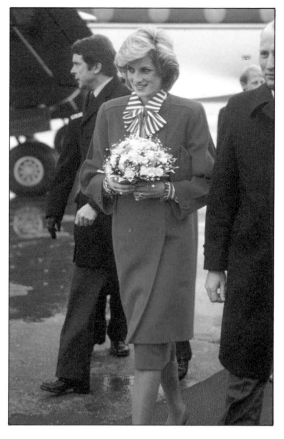

In freezing temperatures in the garden of the British Embassy in Oslo in 1984, the Princess sensibly chooses a thick green velvet suit by Caroline Charles. On this occasion a satin blouse is seen under the jacket. Beige baggy leather boots are worn with a medium-sized heel.

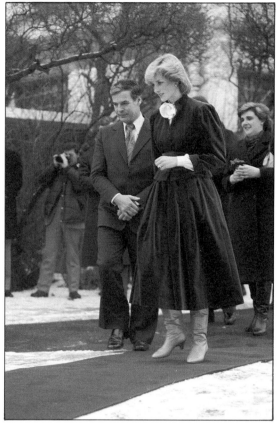

This very feminine red gown in luxurious duchess satin is by Jan Van Velden. The dress is worn with a separate lace bolero jacket, embedded with sequins for a shimmering effect. Two strands of twisted pearls and drop ear-rings complete the outfit worn to a ballet gala in Oslo in February 1984.

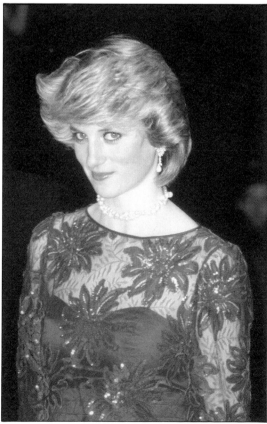

The Princess arrives at Birmingham airport in February 1984 dressed in a bright-red, woollen double-breasted coat by Catherine Walker. The collar, cuffs and pocket flaps are edged in black velvet. A small red hat by John Boyd completes the outfit.

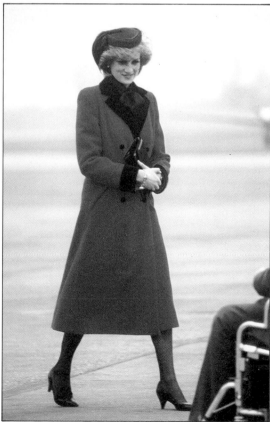

This new evening look for the Princess was first seen at a rock concert in Birmingham in February 1984. The first tuxedo suit to be worn by the Princess was designed by Margaret Howell, and consisted of a white jacket, black straight-legged trousers, a white blouse and a black satin bow tie. Variations of this suit have been popular with the Princess in more recent years.

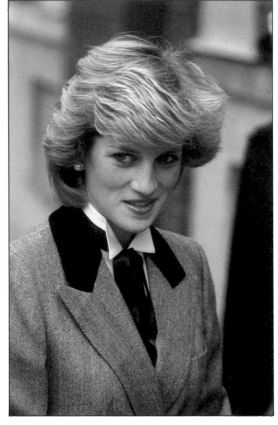

In Lisson Grove, London in March 1984 the Princess wore this grey herringbone tweed coat with a black velvet collar. Under the coat we see the Van Velden wing-tipped collar worn with a satin ribbon tied in a loose bow.

In the early months of her second pregnancy the Princess visited Leckhampton in Gloucestershire. She was dressed in this lilac wool coat by Catherine Walker, with puffed sleeves and a high mandarin collar. The small velvet skull cap with decorative feathers, also in lilac, is by Frederick Fox.

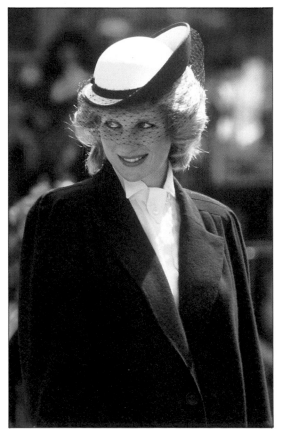

Jan Van Velden's navy blue woollen crêpe coat has been seen on many occasions over the years. Here in May 1984, it looks as smart as ever on a visit to Warrington. The cotton blouse, also by Van Velden, is worn with a patterned silk skirt under the coat. The tilted hat with a face veil is by Frederick Fox.

A high ruffled collar with a flower made from the same fabric created the unusual neckline of this particular dress. Van Velden's navy blue coat is worn over the dress for a visit to Crowthorne in Berkshire in May 1984.

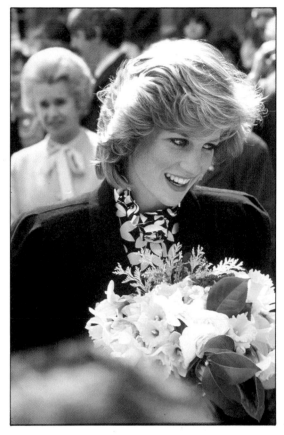

Bright pink accessories such as tights, shoes and bag, brighten up the navy and white dress and coat worn by the Princess to the Chelsea Flower Show in May 1984.

The royal petticoat is showing as the Princess watches polo at Windsor in May 1984. The pale blue and white dress with a white sailor collar is by Catherine Walker; a long-haired cardigan jacket in white by Jasper Conran is worn over the dress.

A neck band has been added to this lilac silk gown by Donald Campbell, probably to give greater support. The Princess is wearing it here at the Queen's Theatre in 1984.

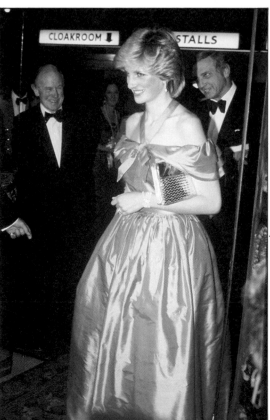

Dapper Couple
Partners in style

The Princess of Wales has visibly influenced the style of clothes that Prince Charles has been wearing over recent years. Before his marriage the Prince stuck to rather conservative, single-breasted suits in classic cloth, traditional city-styled shirts and practical lace-up shoes.

Those days have gone and today we frequently see an extremely well-dressed man with an eye for the chic and fashionable touch. The Prince's suits, although still made in Savile Row, are mostly double-breasted jackets worn with trousers that often sport turn-ups. His choice of cloth is more adventurous and there are noticeably less sombre, dark pinstripes in navy and grey. Although many of the new suits are still navy or grey based they now come in brighter fabrics that include silk, wool, tweed or,

appropriately, the 'Prince of Wales' check.

The shirts are not always 'safe' stripes; he seems to favour the fresh look, and his choice includes some in pale lemon and pink. The collars are neater and the impeccable Windsor knot is much in evidence.

The Prince, of course, is hardly ever seen on duty without a tie, and he has a wide range in silk. The ties vary from regimental ties worn for particular occasions, such as the 'Para' deep maroon tie worn by soldiers or ex-soldiers of the Parachute Regiment, to his personal choice of stripes, polka dots or patterns.

There was a time when the breast pocket of the Prince's suit would only ever display a plain white handkerchief, but currently he seems to favour multicoloured silk handkerchiefs that match his ties and shirts.

Right
During their visit to Melbourne in 1985 the Prince and Princess attended an evening reception at the city museum. The Prince wore a classic navy pinstripe suit, a simple shirt and striped tie; the Princess chose a red silk cocktail dress.

Far right
The Prince and Princess visited Portugal in February 1987. During the official welcome ceremony in Lisbon the Prince wore a beige French-style raincoat over his suit. The Princess sported an air hostess-style hat, a new white zipped coat and matching pleated skirt by Catherine Walker.

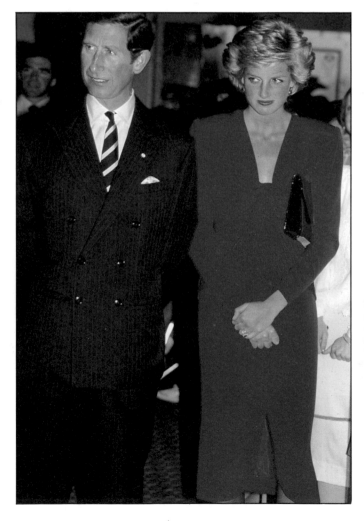

Above
The Prince wore a traditional Scottish kilt, tweed jacket and waistcoat on the remote island of Barra in the Scottish Western Isles. The Princess kept dry and warm in a full-length, green Barbour-style coat.

Left
The 'dapper couple' at home in August 1988. The Prince and Princess dress with appropriate style for a new official photograph to celebrate the fortieth birthday of the heir to the throne.

For a family lunch at Clarence House in August 1987, the Princess wore a new white and navy Catherine Walker dress. The Prince looked dapper in a lightweight summer suit in a grey check and a bold, brightly coloured tie.

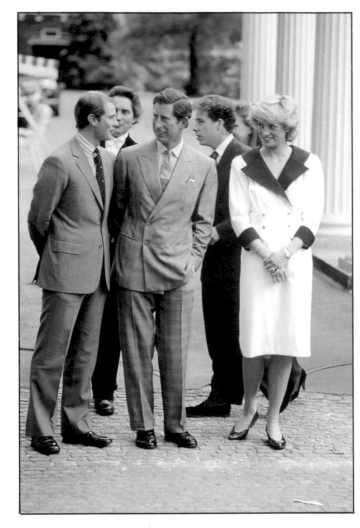

A nautical day for the Prince and Princess when they visited the Italian naval base of La Spezia in 1985. The Prince was in the uniform of a Naval Commander and the Princess wore her favourite Catherine Walker coat dress.

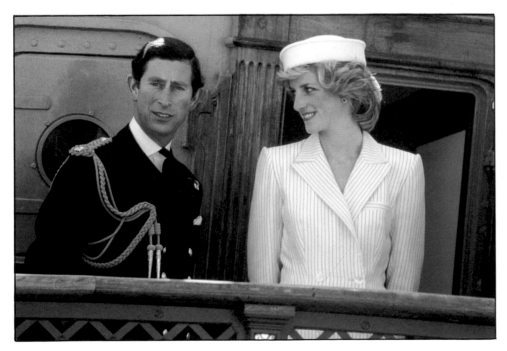

On formal occasions the Prince and Princess complement each other in their dress. At the Remembrance Day ceremony at the Cenotaph in London the Prince will be dressed in military uniform. On these occasions the Princess can reflect the military smartness in her own choice of clothes. The Prince was dressed in the uniform of a Colonel in the Welsh Guards when Their Royal Highnesses attended the 'Celebration of Armistice' in Paris in November, 1988. The Princess, in deference to the mood of the occasion, wore an exquisitely cut black coat and a hat with a face veil.

On a less sombre occasion – a visit to the naval dock yard in La Spezia, Italy, in 1985 – the Prince was dressed in the uniform of a Commander of the Royal Navy. The Princess cheekily echoed the theme in a navy and white pinstripe coat dress and a jaunty nautical-style hat by Graham Smith.

The Princess's taste for stylish shoes has recently been mirrored in her husband's choice of footwear, although occasionally we still see those simple, classic lace-ups. The Prince now wears slip-on brogues, country brogues and black patent evening shoes.

In the thirties the late Duke of Windsor was famous for his baggy overcoats and one of the coats that Prince Charles wears today resembles the style which was so popular with the Duke – it suits him well. Prior to his marriage the Prince stuck to a very plain navy wool, crombie-style coat; it lacked imagination and the chic sense of style which typifies the 'European' baggy look.

Off duty, the Prince and Princess can dress to suit their own life-style. The Prince, who has never been fond of jeans, tends to choose soft cord trousers, tweeds and comfortable cotton trousers for summer wear. Even out of the glare of the spotlight, the Prince remains conservative in his choice of clothes.

During their annual holiday to Scotland the Royal Family like to wear kilts accompanied by Scottish tweed jackets and waistcoats. Prince Charles has several kilts including one in the grey and red of the Balmoral Tartan. The Princess continues the Scottish theme in her choice of check dresses and suits, but has only once been seen in public in a kilt.

One indispensable item of clothing favoured by both the Prince and Princess of Wales is a waxed, cotton Barbour-style coat. They both own several: the Prince has brown and green versions, the Princess navy and green. Wax, country coats are worn very rarely on official engagements, one such being the visit, on an extremely wet day, to the remote Western Isles in 1985.

The Prince of Wales still favours the classic conservative style of dress so beloved of the English establishment. It would be foolish to ignore, however, the fact that his young, fashion-conscious wife has wielded considerable influence over the Prince's wardrobe.

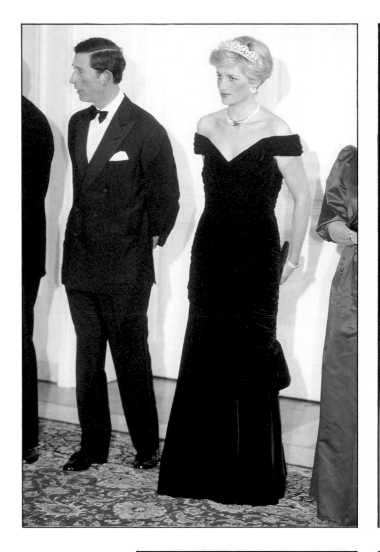

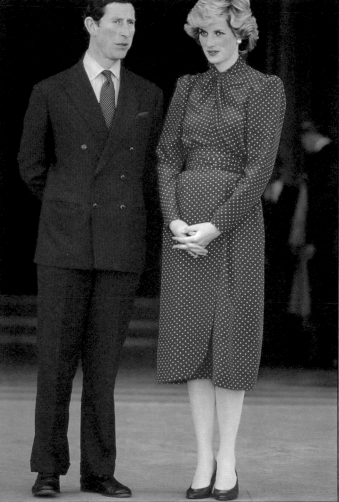

Far left
The Prince and Princess were the epitome of elegance when they attended a formal dinner in Bonn, West Germany in November 1987. The Prince wore a suave double-breasted silk dinner suit and black-patent evening pumps; the Princess looked radiant in a spectacular Edelstein gown.

Left
On the steps of St Peter's Basilica in Rome the navy of the Prince's suit contrasts with the bright pink of the Princess's dress by Donald Campbell. The couple were spending a brief few hours sightseeing in the Vatican City in 1985.

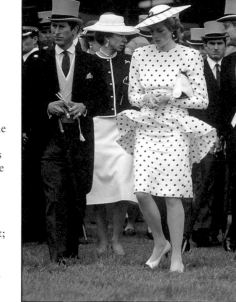

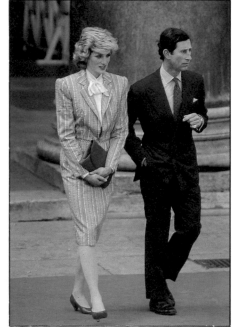

A day at the races in 1986 and, for the Princess, the first time at the famous Epsom Derby. The Prince is in traditional black morning coat, pinstripe trousers and grey waistcoat; the Princess has kept to simple but striking colours in a black and white Edelstein dress.

More sightseeing in Rome although not dressed quite like the usual tourist. The Princess looks happy and relaxed in her fitted multistriped suit, alongside her husband who prefers a classic lightweight navy day suit.

At the Ascot race meeting in June 1984, this apricot faconne silk suit by Jan Van Velden was a popular choice of maternity wear. The loose blouson top has a high neckline with a tie. White accessories and a large hat by Frederick Fox complete the ensemble.

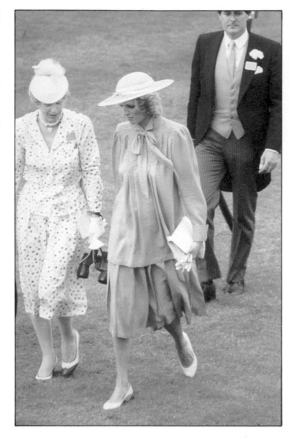

With only a short time to go before the birth of Prince Harry, the Princess visits King's College Hospital in London, in July. A lilac crêpe wool dress and jacket worn over a white blouse with a large square collar ensure that the expectant mother cuts an elegant figure. The complete outfit was designed by Jan Van Velden and the hat by John Boyd.

On a Sunday afternoon watching polo the pregnant Princess wears her pink silk sailor dress by Catherine Walker, with a detachable white collar.

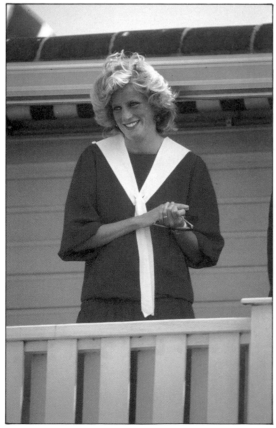

The Princess looks delightful in a very feminine maternity evening gown in a glossy satin by Catherine Walker. This full-length dress, worn to the film premiere of *Indiana Jones* in London, in June 1984, has a dropped waistline, and a blouson top which ties on to one hip.

Arriving at Aberdeen airport with Prince Charles and Prince William in 1984, the Princess is dressed casually in a striped blue and white cotton maternity dress. The short-sleeved white blouse is by Jan Van Velden.

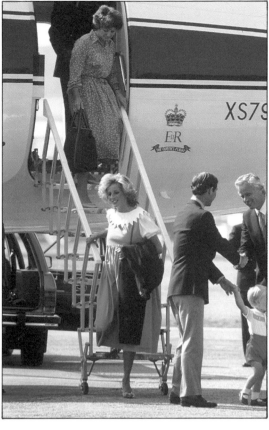

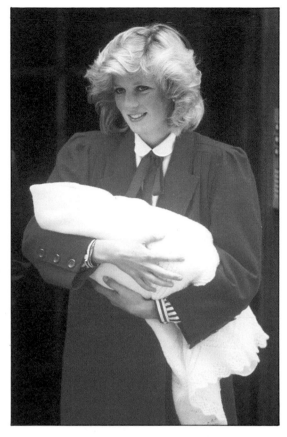

Leaving St Mary's Hospital with her new son in September 1984, the Princess wears her Jan Van Velden red wool crêpe coat over a striped red and white dress by the same designer.

To launch the new liner *Royal Princess* at Southampton in 1984 the Princess has chosen a new red woollen suit. The cardigan-style jacket has brass buttons, the skirt front box pleats and the outfit is worn with black accessories and blouse. The Princess wears her hair tucked inside a woollen beret.

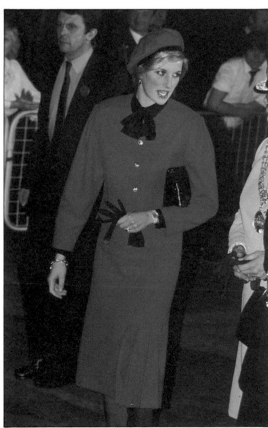

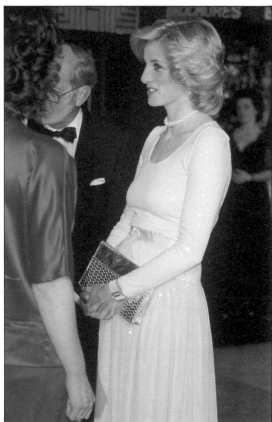

The Princess showed off her *svelte* figure only months after having Prince Harry when she attended a charity performance of *Starlight Express*. The figure-hugging dress in a pastel peach sequin fabric by the Emanuels has a round scooped neckline. The Princess's hair has been highlighted to create a blonder look.

This pillbox hat by John Boyd has all the hallmarks of his extremely successful style – a face veil, a flowing feather and a neat petite shape. This red velvet hat appeared in Leatherhead in 1984.

The first uniform to be worn in public by the Princess was that of the British Red Cross. It consisted of a black jacket and skirt, a white blouse, red tie and a full beret-style hat. It was worn to a Red Cross function in December 1984 in Bristol.

In Ealing in December 1984 the Princess, with a new hair style, wears a pink, woollen double-breasted suit by Jasper Conran. The smart jacket is worn over a satin blouse.

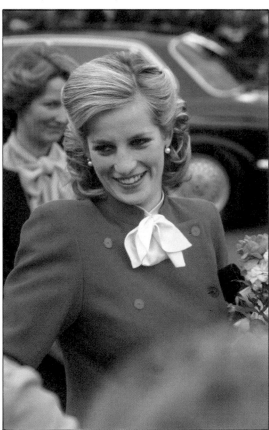

The first Cossack-style hat to be worn by the Princess was this black fake fur creation seen in Shrewsbury in December 1984. A brightly coloured check wool suit is worn with a satin blouse. The hat is by Marina Killery.

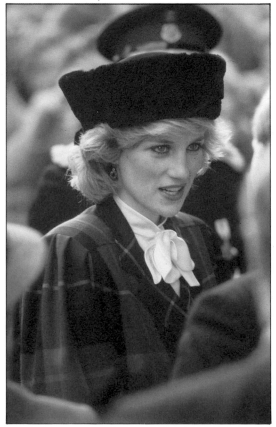

1985
'Carlos an De' ... when in Rome

The sixteen-day tour of Italy, originally planned for October, 1984, and postponed because of the Princess's pregnancy, was now rescheduled for the spring of 1985. The months before this exciting tour were spent in a steady round of engagements across the United Kingdom.

The Princess was kept busy with a full diary but still found time to step in to cover for Princess Margaret on a number of occasions; Princess Margaret had been unwell for some time. At St David's Concert Hall in Cardiff, Wales, the Princess of Wales added a touch of glamour in her dark plum-coloured gown in velvet and taffeta.

A reception was held at London's Lancaster House to mark the beginning of the London Fashion Week, and the guest of honour was the Princess who had done so much to promote British designers and re-establish home-grown talent as a force in the international fashion industry.

Needless to say the evening was the ultimate in fashionable chic and the Princess decided to wear her 'dressing gown' dress in bright blue, pink and white. The gown was identical in style to that of a gentleman's dressing gown, even down to the tasselled rope belt. Whether or not it was a success has never been clear, although it may be ominous that it has not reappeared at a public occasion.

Large square shoulders were very popular in 1985, partly copied from the successful American soap operas. The 'Dynasty' look, as it became known, incorporated these large shoulder pads into almost every type of garment from glittery evening dresses to casual woollen sweaters. The Princess was quick to emulate the prevailing fashion trend.

A few of her older, favourite items were still being worn this year, such as the floaty pale blue, lavender and white off-the-shoulder Sassoon gown, first worn back in 1981; this was a popular choice for film premieres and formal dinners.

In preference to buying new outfits, many familiar garments were being adapted and altered for further use. The pale pink and white silk suit designed by Catherine Walker for the 1983 Australian tour had originally included a full calf-length dirndl skirt. In April, in Bath, we saw the same suit, but this time the skirt had been dramatically remade and streamlined into fitted knee-length knife pleats. Later in the year we also saw the beige-coloured tweed coat by Caroline Charles, first seen in Wales in 1981, altered from a wrap-over style to a double-breasted buttoned coat.

The Italian tour schedule included travelling between such locations as Sardinia, Sicily and Venice. The tour started on Sardinia where the Royal Yacht, *Britannia*, was berthed awaiting its important passengers. Fashion pundits were disappointed during the first few days of the tour as they had anticipated an extravagant new wardrobe. Instead, they saw the Princess in some of her previously worn clothes. The official photographs released on the eve of the tour, taken by Lord Snowdon, featured two new satin gowns, both identical in style but one in a pale shell pink and the other in ivory. Neither surfaced for public appraisal during this tour. However, the Italian people were ecstatic with the Prince and Princess, or 'Carlos an De' as they were affectionately dubbed.

The royal couple undertook a hectic round of engagements in Rome, including an audience with the Pope. After a forty-five minute private audience with His Holiness the Prince and Princess emerged from the Vatican library looking a lot less nervous than when they had entered. The Princess, in keeping with tradition, wore a dignified black dress and a veil to cover her head. In the afternoon, on a return visit to the Vatican City to tour St Peter's Basilica and the Sistine Chapel, onlookers noticed that the colour of the Princess's pink and white dress exactly matched the cummerbunds of the priests who were escorting the royal sightseers.

In Rome the Princess seized the opportunity to visit the 'Hospital of Baby Jesus'. It was here that we saw one of her large-shouldered suits in black and white cotton, by Bruce Oldfield. A hat was worn with the suit – a black paribuntal straw fez by Viv Knowlands.

A solemn occasion during the tour was a visit to the Anzio beachhead some thirty miles from Rome. The Prince looked splendid in the uniform of the Colonel-in-Chief of the Gordon Highlanders, while the Princess kept to a conservative burgundy and white striped dress in a heavy satin.

The Mayor of Florence held a dinner for the Prince and Princess and the occasion gave her the opportunity to wear a new off-the-peg cocktail dress by Jacques Azagury. The shorter-length dress was in black velvet with a frothy layered skirt in blue organza.

In Venice the Emanuels' designs made a long-awaited reappearance. As she strolled along the canal edge the

This shimmering satin suit is worn over a pink silk camisole top for an evening at a rock concert in Melbourne, Australia in October 1985. The suit is by Bruce Oldfield.

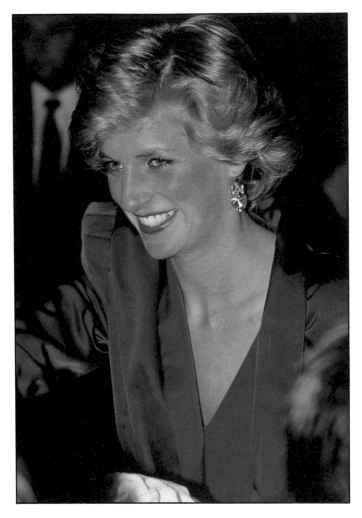

and Princess kept their umbrellas up and stayed dressed in warm wool clothes and Barbour-style coats.

Towards the end of the year the Princess made a solo visit to Berlin in her capacity as Colonel-in-Chief of the Hampshire Regiment. It was evident from her new, shorter tailored suits that she was keen to project a more mature image, a far cry from all those fussy layers, bows and ruffles.

In October, it was time for the Prince and Princess to return for a second visit to Australia. This schedule was a little less demanding and they were based mostly around Melbourne. The Princess, now sufficiently confident to wear clothes that accentuated her marvellous figure, was happy in very tailored dresses and suits. Hats were still popular, although they were far distant from the small cap style of a few years before. Now larger, flatter brims worn slanted off the face were most frequently seen.

At a film premiere in Melbourne the Princess wore a favourite gold lamé gown. Oozing glamour, this dress had been seen a few months before at a Bruce Oldfield charity gala in London. As the Princess met the celebrity guests, including the soap queen Joan Collins, one could not help thinking that she looked more like a film star than any of them. The royal couple then flew on directly to America from the Australian tour for a week's official visit.

Many new clothes were packed for the American stop-over, but none so exciting as the deep midnight blue velvet gown by Victor Edelstein worn with such aplomb at the White House dinner and dance. The American wardrobe also included a Kanga design. The uncrushable blue and white dress, worn to a polo match, was made by a close friend of the Prince and Princess, Lady Dale Tryon – known more commonly as Kanga – the name she has given to her highly successful fashion business. Her designs are always in an array of colours and are extremely suitable for day and evening wear.

As a busy year drew to a close the Prince and Princess went to Windsor Castle for a traditional family Christmas before travelling up to Sandringham to plan for another year of royal duties.

Princess could be seen wearing a long, green check coat with a square collar and a hat with a jaunty turned-back brim.

With the Italian tour behind them the Prince and Princess returned to a normal routine that included spending a few days on the remote Scottish Western Isles. Predictably, it rained for most of the time and the Prince

For a concert in Cardiff in February 1985 the Princess wore a strapless evening gown in plum taffeta and velvet by Gina Fratini. A small bolero jacket, also in velvet, is worn over the dress.

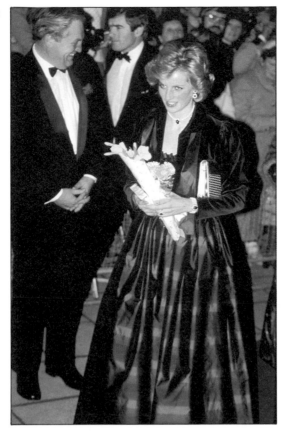

The bright red wool suit worn here is complemented by red hosiery for a visit to the Cirencester Police Station in February 1985. The suit is worn on this occasion with a red felt boater and, under the jacket, the ever versatile Van Velden blouse.

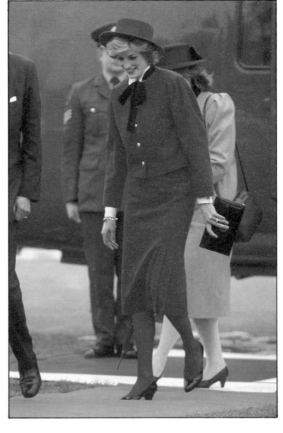

The Princess attended a reception in London in March 1988 at the beginning of the British Fashion Week. For this particularly chic occasion she wore an unusual dressing-gown-style dress in vivid satin. Bellville Sassoon designed the dress with a characteristic rope-tie belt.

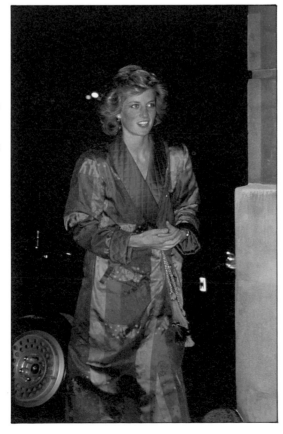

This royal blue skirt and three-quarter-length coat worn to Hereford in April 1985 is combined with a slanted felt hat. The double-breasted coat has deep pleats in the sleeves and is loosely fitted around the cuffs. It was designed by Bellville Sassoon.

The breeze catches the Princess's skirt as she arrives in a helicopter of the Queen's Flight in Bath in April 1985. The skirt of this silk suit by Catherine Walker has been altered from its original dirndl style to a pleated shorter look.

Bruce Oldfield designed this suit in a blue-grey check. The jacket has an unusual cut and large padded shoulders. The top of the jacket is generous and falls into a seam under the bustline. The skirt has a high slit at the back. Grey leather shoes and clutch bag are chosen to accompany the outfit.

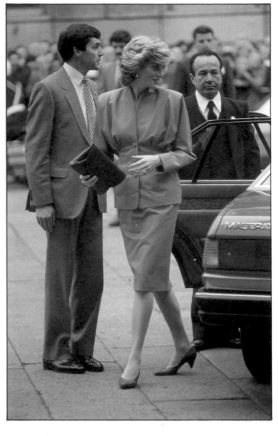

An off-the-peg Jacques Azagury cocktail dress being worn in Florence, Italy in April 1985 to the mayor's dinner. The dress, with padded shoulders, has a black velvet bodice with glittering stars and shapes. The skirt has two layers of blue organza falling from the hip.

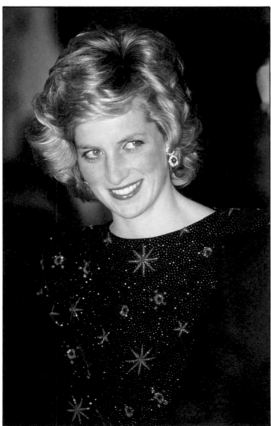

This smart tailored suit by Jasper Conran in a bright tomato red was chosen for a sightseeing trip in Florence in April 1985. A simple blouse is worn under the long jacket. Tights and shoes are in the same cheerful colour.

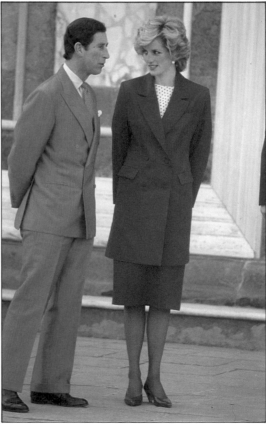

In the warm climate of southern Italy this cool silk suit by Jasper Conran in a grey and white pattern was a practical and yet pretty choice to wear on a visit to Barri. Seen originally on the Canadian tour of 1983 the suit has a pleated skirt and a long top that is worn belted.

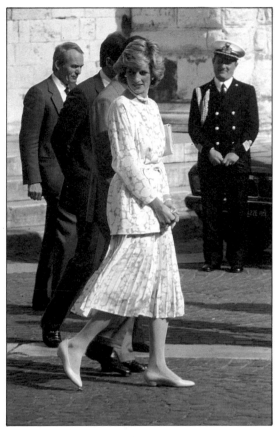

This black straw fez-style hat by Viv Knowlands was seen during the Italian tour of 1985. The hat was chosen for a visit to the children's hospital in Rome to complement a black and white Oldfield suit.

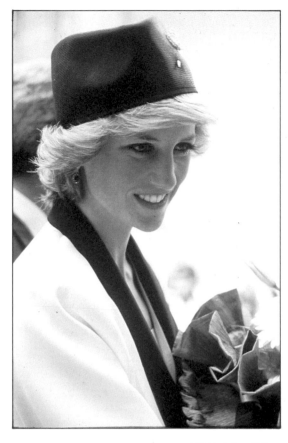

A very special meeting in Rome in April 1985 required the Princess to adhere to the demands of protocol. To meet the Pope at the Vatican, the Princess wore a black lace calf-length dress by Catherine Walker. The dress with a dropped V-shaped skirt was worn with a lace veil in the same fabric.

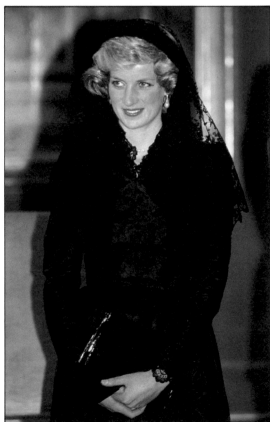

To the Prime Minister's lunch in Rome in April 1985 the Princess wore her striped silk suit by Bruce Oldfield. The smart suit has a short fitted jacket and straight skirt and is in grey, pink and primrose stripes. The drop glass ear-rings match the pink stripe in the suit.

The priest's cummerbund matched the shade of pink in the Princess's dress when she visited St Peter's Basilica in Rome in April 1985. The silk dress by Donald Campbell, with a twisted neckline and matching belt, has been a popular choice for many engagements.

Strolling across the piazza in Venice in 1985 the Princess wears a new Emanuel coat in a deep emerald green and black check wool. The coat, worn over a simple cream blouse, has wide padded shoulders and an exaggerated collar. The large hat with a turned-back brim is in the same elegant shade of emerald green.

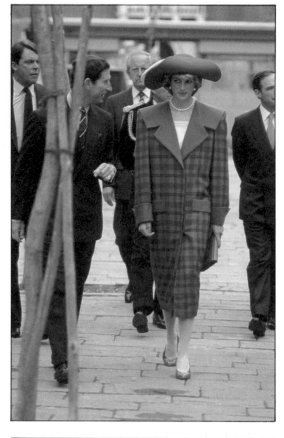

The royal blue and black fitted crêpe dress worn here in Venice in April 1985 was first seen earlier in the same year. The dress, by Bruce Oldfield, has an unusual waistline in the irregular cummerbund effect in a plain black fabric.

During a visit to Stornoway on the remote Western Isles of Scotland, the Princess wore a plum check woollen suit. Catherine Walker designed the short-fitted jacket with a velvet collar and the full sunray-pleated skirt. A small black bowler hat completes the ensemble.

To keep the driving rain at bay in the Western Isles in 1985 the Princess wore a full-length green Barbour-style coat in waxed cotton. The coat has an optional hood that came in useful on this particular trip.

Down in the pony lines at the Guard's Polo Club in July 1985 the Princess is dressed in a smart black and white silk dress. Seen previously at various official appointments, the dress has a high neckline and is tightly belted.

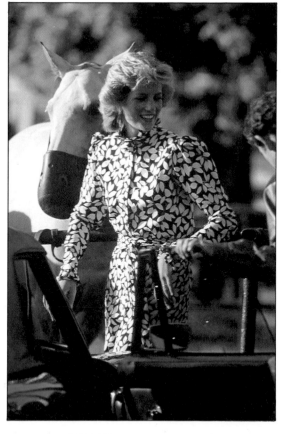

Sitting with friends to watch polo in the summer of 1985 the Princess keeps to her casual off-duty clothes. A simple white cotton skirt and blouse, worn with a red cardigan and red leather shoes is the order of the day.

Arriving for a family lunch in Scrabster, Scotland in August 1985 the Princess wears a straight skirt with side-kick pleats. The plum check exactly matches a suit by Catherine Walker worn a month earlier in Stornoway. A short cardigan in plum is worn over the cotton blouse.

Gloves and Muffs
Off the cuff

To be properly dressed in the first half of this century required a lady to wear gloves, especially in high social circles and on important state occasions. The Queen and Queen Mother are rarely seen without gloves, even today. It is only off duty that they bare hands in comfort.

For the younger generation of royal ladies the wearing of gloves has been somewhat more optional, and the strict rules which applied to past generations seem to have disappeared.

All the female members of the Royal Family still choose to wear gloves but they differ over what they see as an appropriate occasion. The Princess of Wales has not been a great lover of wearing neat little day gloves for the endless handshaking she has to endure. Her sisters-in-law, however, often like to complete their day wear outfits with wrist-length gloves. The Duchess of York seems to enjoy wearing gloves and the Princess Royal has doggedly worn them for years, following the example set by her mother.

The Queen and Queen Mother favour white or ivory gloves that reach almost to the elbow. The Queen also likes plain black gloves for day wear. The Princess of Wales rarely wears gloves for day wear unless it is very cold, then she usually sticks to brown or black leather pairs. In Paris in November 1988, the Princess chose an elaborate pair of gloves, with a band of real fur around the cuff.

In 1986 the Princess discovered that evening gloves were the perfect accessory to offset an evening dress. She began

Right
The Princess visited the Brixton Enterprise centre in February 1986 and carried the favourite black muff in preference to allowing it to hang with a neckstrap.

Far right
This black muff is the perfect fashion accessory for the purple Cossack-style suit and hat – the Princess even has room to tuck her small bouquet of flowers inside the muff. A plaited neckstrap holds the muff in place. The suit is by Caroline Charles.

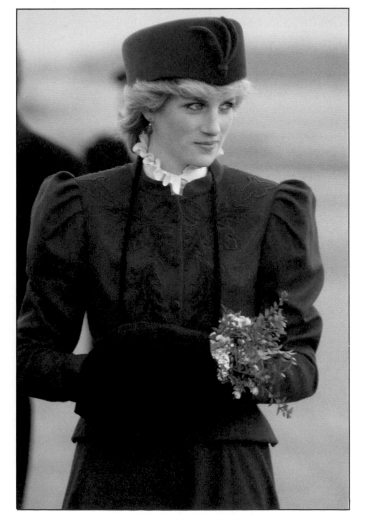

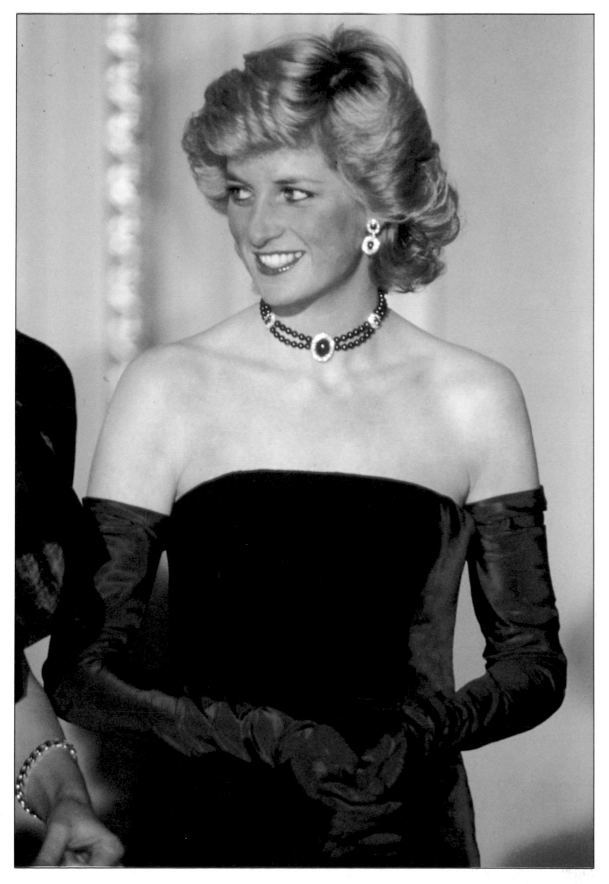

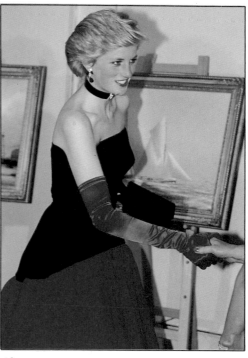

Above
One red and one black – imaginative use of colour for long evening gloves which were worn with a flamenco-style dress by Murray Arbeid in London in 1986. The slim-fitting gloves are in satin.

Left
These long gloves are made in the same deep-purple taffeta as the Catherine Walker dress which was worn to the opera in Munich in 1987.

Right
The black muff again, this time teamed up with a pink and black jacket and skirt. The decorative cord pattern on the front of the muff matches the optional neckstrap which was not worn on this occasion.

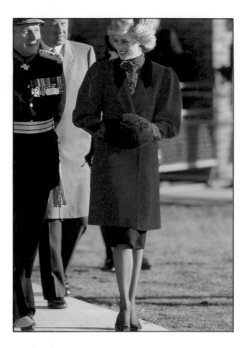

Left
A rare occasion when the Princess chooses to wear gloves for day wear. Here we see simple black wrist-length gloves worn with a black and white suit at the Melbourne Cup race meeting in 1986.

Right
Long satin gloves in shocking pink add a splash of colour to this evening dress on the occasion of King Constantine of Greece's party at Claridges Hotel in London in 1986.

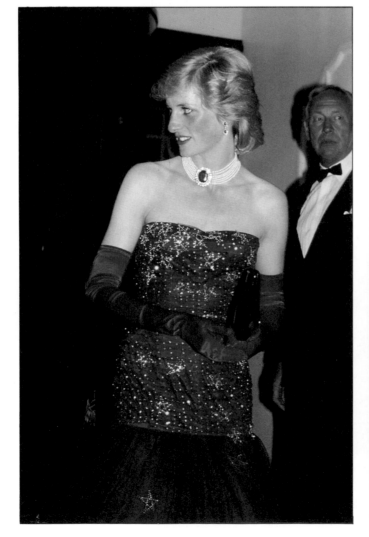

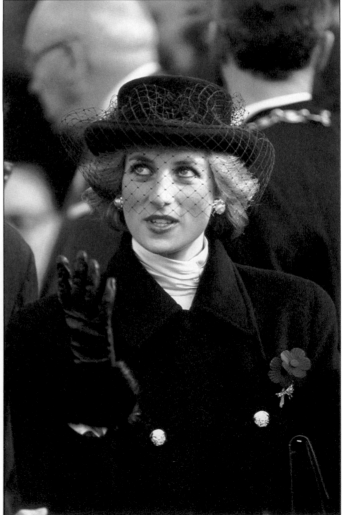

Far right
A band of real fur has been used for edging these soft black leather gloves which were worn in Paris in 1988. It is unusual for the Princess to wear real fur.

to wear very long, slender gloves that stretched to the top of the arm; most of these were in a shiny satin although some were in soft kid. At the America's Cup Ball in London in 1986 the Princess wore a pair of gloves to complement her flamenco-style dress in red and black. In a daring gesture she wore one black glove and one red glove.

In Munich, in 1987, Catherine Walker designed the mauve evening gown that the Princess wore to the Opera. She chose gloves in matching purple taffeta.

The strict rules governing the Ascot race meeting at one time stipulated that gloves must be worn in the Royal Enclosure. Nowadays, however, most ladies just carry their gloves as an additional fashion accessory. The Princess prefers that interpretation and only occasionally will you see her wearing the gloves. In 1981, however, she faithfully wore her gloves every day – it was her first trip to the Ascot meeting.

If the Princess is wearing a long-sleeved gown she will not bother to wear or carry evening gloves. In London, in 1988, at a grand banquet held by King Olav of Norway, most of the female members of the Royal Family attending were either wearing or carrying gloves; but not the Princess of Wales. At the Derby in 1987, the Queen, Queen Mother, Princess Royal and Duchess of York all wore gloves as they lined up to watch the races; the Princess of Wales clasped her race card with her bare hands.

In 1981, the Princess carried her first 'muff'. It was grey and made from grey fake astrakhan fur. The muff was worn on a snowy day to visit Gloucester Cathedral. This muff has not been seen again, but since 1985 a black, smaller muff shaped like an American football has been carried many times. This black muff was particularly popular during the 'Cossack' look. It has an optional neck strap in a black twisted cord, and sometimes the Princess lets it hang loose when meeting people, or she may choose to carry it without a strap.

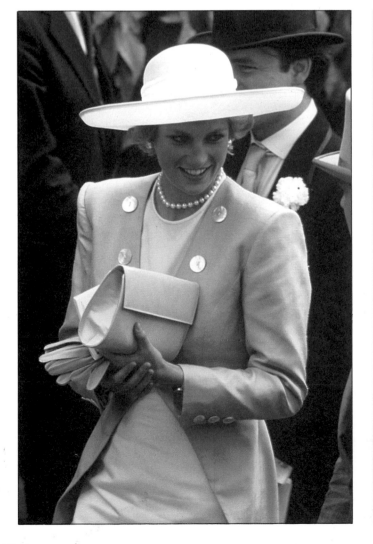

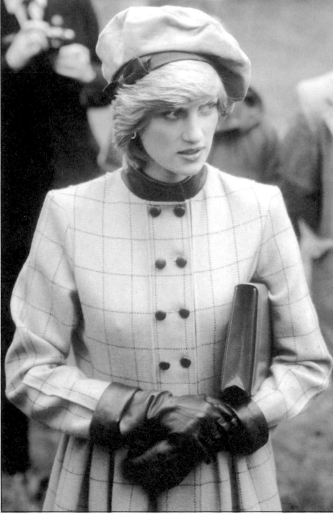

Far left
These soft grey gloves are carried more as decoration than for practical use at the Ascot race meeting in June 1988. The gloves were not worn during the day but did give an added flourish to the grey top coat and white linen dress by Catherine Walker.

Left
In Wales in 1982 these brown leather gloves kept the Princess warm; they also complemented the leather trim of the collar and cuffs of this coat dress by Caroline Charles.

Taking Prince William to school in September 1985, the Princess wears her blue and black knitted sweater by Jasper Conran tightly belted. The slimline black skirt has a high back slit.

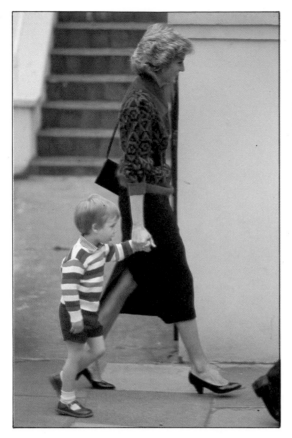

For the journey to Australia in October 1985 the Princess wore a rust-coloured suit with a peplum jacket and knee-length skirt. A new striped satin blouse with a high neck is seen under the jacket.

A pink and black suit by Victor Edelstein brightened up a wintery day in Berlin, West Germany in October 1985. Visiting the Royal Hampshire Regiment, the Princess wore the regimental brooch pinned to her top pocket. The small hat in pink and black is by Frederick Fox.

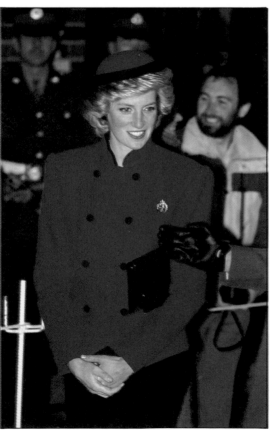

Another fitted suit seen during the brief Berlin visit in 1985 consisted of a short dark-green jacket with a rolled collar and a knee-length black skirt. The regimental brooch is this time pinned to the neckline of a striped blouse.

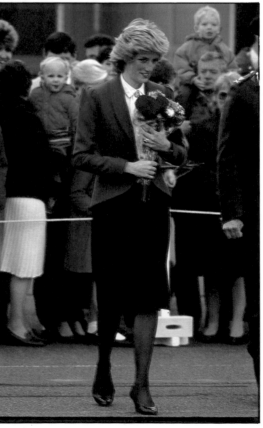

A new pinstripe coat dress is seen here as the Princess arrives in Melbourne, Australia in October 1985. The dress, in a light coffee colour by Catherine Walker, has white stripes running through it. The double-breasted bodice is buttoned to one side and has a plain round neckline. A round turned-brimmed hat is worn in matching shades of white and beige.

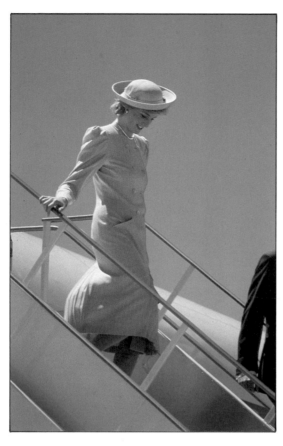

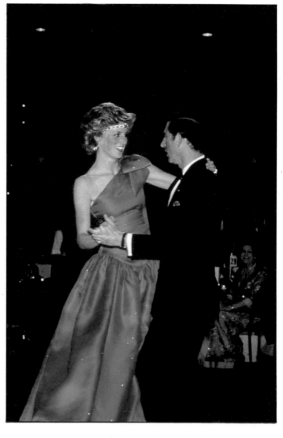

Swirling around the dance floor at the Southern Cross Hotel in Melbourne in October 1985, the Princess wears her Queen Mary choker as a headband. The silk dress, in a daring one-shouldered style, is by the Emanuels, and has a dropped waist and a full skirt.

The Princess wears the 'flying saucer' hat by Frederick Fox during a visit to Puckapunyal in Australia in October 1985. The dress, in a matching deep plum by Catherine Walker, is very fitted with a wide belt and a deep neckline edged with a white collar.

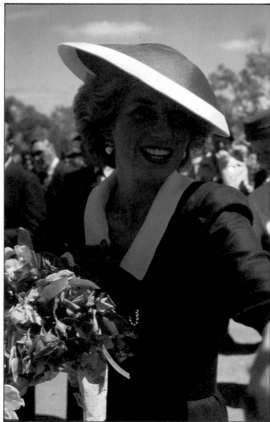

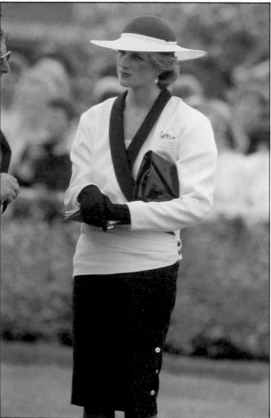

For a day at the races in Melbourne, Australia in 1985 the Princess chose a black and white cotton suit by Bruce Oldfield. The jacket has large padded shoulders, a deep rolled collar and fastens on to one hip with large buttons. The skirt is also buttoned up one side. Accessories include black patent shoes and bag and short black cotton gloves.

Bruce Oldfield at his best: the gold lamé gown seen on many occasions has tiny pleat detail, not only on the flowing skirt but on the complete bodice and sleeves. The dress is worn here to a film premiere in Melbourne in 1985.

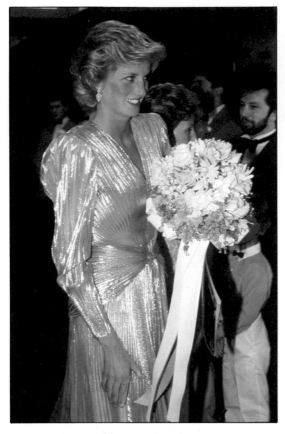

The satin cocktail suit, in a deep shade of purple, was worn to a rock concert in Melbourne in 1985. The jacket sweeps into a clip fastening at the front and is worn over a pink silk camisole top. The suit is by Bruce Oldfield and is worn with satin evening shoes and purple tights.

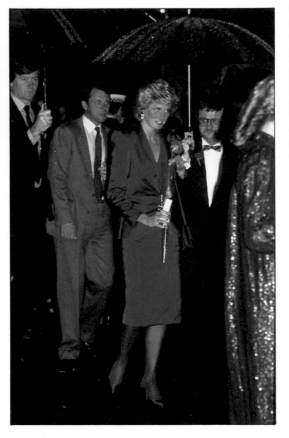

Visiting a school in Australia in 1985 the Princess wears a dark navy woollen suit over a high-necked satin blouse. The jacket has a velvet stepped collar and pocket flaps. A small diamond brooch in the 'Prince of Wales Feathers' design is pinned to the cravat tie.

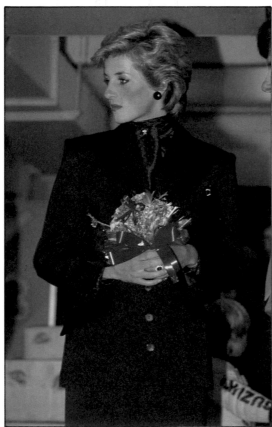

Catherine Walker's cream and navy pinstripe coat dress is worn with a small hat by Graham Smith at Kangol to visit Portland, Australia in October 1985. A navy leather clutch bag is neatly tucked under the Princess's arm.

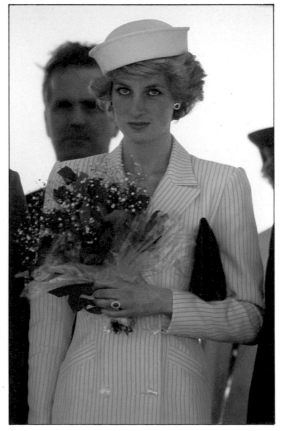

This pretty lilac crêpe woollen dress, with a dropped waistline and pleated skirt, was designed by Jan Van Velden. It is worn with a white lace collar and a dainty hat by John Boyd to visit Mildura in Australia in November 1985.

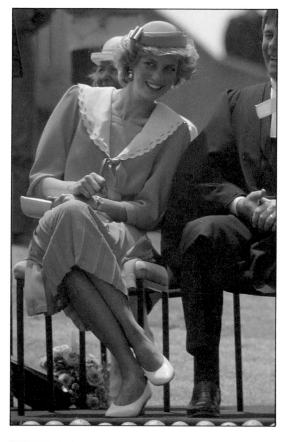

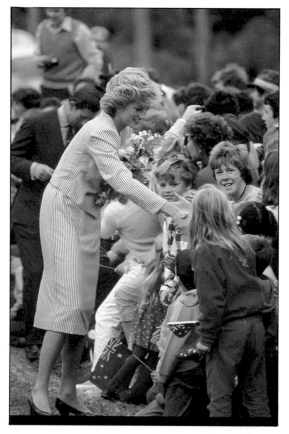

This blue and white striped cotton suit was chosen for a visit to the Australian town of Macedon in 1985. The short jacket is worn without a blouse. The suit was seen a few years later being worn this time by the Princess's elder sister.

The Princess wore this green, blue and white check dress to Rotomah Island in Australia in 1985 but has not chosen this particular outfit for a public engagement since then. The pretty dress has a lace collar and is belted at the waist. The shoes are livened up with jaunty tartan clip-on bows.

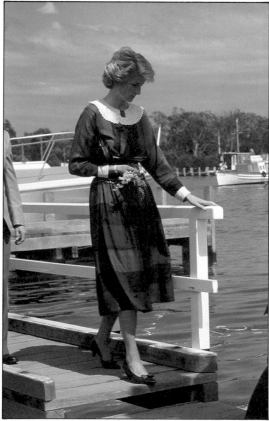

In Washington in November 1985 the Princess wore a new red and white suit with a long rolled collar. At the airport the suit was complemented by a striking hat, but this was discarded as the visit progressed.

Polka dot parade

Polka dots in every size and colour monopolized the fashion seasons of 1985/86. But, unlike a lot of women who were only just beginning to wear 'dots', the Princess of Wales had preceded the fashion trend as far back as her 1981 pre-wedding wardrobe.

The first polka dot apparel that we saw the Princess wearing was a red and white silk suit by Jasper Conran, worn during one of the Princess's early walkabouts in the West Country town of Tetbury. That was the beginning of quite a collection of polka dot items from dresses and suits to blouses, trousers and socks.

The Princess's first maternity wardrobe included a number of dresses by Catherine Walker of the Chelsea Design Company. They featured fabrics with small feminine polka dots set against a range of colours from soft powdery pastels to stronger, bolder colours such as navy and green. Polka dot clothes have featured in the Princess's formal and informal wardrobe.

One outfit that was particularly memorable in the polka dot phase was one worn to a charity polo match at Smith's Lawn in 1985. As the Princess proceeded around the pony lines all attention was on her feet ... for she was wearing a pair of red and white polka dot ankle socks. The accompanying ensemble, a red and white polka dot skirt and a casual 'sloppy joe' sweater, was pure nostalgia – the look of the fifties and the rock and roll years. The socks were to give the growing polka dot phase a boost and it was reported that in the week following the Princess's appearance sock shops throughout the United Kingdom

Right
The polka dot theme was carried through to the top of the head for an outfit chosen by the Princess to wear to Carolyn Herbert's wedding in July 1985. The silk dress, in pink and white, was accompanied by a short jacket. The spotted scarf created a turban-style hat for the occasion.

Far right
Were the choice of colours of this silk dress purely coincidental, during a vsit to Nija Palace in Kyoto, Japan, in May 1986? The dress from Tatters in the Fulham Road was particularly appropriate for the first day of engagements on the Japanese tour.

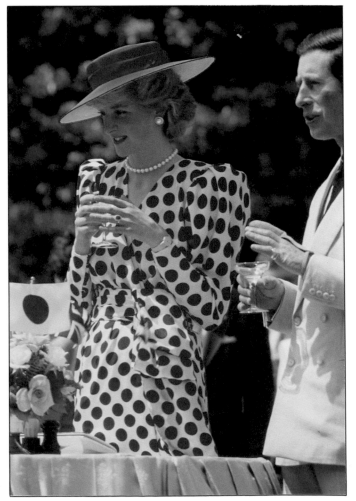

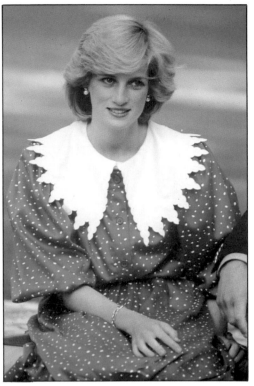

Above
This green and white dress made of satinized cotton was chosen for a photocall on the lawns of Government House, New Zealand in 1983. The dress was worn over a white Jan Van Velden blouse with a large white puritan pointed collar.

Left
This dress, in fuchsia pink silk with small white polka dots, looked cool and comfortable when worn by the Princess during an official ceremony in Perth, Western Australia, in April 1983. The dress, by Donald Campbell, is worn with a John Boyd hat.

Right
The elegant black and white Victor Edelstein dress was seen at the Royal Ascot race meeting in June 1988. The hat in a contrasting polka dot theme is worn cheekily to one side.

Far right
Polka dots are the dominant theme for this bright blue suit and satin high-necked blouse by Jan Van Velden. This was a new suit made to wear in Canada in 1986.

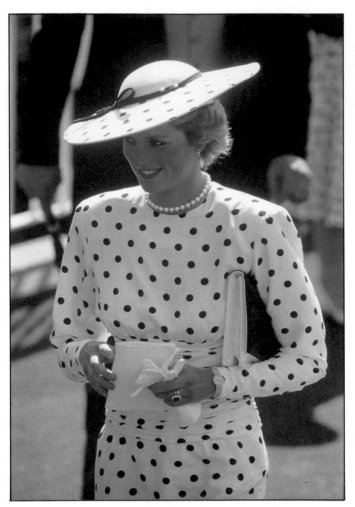
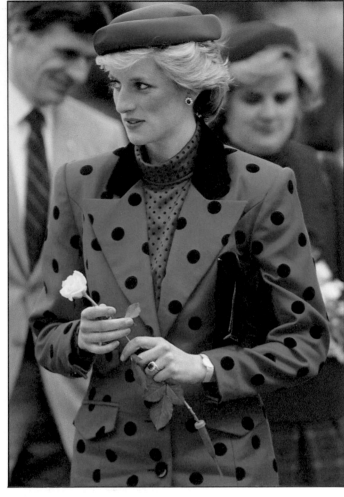

An early taste of the polka dot style in March 1981. The then Lady Diana Spencer was visiting the West Country town of Tetbury. The two-piece silk suit by Jasper Conran is worn with a high-necked blouse.

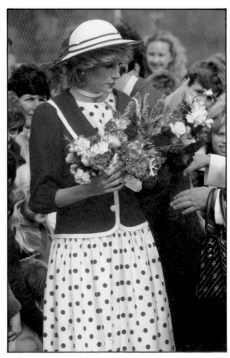

Another early polka dot oufit was this red and white dress by Catherine Walker. The silk dress is worn under a fitted jacket in red with white trim.

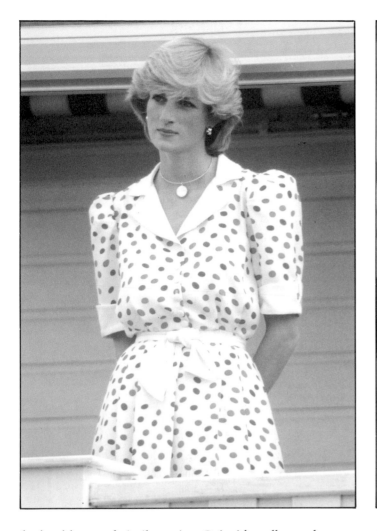

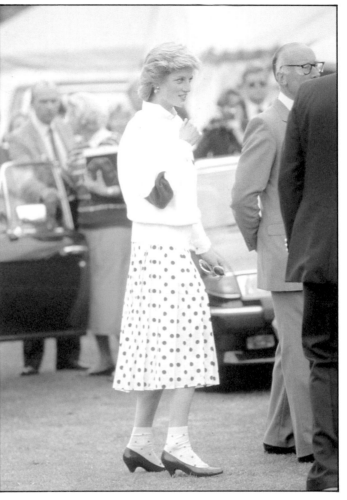

Far left
This neat cotton dress with red and green polka dots by Catherine Walker was ideal for an afternoon spent watching polo at Smith's Lawn, Windsor, in the summer of 1983.

Left
This was one of the most memorable polka dot ensembles, worn by the Princess to a polo match in 1986. The rock and roll look of the fifties is recreated in the Princess's choice of skirt, 'sloppy joe' sweater and, of course, those famous ankle socks. The co-ordinating ensemble is from the German fashion house, Mondi.

had sold out of similar pairs. Coincidentally, at the very same polo match the future Duchess of York was wearing a polka dot black and white dress.

One of the Princess's more elegant polka dot outfits was a dress by the designer Victor Edelstein. Evidently a firm favourite, the black and white dress emphasizes the Princess's *svelte* figure and looked incredibly chic when worn at the Epsom Derby in 1986 with a large slanting hat of the same fabric. The Princess paraded the outfit again at the Ascot race meeting in 1988 and at other functions including a polo match at Windsor.

The choice of polka dots was beginning to wear thin by late 1986, although some new polka dot outfits, such as dresses and suits, were included in the wardrobe for the Japanese and Canadian tours. The dress worn by the Princess on her first day of engagements in Japan looked similar to the design and colours of the Imperial Japanese flag – a white background with large red dots. By the end of the year, when choosing her Gulf tour wardrobe, the Princess had definitely decided to drop 'dots' for a while. We have, however, seen them in 1988 in a couple of new dresses and in a few of the old favourites, which have been given a second airing.

Polka dots have also featured in some of the Princess's accessories of late, including a pink evening bag with blue dots seen in 1988, and a pair of polka dot shoes worn at a fashion show in Sydney.

The Princess danced the night away at the White House Ball in November 1985 in this dramatic dark navy velvet dress by Victor Edelstein. The dress, with matching long evening gloves, has a fitted skirt that swirls out below the knees. A stunning seven-strand pearl choker and a huge sapphire clasp create a dazzling effect.

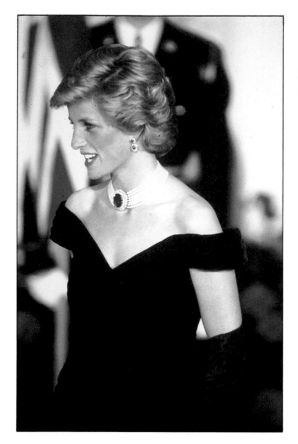

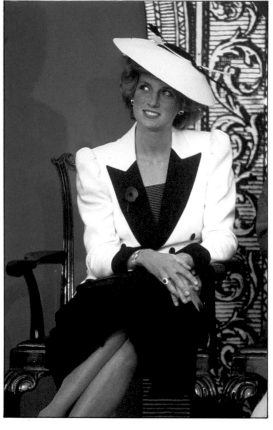

Another popular Catherine Walker creation worn so often by the Princess is this elegant cream and black wool suit seen here at the National Gallery in Washington, DC in 1985. The double-breasted jacket has covered buttons to match the collar and cuffs. The slanted hat is by Frederick Fox.

A formal dinner was held at the British Embassy in Washington, DC in November 1985 and for the occasion the Princess chose her drop-waisted gown by Murray Arbeid in ivory taffeta and lace. She also wore her Queen Mary tiara.

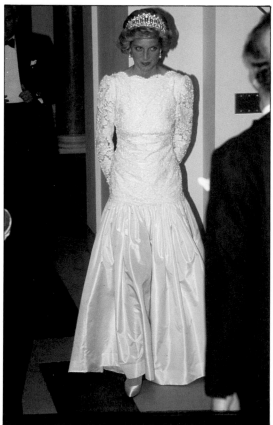

Standing to attention as a mark of respect at the Arlington National Cemetery in Washington, DC in 1985 the Princess peeps up from under her slanted felt hat. The Bruce Oldfield dress was seen earlier in the year.

This stunning one-sleeved, slinky evening gown by Hachi was worn to the dinner at the National Gallery in Washington, DC in 1985. The dress is scattered with gold and silver bugle beads and incorporates an elaborate design on the shoulder and waist.

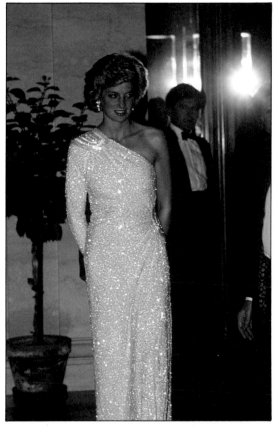

The Princess looks cool in the hot sun in Palm Beach, Florida in November 1985 in a dress designed by a friend. Lady Tryon or Kanga, as she is known in fashion circles, created this uncrushable blue and white summer dress that was worn to a polo match.

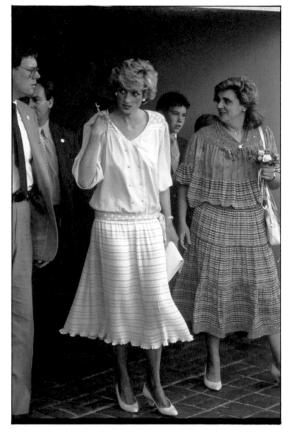

This raspberry crushed-velvet dress by Catherine Walker has only been seen on very few occasions. Here it is worn to a dinner held in Palm Beach in November 1985. The fitted long dress is ruched up the front and has padded shoulders.

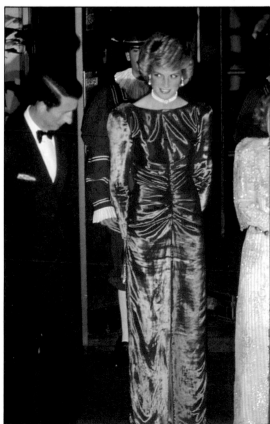

Departing from Palm Beach, Florida in November 1985 the Princess wears a suit by Arabella Pollen. The jacket, in cream and coffee stripes, is made from a combination of silk and cotton. The dress worn under the loose jacket is in a fine silk. Around the Princess's neck is her diamond and gold heart-shaped necklace.

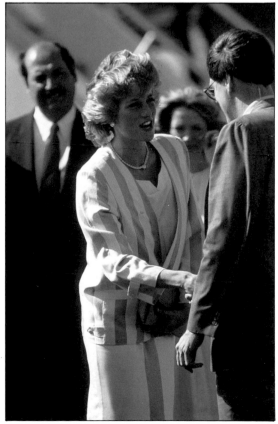

To the 'Gold and Red' charity ball held at London's Albert Hall in November 1985 the Princess wore this bright red silk dress by Bruce Oldfield. The dress has a twisted neckline and ruched detailing up the front. The back has a deep 'V' neckline, the skirt a high front slit.

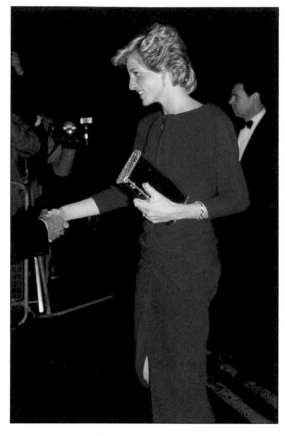

The Princess sitting pretty, in a navy velvet and lace evening gown at a concert in Swansea, Wales in November 1985. The dress, by Catherine Walker, has a deep cut-out neckline in-filled with lace panels. A diamond and sapphire choker is attached to a velvet ribbon.

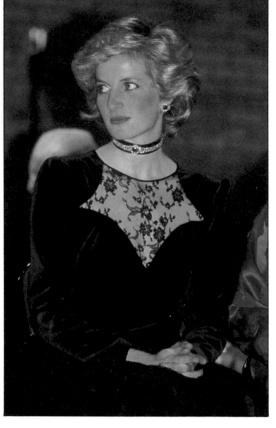

Just before Christmas in 1985 the Princess wore a smart new day dress in a small grey and white check to attend a Red Cross function at London's Guildhall. The dress has padded shoulders and a decorative bow at the neck.

The cream wool suit by Bruce Oldfield, worn to the World Travel Market at Olympia in 1985, had been seen before in the USA. The short jacket has a valanced ruffle at the neckline. A silk pocket square matches the deep red blouse. The hat sports an unusual swept-up brim and a face veil.

1986
Full of Eastern promise

By 1986 life was getting increasingly more frantic for the Prince and Princess of Wales. A number of foreign trips were arranged, plus two private holidays in Switzerland and Majorca.

Women's fashion was in especially volatile mood, and it was evident that the Princess would need to revamp her wardrobe to remain in the forefront of the industry, especially as one of her trips would include the promotion of British trade to Austria.

The year also included family celebrations – the Queen's sixtieth birthday and a family wedding, with Sarah Ferguson due to marry Prince Andrew in July. Weddings, of course, are a good excuse to buy a new outfit.

The Cossack look was strong in 1986 and the Princess wore many suits and coats in this style. She also started to carry a warm muff on many of her winter engagements. In January, the Prince and Princess spent a holiday at Sandringham, the Queen's Norfolk estate. The snowy winter scene was complete as the family trudged back to the house after church, dressed warmly in fur coats, hats and boots. The Princess was wearing one of her mock fur Cossack hats and a red coat that resembled a military great-coat. The shape of hats during the year remained high and off the face, as was seen in the winter styles.

In April, in Vienna, the Cossack look was momentarily forgotten. Arriving by Concorde the royal couple were thrust into the 'British in Vienna' festival. The Princess kept to shapely fitted dresses and a couple of outfits seen during previous years. Pinstripes and sequins featured strongly in the 1986 wardrobe and in Austria the Princess was seen wearing both. A red and navy pinstripe coat dress was worn on the first day of the visit and to attend a gala performance by the London National Theatre; the company had flown to Vienna especially for the festival. The Princess chose a new, slinky green sequinned dress with a long slit up the front of the skirt to wear at the performance.

During the Austrian visit the Princess was plainly delighted to attend a fashion show at the Hofberg Palace. The show was held to promote British designers, a number of whom were already on the Princess's personal list. After the show the Princess chatted with the models and revealed a few secrets: her dress size was a slender size ten and she loved the black clothes that were currently enjoying a revival.

The Princess's words were sadly prophetic for a few weeks later she attended the funeral at St George's Chapel, Windsor, of the Duchess of Windsor.

April was marked by the Queen's sixtieth birthday and many celebrations. One of the most glittering events was the 'Fanfare for Elizabeth' concert held at London's Covent Garden Opera House. The royal ladies arrived bedecked in their splendid evening gowns and diamonds. The Princess of Wales wore a new ruched pink and blue polka dot dress with pink tights and shoes.

There were two state visits to England in 1986, the first by the King and Queen of Spain in April, and later in the year by the President of the Republic of Germany. The Prince and Princess greeted King Juan Carlos and Queen Sophie on the tarmac at Heathrow airport; being close friends they all kissed each other warmly after the customary formal greeting. It was mildly amusing to witness Queen Sophie and Princess Diana exchange kisses of welcome as they were both hampered by respective large-brimmed hats.

In late April the Prince and Princess flew off to begin a tour that would involve travelling nearly 12,000 miles in two weeks to Canada and Japan. The first stop was British Columbia and it was here that we saw the Princess blend new and old outfits. In Japan nearly all the Princess's clothes were new.

During a visit to Expo '86 in Vancouver, the Princess was seen in a new black and white suit, a black bandeau provided an interesting alternative to a hat. This new style of headdress has not been worn again.

In Japan, 'Diana mania' was rampant as the local girls longed to have an English rose complexion and the Princess's blonde hair. The Japanese, being very fashion conscious, were keen to observe her clothes; they commented favourably on her selection, which included many Catherine Walker designs.

The custom of removing shoes when entering a house caused the Princess a little embarrassment when she attended an Ikebana demonstration. The press photographers were positioned directly in front of the Princess and all proceeded to zoom in on her red painted toe nails that were clearly visible under her pale tights.

In Tokyo Princess Diana wore a new suit by Bruce Oldfield with the skirt length hoisted up above her usual styles. Not accustomed to seeing the royal knees, the straight skirt was a dramatic change and the long jacket worn with it only served to emphasize its length. The

short Japanese girls envied the Princess's long elegant legs.

At the banquet held on the final night of the tour the Princess paid her own tribute to Japanese fashion by wearing a new dress designed by the London-based Japanese designer Yuki.

Away from the glamour of banquets, the Princess was back in her casual clothes to watch polo. Various pairs of trousers became popular, including some tailored cream pinstripes and a pair in baggy gingham cotton.

Shortly before the royal couple were to visit the Gulf States, Richard Dalton created a new style for the Princess's hair. It was a very short 'DA' cut. First popular during the rock and roll era, this style took a bit of getting used to but was a practical choice for the hot climate of the Arabian tour.

The Princess had a number of new evening gowns ready for the tour, but shortly before they departed to Oman she attended a dinner at London's Guildhall. The pink and gold dress worn that night was in fact a past model revamped. Gone were the ruffles and gathers of the 1983 style; instead there was a simple round neckline, a dropped waist and leg-of-mutton sleeves.

Wild predictions were made for the Princess's Gulf wardrobe. Would she wear full-length clothes to comply with Islamic custom? Long, baggy culottes and robes were presumed to be packed in her luggage. Oman was the first country stop on the itinerary and the Prince and Princess were guests of His Majesty Sultan Qaboos Bin Said. They received a colourful welcome on the lawns of the newly built luxury palace in Muscat. The Princess respectfully dressed with discretion by wearing a calf-length pleated skirt and long loose jacket, although it was far removed from the swathes of fabric that made up the traditional Omani dress and head covering worn by the minister's wife who was accompanying the Princess.

The contrast of East and West was also very evident on the second day in Oman when the Princess visited the Muscat University. Groups of young female students gathered in one corner to meet the Princess while the male students assembled with the Prince fifty yards away. The tall blonde Princess, with short hair and a very exposed neck, was rather conspicuous amid a group of girls in bright robes and headscarfs.

In Qatar the Princess was given the rare honour of attending a dinner with the Amir and the Prince of Wales. It was Prince Charles's thirty-eighth birthday and usually it would have been a men-only dinner in accordance with the custom. Men and women do not mix socially. The dinner guests proceeded down the long marble corridors of the palace. The Princess, dressed in a stunning, pale blue gown, was conspicuously out of place among the Arab men in their dark robes; she, and her lady-in-waiting, were the only women present.

A brief two days were spent in Bahrain, one of the Arabian countries where the strict Islamic codes have been relaxed a little in favour of a more Western way of life. Here the Princess wore two new gowns by the Emanuels: a navy and white striped dress and coat, and a new ivory beaded evening gown. While visiting the local handicapped school the Princess was presented with a heavily embroidered Bahraini dress. In Japan, in similar circumstances, the Princess tried on her kimono to the delight of her hosts.

Saudi Arabia was the last country to be visited by the royal couple and it is here that the code of dress for women is the strictest. A special religious police force exists to ensure that the dress code is adhered to, although they were not asked to inspect the royal visitors. The local women dress heavily in purdah; no flesh must be seen other than that left above a face veil or mask. It was, therefore, quite a surprise when the Princess arrived in Riyadh in a calf-length, fitted green and white dress. Although the skirt was flowing, it was tightly belted and accentuated feminine curves. The breeze caught the lightweight silk as the Princess stepped down from the aircraft and her bare legs were readily exposed. She was evidently intent on dressing as close to her usual style as was feasible, unlike the Queen who wore very romantic, flowing clothes during her Saudi visit.

King Fahd was a lavish host and it was at his huge new palace in Riyadh that a dinner was held on the first night. The Prince and Princess arrived together, the Princess sweeping along the red carpet in a new full gown in black and white satin. She was not to stay for long in these sumptuous surroundings, however, as the men-only rule was in force.

Prince Sultan bin Salman hosted a desert picnic for the royal couple a short distance from Riyadh. The Princess had kept one fashion surprise up her sleeve until this late stage of the tour. She was wearing a pair of white silk trousers, similar in style to a pair of Indian choodaris, with a long silk tunic. As she sat and ate the lamb and rice course of the desert feast she looked extremely comfortable in the cross-legged position.

Back in London the Princess had to readjust to the British winter. In Canterbury, in December, shortly after her return from the Arabian desert, she was seen warmly wrapped in a very long, swirling blue coat and one of her new suede Cossack hats.

With all the formalities and ceremony of official tours and public functions behind her, the Princess spent the few weeks before Christmas behaving like any other mum – Christmas shopping and attending her sons' school nativity plays. As the Princess strode across the pavement outside Mrs Mynor's nursery school, dressed in a tight-fitting pair of drain-pipe trousers and a bomber jacket, she looked far removed from the glittering Princess in diamonds and silk that, only a few weeks before, had charmed the ruling houses of the Middle East.

A back view of Bruce Oldfield's woollen suit with a tulip-shaped three-quarter-length jacket with a wide cummerbund waistline. The plum and grey patterned jacket is worn over a straight skirt. The hat is in a matching fabric.

This Cossack-style suit by Caroline Charles was worn to Hull in March 1986. The suit consists of a fitted short jacket and a full flowing skirt in a purple wool. The high hat is in dark velvet. Black shiny patent boots and a black muff are also worn.

Caroline Charles designed this warm blue velvet suit which the Princess wore to Cardiff, Wales in March 1986. The two-piece suit has a jacket that fastens at the front with small buttons. A wide belt in matching fabric is worn around the jacket. The Princess carried her black winter muff.

A cheeky pork pie-style hat in velvet matches this beige wool suit which was worn to West Byfleet, in Surrey in March 1986. The short jacket has wide puff sleeves and is worn over a cream ruffled blouse.

Off duty at Aberdeen airport with Prince Harry in March 1985, the Princess keeps to a casual style with a pleated wool skirt, hand-knitted sweater and short bomber jacket. A casual warm scarf keeps out the cold wind.

This red Cossack-style coat seen here in Basingstoke in April 1986 is a popular choice for the Princess. Black covered buttons and a black muff act as an antidote to the red.

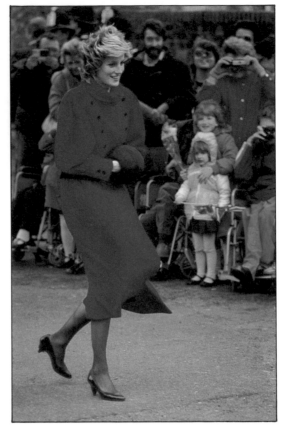

This coat dress has a deep ruffle edging one side of the neckline. The dress, by Catherine Walker, fastens at the front with buttons. It was worn in April 1985 to visit the Vienna Boys Choir.

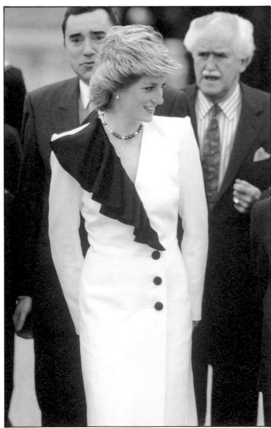

Back to a popular pinstriped coat dress during the short visit to Vienna in 1986. Again the dress is by Catherine Walker but this time in a bright red and navy stripe. A Breton-style hat by Graham Smith at Kangol is worn in matching fabric.

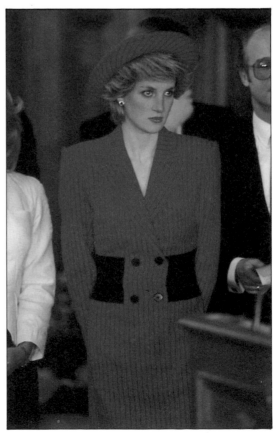

Completely polka dotty in Canada in April 1986 in a royal blue and black suit and blouse by Jan Van Velden. The jacket, in bolder spots, has a stepped collar and is worn over a blouse of finer spotted satin. A small hat by Graham Smith at Kangol is worn with the suit.

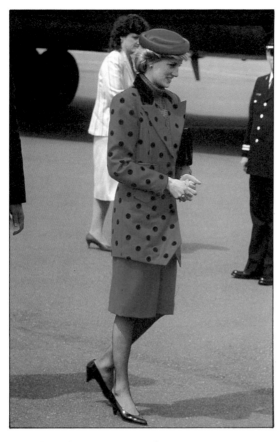

This black and white suit has a wide peplum jacket with a black collar and buttons. The skirt is cut longer at the back and shoulder pads square off the jacket. A twisted headband is worn in preference to a hat to visit Vancouver, Canada in April 1986.

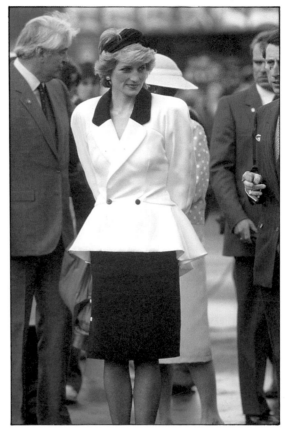

The blue and white fabric of the camisole top seen under this suit has been repeated on the small round hat. The short cardigan jacket is left open. Catherine Walker designed the suit and Graham Smith at Kangol the hat for the tour of Canada in April 1986.

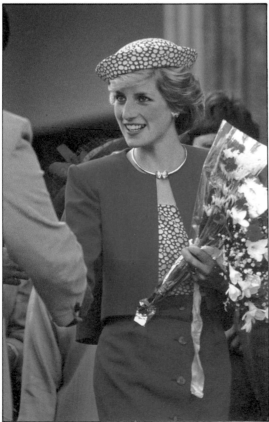

A champagne toast in Kyoto, Japan in May 1986. The Princess in her red and white wrap-over silk dress also wears a large red hat. The dress has wide padded shoulders and high gathered sleeves. It is worn tightly belted and came from Tatters in London.

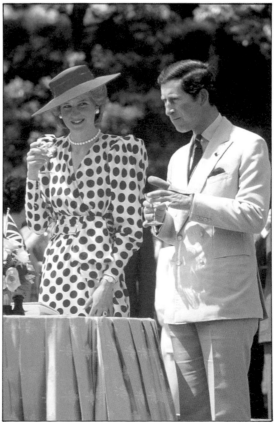

Handbags
The essential accessory

A handbag is a most useful fashion accessory for a royal lady, not so much for carrying essential items but as an object to caress if feeling a little self-conscious when in the public eye. Male members of the Royal Family frequently resort to stuffing hands into pockets but this does not look very smart, nor, indeed, is it possible for royal ladies to follow suit. Clutch bags on these occasions are such marvellous items to break up a formal, rigid pose. The Princess of Wales tends to favour clutch bags more than any of the other members of the family. Her collection of bags in this style ranges from a very simple oblong shape to ornate curved semi-circles decorated with lots of top-stitching.

The Princess has a number of classic bags that will complement any outfit or occasion. These come in navy, white, black and brown. They are usually in a soft leather with a simple magnet clasp, and rarely have any form of buckles or gilt decorations. The Princess also likes patent leather bags that match her classic low-heeled shoes and baggy boots. Occasionally, these shiny bags are toned in with another colour, such as the black patent and red leather clutch bag carried on a visit to Caen in September 1987.

The Princess carries her clutch bags high under her left arm, neatly tucked out of the way while she shakes hands. Some of these bags have the option of a long shoulder strap, but it is only on the more casual occasions that the Princess resorts to this variation. For the more casual engagement the Princess often chooses

Right
One of the Princess's larger bags, occasionally used without a strap, is made from soft navy leather and decorated with a cream rolled piping. The Princess has tucked the straps neatly into the bag to carry it during a visit to Liverpool in August 1987.

Far right
Bruce Oldfield's gold lamé dress and custom-made evening bag. The flap of the bag has tiny pleats to complement the design of the dress. The Princess is seen carrying the bag to a gala dinner in London in March 1985.

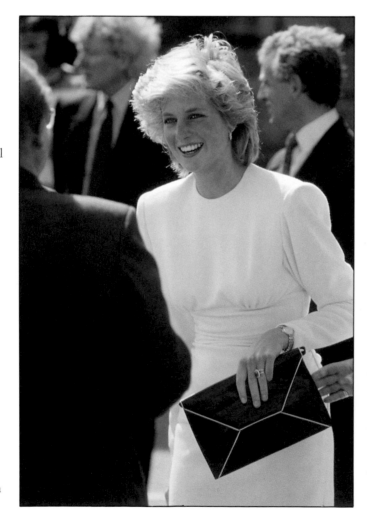

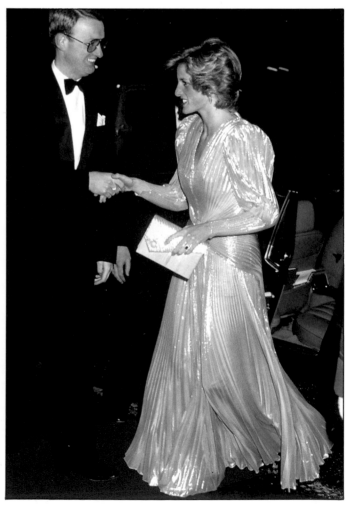

Above
This must be one of the Princess's smallest bags – usually carried when attending an evening reception or cocktail party. The tiny black silk bag just fits into the hand and is ideal for a comb and lipstick.

Left
This bright pink bag is made from a highly polished leather and is carried by the Princess in Adelaide, Australia, in 1988.

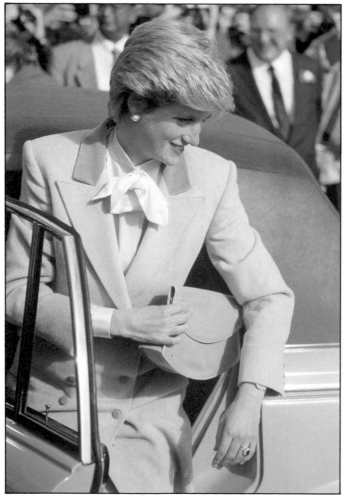

Above
This unusual 'sac' bag is made from woven leather. The Princess carried it at Smith's Lawn, Windsor, while attending the Constantine Cup polo match in June 1985.

Right
This irregular-shaped beige leather bag is often seen with a shoulder strap on informal occasions. Here, however, the Princess tucks it under her arm during a visit to Giggleswick in Yorkshire in September 1986.

Far right
The Princess is seen casually carrying one of her padded bags from Souleiado. The quilted floral bag with a zip fastening was seen on many occasions, including polo matches and on her honeymoon.

a larger bag with long straps, in bright, vibrant colours. At polo matches, for instance, the Princess prefers the practicality of large, roomy 'sac' bags. In the early eighties we saw the Princess with several quilted floral bags from Souleiado. These were draped casually over her shoulders as she walked around the pony lines at the polo clubs.

When travelling on official business the Princess is often seen carrying a briefcase aboard the plane. Usually in rich burgundy leather, it contains notes and information for her busy range of engagements. The Princess's wardrobe also travels in style – the selection of clothes and hats chosen for an official tour is carefully packed and hung in large silver metal trunks that are easily manoeuvred on and off planes and ships.

For evening wear the Princess prefers small compact styles, the size of a large purse. These elegant little bags are often covered in a surplus piece of fabric from a particular evening gown, such as the bag carried by the Princess when wearing her spectacular gold lamé dress by Bruce Oldfield, first worn in 1985. The square bag in the same lamé is carefully covered and includes identical detailed pleating that is followed through in the design of the dress.

For practical use, when travelling on holiday or with the children, the Princess likes her roomy satchel-style bags, some in colourful patterned canvas, edged in soft leather and fastened with a simple buckle. These bags are more elaborate versions of the popular shooting and fishing bags that have become fashionable in recent years.

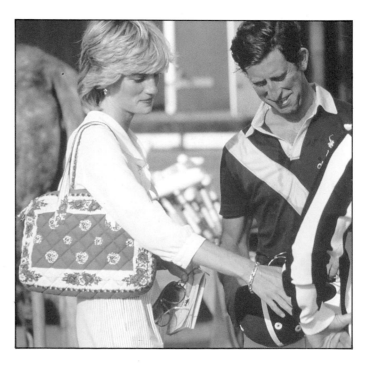

On important official engagements the Princess is very aware of the importance of the 'total look'. It is not enough for her outfit to catch the fashion-conscious eye, all the accessories are carefully chosen to complement her clothes in both colour and style: her taste in handbags is no exception.

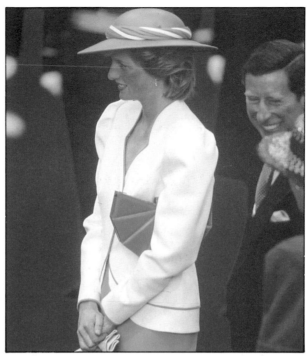

Right
Handbag and suit are perfectly matched for the State Visit of the President of West Germany in August 1986. The design is reminiscent of orange segments with top stitching; the turquoise-blue leather is identical to the colour of the hat and skirt.

Below
A good example of using a bag to keep the hand occupied. The Princess grasps her white leather bag behind her back while listening to a speech in Mildura in October 1985.

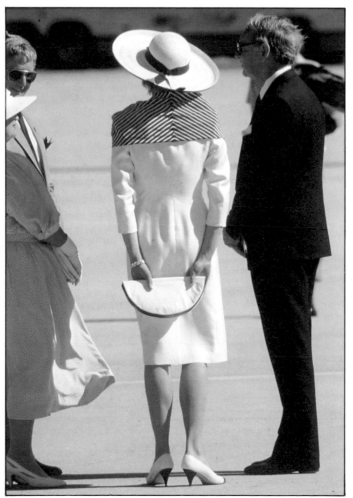

Left
While waiting on the tarmac at Sydney airport in January 1988, the Princess flapped her clutch bag behind her back. This white and navy bag was originally chosen to complement an outfit in Saudi Arabia but came in useful to enhance the nautical look of Catherine Walker's white and navy linen dress.

The Princess sits sporting a rather shy expression during a visit to Tokyo in May 1986. To watch a demonstration of Ikebana the Princess was required to leave her shoes at the door as custom dictates; she reveals red painted toe nails beneath her pale tights.

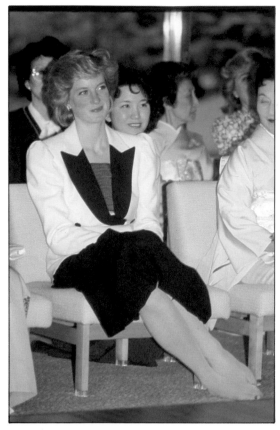

The Princess pays tribute to her Japanese hosts by wearing a new evening dress designed by the Japanese designer Yuki to a banquet in Tokyo in May 1986. The neckline of this deep purple dress is encrusted with bugle beads. A headband of diamonds and sapphires adds an extra touch of glamour.

A new pale satin evening gown by Catherine Walker was worn to the British Embassy dinner in Tokyo. The fitted bodice has a V-shaped waistline from which falls a very full skirt. The sleeves are gathered and stand high off the dress.

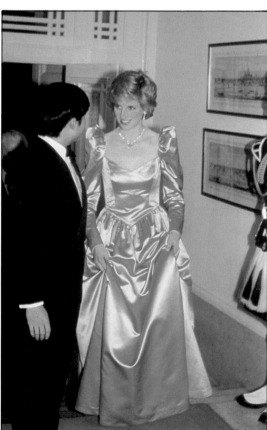

This fun sweater with large circular satin appliqué design was worn to a polo match with smart tailored trousers in a pinstripe cream lightweight wool. A wing-collared blouse is worn under the sweater on this occasion in 1986.

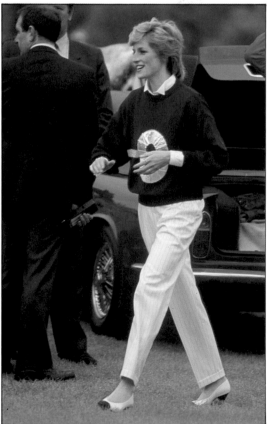

The Princess wore an unusual *diamanté* and beaded necklace when she visited the headquarters of the London Ballet in June 1986. The elegant green dress is very fitted with a ruched waistline and large padded shoulders.

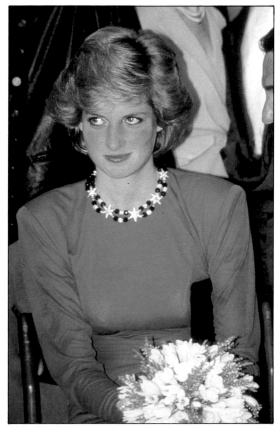

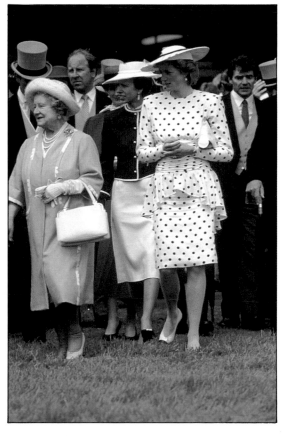

A day at Epsom races in June 1986, and the Princess wears her black and white polka dot dress by Victor Edelstein. The dress has a gathered peplum fanning out from a ruched waistband.

Another Edelstein design for racing – this time an ivory suit seen at Ascot in 1986. The peplum jacket fastens at the front with nine small buttons, the collar is a perky stand-up style. The accessories are all kept to a simple beige. The large hat is by Philip Somerville.

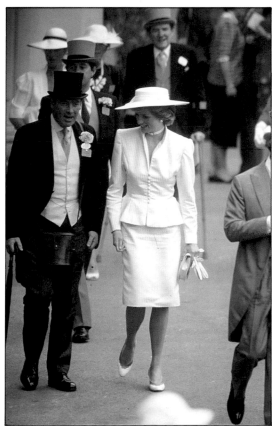

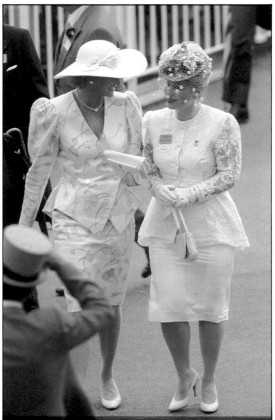

Ivory again for Ascot, but this time it features on a printed floral silk suit by Catherine Walker; the jacket has a pointed hem. The hat is by Philip Somerville.

Visiting Brixton in the summer of 1986 the Princess wears a new lightweight green and white check suit. The short waiter-style jacket has a large white collar and turned back cuffs.

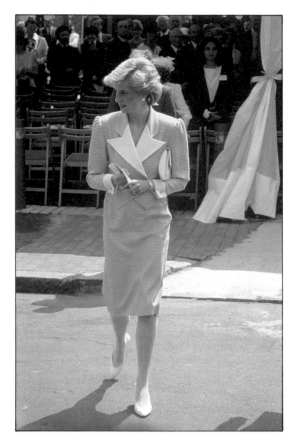

The Princess enjoys an afternoon at polo in July 1986 dressed simply in black and white. The jacket worn belted has an irregular hemline; the knee-length black skirt reveals bare tanned legs and open peep-toe shoes.

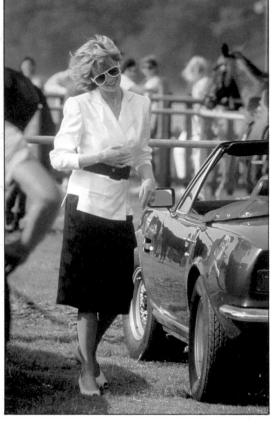

This elaborately embroidered gown is by the Emanuels. The low-cut boned top falls into pointed peplums and the full-length skirt is in fine chiffon. Long gloves enhance the elegant appeal of this gown which was worn to a banquet in London in July 1986.

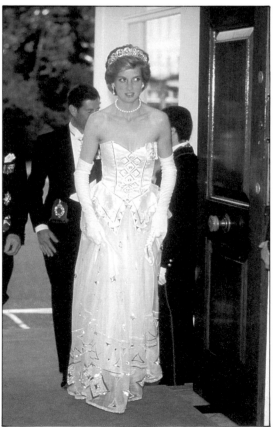

Bruce Oldfield's crushed peach silk suit was first seen in Japan in 1986 but here in July the Princess wears it to Coventry. A high beret hat is edged in the same silk.

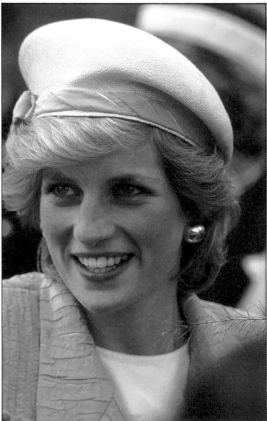

The ivory lace cocktail dress seen here for the only time in public at the Royal Academy of Arts in London in 1986. The satin sash threads through the dress to fall off one hip.

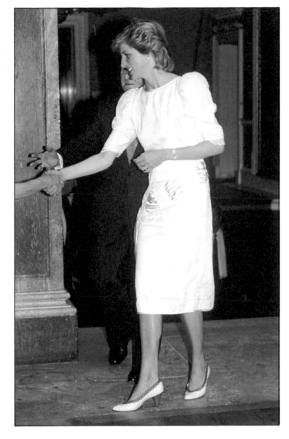

This outfit is reminiscent of the 'Lady Diana' styles of 1981, but here it is July 1986 at a polo match at Smith's Lawn and the Princess wears the pretty pink quilted jacket accompanied by a white blouse and skirt with front kick pleats.

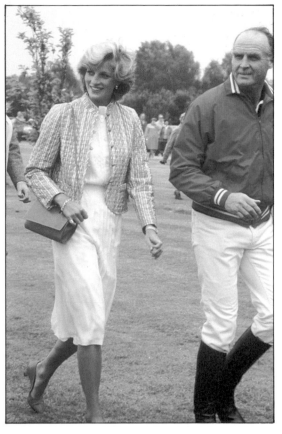

Visiting Sheffield in July 1986 the Princess wears her deep pink three-quarter-length coat which has been seen on many occasions. A spotty silk blouse peeps out from under the coat. A black hunting-style hat with face veil was designed by Viv Knowlands.

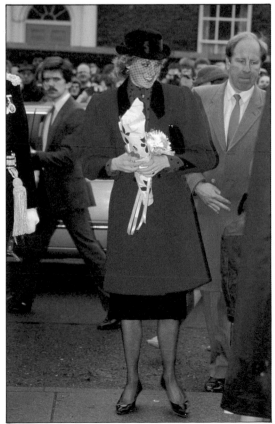

A family occasion in September 1986: the Braemar Games and in true Scottish style everyone dresses appropriately in kilts and tartan. The Princess wears a bright pink wool jacket over an embroidered cotton blouse. The kilt is in a multicoloured tweed. The beret is in matching pink.

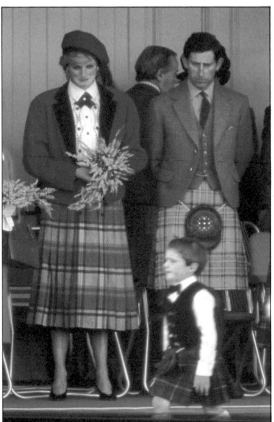

Returning from a holiday in Scotland, the Princess boards the Royal Flight with Prince Harry in September 1986. The Princess wears a casual black pleated skirt, ruffled striped blouse and a patterned cardigan.

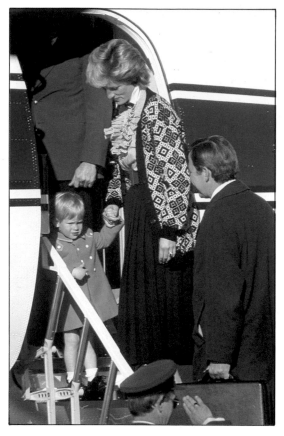

Black velvet and red taffeta combine to dramatic effect in this flamenco-style gown by Murray Arbeid, first seen here at the America's Cup Ball in London in September 1986. The full skirt has a graduated hem and layers of black net underskirts. Long gloves in the two colours are elegant accessories.

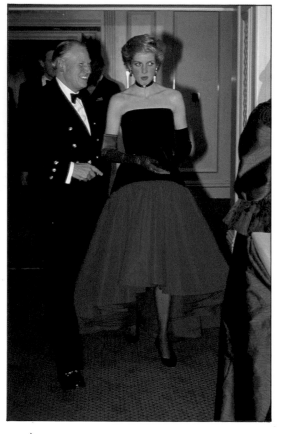

A navy sequinned cocktail jacket is chosen for a trip to the Mermaid Theatre in London in 1986. This useful garment is worn over a satin blouse and a black velvet skirt, all by Jan Van Velden.

Pinstripes again, but this time it's a two-piece suit by Catherine Walker. The royal blue suit has a velvet collar, cuffs and pocket flaps and is worn over a Van Velden white blouse with ribbon tie to visit St Mary's Hospital in November 1986.

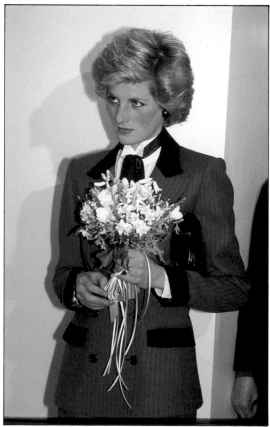

The Princess returned to the Cossack look when she visited Coventry in 1986. The Caroline Charles tweed coat is still being worn five years after we first spotted it. The high hat edged in brown velvet has a large bow at the rear.

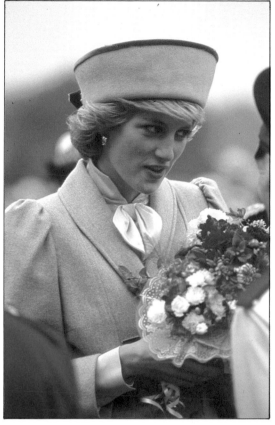

The Princess's new short hair cut seen here in November 1986 during a visit to the Brompton Hospital in London is emphasized by the simple neckline of this coat dress by Catherine Walker. The Princess still favours one of her famous pearl chokers.

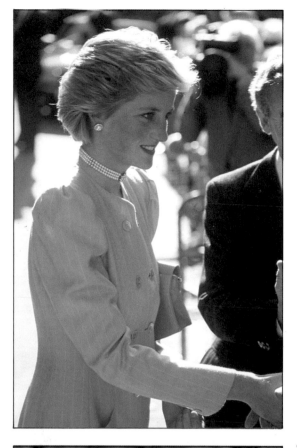

The shapely pink jacket of this suit by Victor Edelstein contrasts well with a black wool skirt with front kick pleats. The Princess wore the suit to visit Littlehampton in November 1986.

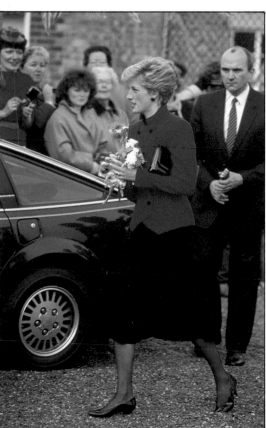

This dress, by Catherine Walker, has undergone dramatic alterations since we last saw it in 1983. It now has a long fitted bodice with a full drop-waisted skirt. The sleeves are now long and high at the shoulders. The 'new-look' dress is seen at London's Guildhall in November 1986.

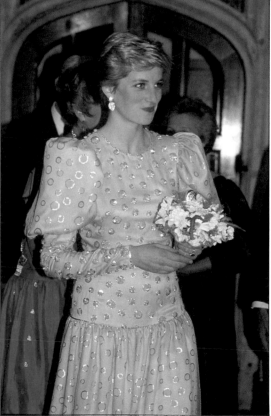

Maternal instincts

After only a short time in her new role as the Princess of Wales it was announced that Her Royal Highness was expecting her first baby.

It is always difficult for first-time mothers to familiarize themselves with what is practical and comfortable to wear during the months of waiting. For most women it can be a difficult time, for one has to come to terms with the changing shape of one's body. For the Princess, forever in the public eye, it must have been extremely hard. The priority must be comfort and the Princess would have been very comfortable in the generously cut dresses and suits that she chose to wear during her two pregnancies.

Many of her favourite designers contributed to the maternity wardrobe with an array of styles. On the day of the announcement of her first pregnancy the Princess was attending a formal luncheon at London's Guildhall. It seemed a little premature, but she appeared wearing a full multicoloured wool coat by Bellville Sassoon. During the following months, however, the styles were not so pronounced. For a visit to Chesterfield she chose a multicoloured printed dress and, to the surprise of many, she wore it belted. However, this dress could not be worn for long and soon we saw the emergence of some very feminine maternity dresses in soft pastels and flowing fabrics. Many of these were made by Catherine Walker of the Chelsea Design Company and Jan Van Velden.

Van Velden also made a number of very smart wool

Right
The day of the pregnancy announcement in November 1981. The Princess in her loose wool coat by Bellville Sassoon. The function was a luncheon held at London's Guildhall.

Far right
Another garment with a Bellville Sassoon label, this time a soft wool coat in an unusual shade of turquoise. Embroidered flowers adorn the yoke and pockets for decoration. The coat has a simple three-button fastening and a high mandarin-style collar.

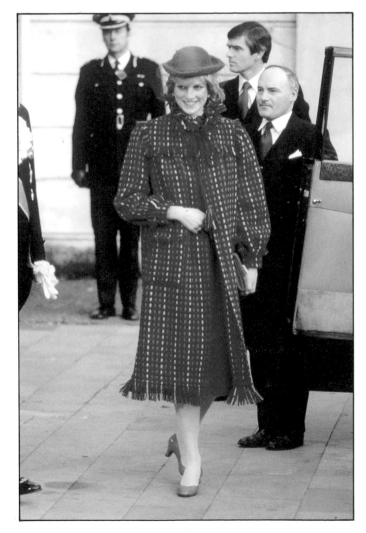

Above
This is one of the pink maternity coats seen at a service at Westminster Abbey in early 1982. The coat by Bellville Sassoon has unusual pom-pom ties.

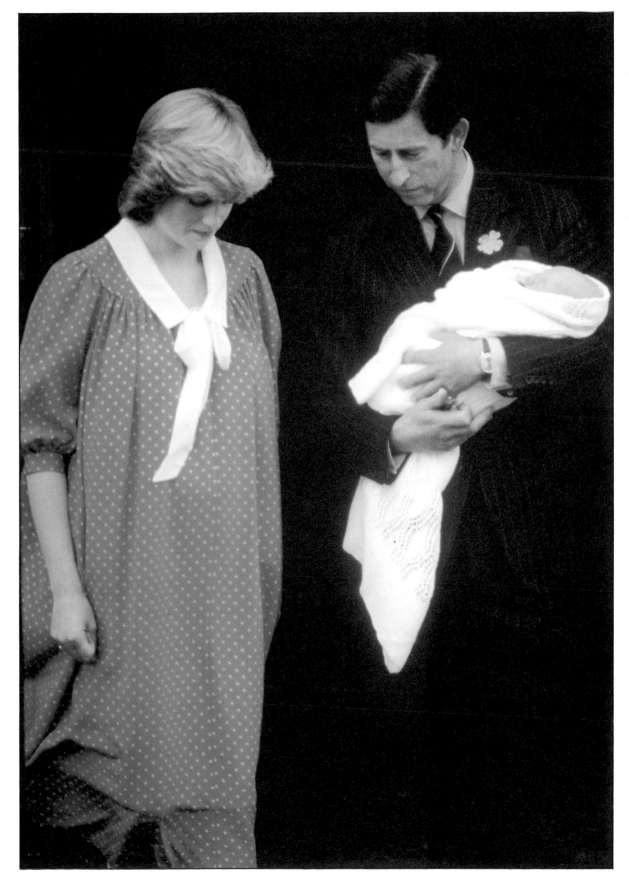

Left
One of the many green maternity dresses. This one has white polka dots and a white collar and tie. The dress, by Catherine Walker, was worn by the Princess as she left St Mary's Hospital after the birth of Prince William in June 1982.

Right
The Princess reveals her pop socks as she steps down from the Royal Flight on her visit to Huddersfield in April 1982. A pink mohair coat by Bellville Sassoon is worn over a navy and white polka dot maternity dress.

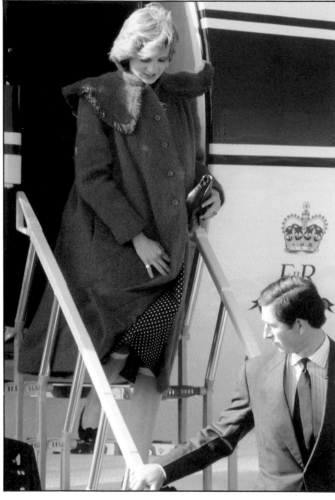

Far right
One of her cool, pretty cotton maternity dresses, this one designed by Catherine Walker, seen during an afternoon of polo at Smith's Lawn, May 1982.

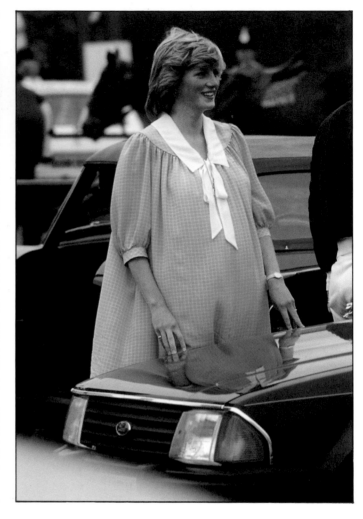

coats that were extremely practical both during and after her pregnancies. The same designer also made suits in coloured silks that were adaptable for post-natal wear.

During a visit to the Scilly Isles in April 1983 the Princess wore what must have become one of her favourite and prettiest maternity dresses – it was a fetching powder blue dress with small white polka dots. The dress had a small ruffle neckline and the length was generously cut; this enhanced her image of a fresh young mother-to-be.

The Princess's maternity wardrobe contained a large selection of coats, all different in style. These included three in varying shades of pink; two of the 'pink phase' coats were an almost identical shade of fuchsia pink. The first to be worn was full length and in wool, it had a square yoke edge with a ruffle and a high neckline tied with pom-poms. The second coat was in a rough mohair, it had a large pointed collar with fringed edging. The third 'pink' coat was in a very pale pastel shade with a high neckline.

Another whim of pregnancy was the Princess's obvious penchant for the colour emerald green. This green drifted into dresses and coats – during a visit to Leeds in the latter part of her first pregnancy the Princess wore a tailored coat

with a mandarin-style collar. The coat, in a deep shade of emerald, had appliqué designs swirling across the top of the bodice. Lilac was also a prominent colour at this time. A coat with a mandarin collar, in a strong shade of lilac, was worn during visits to Glastonbury and Coventry. The colour suited the Princess well, especially when offset with a crisp white blouse or accessory. One memorable outfit was a very flattering dress and matching jacket in lilac crêpe. The Princess wore the ensemble on visits to Odstock Hospital in Salisbury and the King's College Hospital in London.

Feminine, large-collared blouses featured highly in her choice of maternity clothes. Most were in white but there was also a very pretty example in shell pink. The collars usually extended from shoulder to shoulder – a clever trick to take the emphasis away from the growing midriff. The shape of these large collars varied from severe points to gentle curves edged in lace.

An extremely practical accessory that the Princess obviously found comfortable was a pair of 'pop socks'. They would have gone unnoticed had a gust of wind not revealed the elastic tops during her climb down the steps

Far Left
One of the most popular maternity dresses by Catherine Walker in a powder blue polka dot. The dress is very full and long and is worn with sensible black patent pumps during a walkabout in April 1982, in the Scilly Isles.

Left
This was a very feminine maternity gown in an 'empire' style. The dress, by Bellville Sassoon, is in a pale ivory chiffon and is shot through with silver and gold threads. The sleeves are fastened with ten tiny buttons from the elbow to the wrist. The occasion was a dinner at the Royal Academy of Arts in Piccadilly in May 1984.

of the Royal Flight during a visit to Huddersfield. The socks were also revealed as the Princess departed from St Mary's Hospital after the birth of Prince William.

The Princess still had to attend a number of formal evening engagements and as she could no longer wear some of her more fitted evening gowns a few more accommodating dresses were required. Several of these full-length dresses were in a soft white chiffon shot through with silver threads or embroidered with small bugle beads.

At the premiere of *Indiana Jones* in London's West End the Princess appeared in a shimmering pale blue satin gown. This had full padded shoulders, a rolled neckline and a full generous blouson top that tied on to one hip. The designer was Catherine Walker. Many of the clothes worn during the Princess's pregnancy have been adapted for wear after the royal births, either by adding belts or by streamlining seams. These clothes have proved a practical and popular addition to the royal wardrobe.

Far Left
The strong lilac wool crêpe dress and jacket by Jan Van Velden was one of the brightest garments the Princess wore in the summer of 1984. She chose to wear a pretty, square-necked blouse under the suit for a visit to the Odstock Hospital in Salisbury.

Left
This comfortable two-piece suit was often worn over one of her large-collared blouses that featured in the royal wardrobe at this time. Here the pink, white and blue liberty-print suit by Jan Van Velden is chosen for a visit to the Royal College of Surgeons in Glasgow, in May 1984.

The Princess wears a new lavender and white silk jacket and pleated skirt by Jacques Azagury on the first day of her visit to Oman in November 1986. A wide straw hat is worn for the arrival ceremony at the Sultan's Palace in Muscat.

Wearing a hand-painted linen dress, the Princess stands out in a crowd of local students at the Oman University in November 1986. The drop-waisted dress with an over-sized collar is by Paul Costelloe.

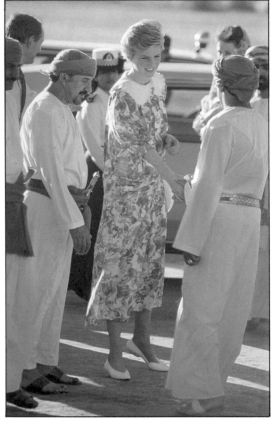

This classically elegant evening gown by the Emanuels was worn to a dinner in Oman in November 1986. The gown, in a luxurious ivory satin, has a lace bodice scattered with sequins. The wrap-over skirt ties on to one hip.

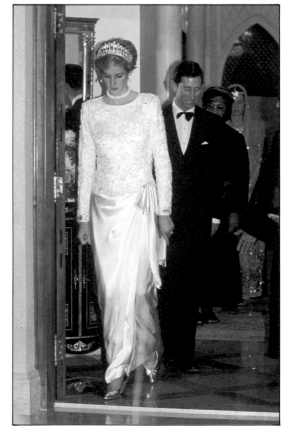

Visiting the British school in Doha, Qatar in November 1986 the Princess dresses brightly in an emerald green silk dress by Catherine Walker with a long white rolled collar that ties on to one hip. She carries a large white clutch bag.

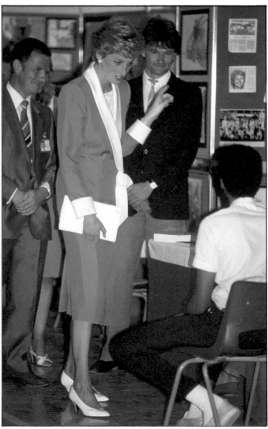

In Bahrain in November 1986 the Princess wears a new suit by the Emanuels in navy and white silk. The long flowing top coat is worn over a camisole top and a pleated skirt.

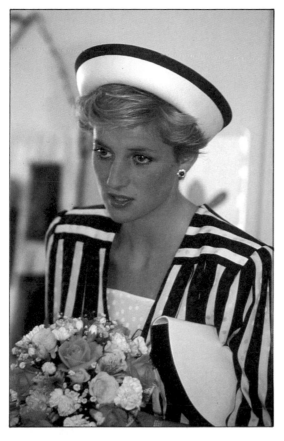

A neckline with a difference on this dress by the Emanuels worn in Bahrain in 1986. The dress has a bodice that sweeps up to a fan on one shoulder. Small clusters of bugle beads are sewn on to the top of the dress for that extra sparkle.

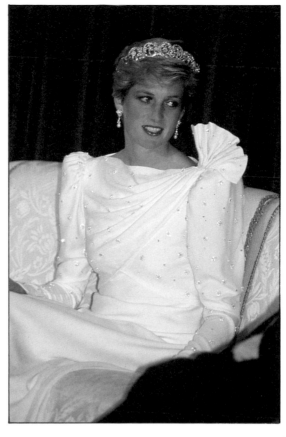

Arriving in Saudi Arabia in November 1986 the Princess decided not to wear a flowing gown as predicted but instead is seen in a new tightly belted green and white silk dress by Catherine Walker. The neckline with a white collar has an inset to prevent embarrassing glimpses of the royal cleavage.

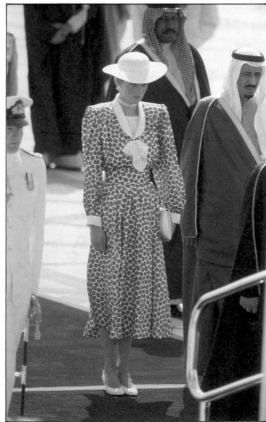

This blue and white tunic with white pantaloons by Catherine Walker was worn to the desert picnic in Saudi Arabia; the Princess later had to sit cross-legged. She also wears diamond drop earrings in the shape of half moons.

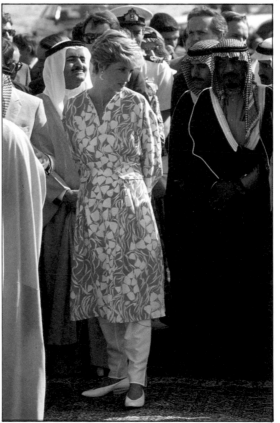

Catherine Walker designed this two-piece silk suit in red and white. The tunic top has a hip decorative bow. The pleated skirt falls just below the knee to reveal bare legs and two-tone shoes.

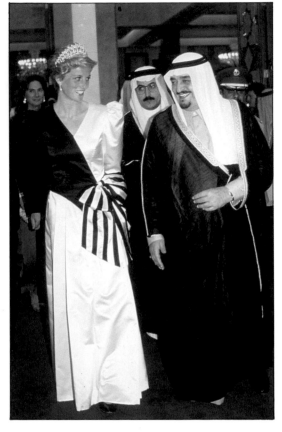

The Princess with King Fahd in Riyadh in November 1986; she is wearing a long black and white duchess satin gown by David and Elizabeth Emanuel. The dress ties on to the hip with a large striped bow.

On the final day of the 1986 Gulf tour the Princess visited Jeddah. For the occasion she wore a new Anouska Hempel dress in a rich blue. The bodice has a white satin over-bib that is cut diagonally across the dress.

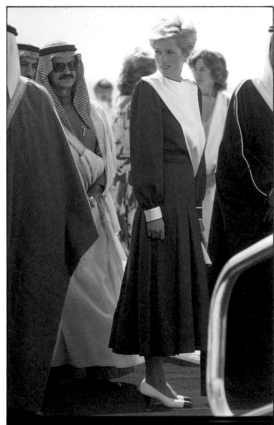

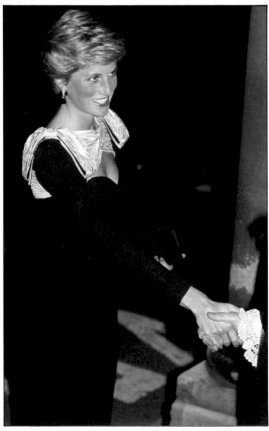

Back in London after the Gulf tour the Princess can afford to be a little more daring and wears a fitted black dress with a stylish cut-out neckline. The dress, by the Emanuels, has a satin collar that ties on to the shoulders. It was a particularly stunning choice for a dinner at the Mansion House in December 1986.

This Cossack hat has been covered in a soft bright blue suede that matches the Edelstein coat worn to visit Canterbury in December 1986. The Princess also wears new ear-rings in gold with blue stripes.

After taking the children to school in December 1986 the Princess is photographed casually dressed in a pair of tight drain pipe trousers tucked into high over-the-knee boots. A dark navy bomber jacket is worn to keep out the English winter chill.

This fitted dress by Catherine Walker, completely covered in dark green sequins, made an appearance during the Princess's visit to Vienna in 1986. It is worn with the Prince of Wales Feathers necklace and dangling ear-rings.

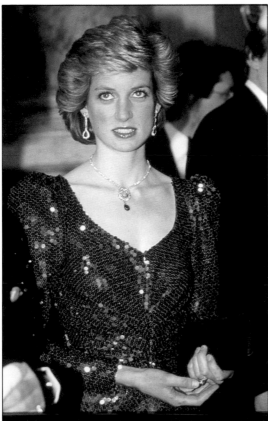

In Covent Garden, London in December 1986 the Princess wore this white jacket with a high mandarin collar tightly belted over a short black skirt. Note the black fish-net tights!

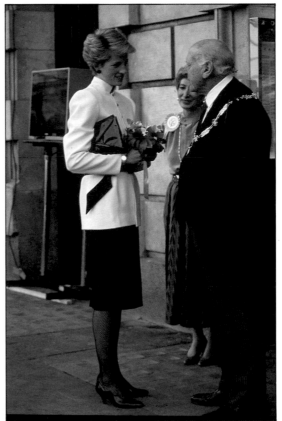

Beating the retreat ... of the hemline

By 1987 the Princess was wearing clothes that, on the whole, relied upon simple tailored cuts for effect. Most of her skirts were getting progressively shorter but still remained just within the boundaries of royal protocol. Occasionally the trend for exposing more leg above the knee was totally disregarded and the Princess would choose to wear a calf-length pleated skirt of which she has a number in varying colours. A few interestingly shaped hems appeared in suits by Catherine Walker and Arabella Pollen.

Evening wear was extremely glamorous, with the vast majority of her dresses revealing bare shoulders. The skinny shoulders that caused concern back in 1982 were long gone, and the Princess was currently looking very fit

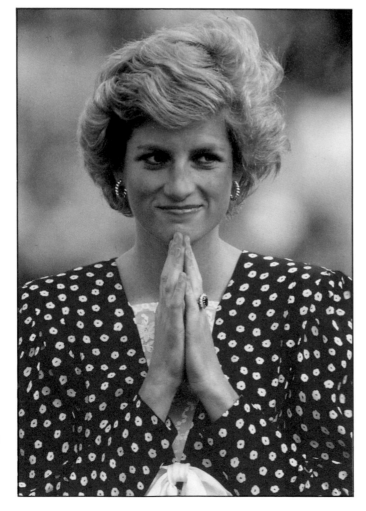

This very feminine red and white dress has been worn on numerous occasions, ranging from formal dinners to polo matches. The light-weight silk dress has a deep 'V' neckline that is infilled with a panel of delicate lace.

and robust, probably due to her health and exercise regime and her new-found love of tennis.

In September, during a visit to Caen, France, it was commented that the Princess looked a little plump. Plump could hardly be the correct word to describe the Princess as she arrived in a stunningly elegant red and black suit. The style of the hat may have drawn attention to any extra pounds. The Princess had swept all her hair under a bavolet-style scarf. We had not seen the Princess to date without her hair visible and it gave her face a totally different shape.

During 1987 the Princess wore many smart day suits. The jackets were often double-breasted and many were decorated with a double row of brass buttons. Two particularly interesting suits worn for the first time this year incorporated a lot of decorative braiding.

The first suit seen in this style was a turquoise, moiré taffeta cocktail suit worn to a fashion show in Madrid during the Prince and Princess's four-day tour to Spain. The suit was made by the Turkish-born designer, Rifat Ozbek, who is based in London. The Princess recognized the talent of this young designer long before he shot to fame in 1988 when he became British Designer of the Year. Elaborate gold appliqué patterns adorned the lapels and sleeves.

Another suit that was definitely out of the ordinary was made by Catherine Walker. It was in a cream, lightweight wool in a distinctive drum majorette style. The short jacket had heavy gold braiding across the front and gold epaulettes on the shoulders. The fitted skirt's hemline curved into a short 'V' at the front to reveal the knees. The suit was worn with a high pillbox hat. This unusual combination was first seen at Gatwick Airport when the Princess joined her husband to greet King Fahd of Saudi Arabia at the start of his state visit to Britain.

A few weeks later the Princess caused critical comment when she wore the same suit to the passing out parade at the Sandhurst Royal Military Academy. Her detractors thought that it was overtly gimmicky to wear a military-style suit to such an event. Everyone agreed, however, that as the Princess inspected the cadets on the parade ground she looked splendid.

The Prince and Princess visited Portugal in February and it was here that we saw another unconventional outfit make a first appearance. During most of the Portuguese visit the Princess stuck to her familiar suits and dresses, but

on the final day, in Oporto, she surprised everyone by appearing in a short 'puff-ball' skirt.

These rather odd looking garments were all the rage at this time. But it was a short-lived trend, probably due to the fact that they only suited girls with model-like figures and long slender legs. The Princess fitted into this category and purchased two puff-balls both with a similar navy and white theme. They were worn with a tailored, double-breasted blazer, and all the garments were made by Catherine Walker. The second puff-ball made its appearance in the South of France when the Prince and Princess made a very brief visit to the Cannes Film Festival.

Hats were still popular with the Princess. They differed in styles from a beret, to a turban, to wide elegant styles which were extremely popular this year.

Blouses were kept to unfussy lines, mostly in plain coloured silk with a round neckline, although once or twice during the year variations of the old favoured ruffle theme appeared, one such example being a black and white striped blouse with a ruffle down the front.

A few designers that had not received royal patronage for a while reappeared; the very dainty white lace dress by Zandra Rhodes was worn by the Princess to the London Palladium. This same dress was seen a year later being worn by Lady Sarah Armstrong-Jones during her visit to China. The Princess of Wales has always been happy to pass on clothes to her family and friends. Lady Sarah has been seen in a number of the Princess's garments, as was the Duchess of York before her marriage.

One of the new designers on the Princess's list was Alistair Blair. Mr Blair had been brought to our attention previously by the Duchess of York, for whom he designed a number of outfits, including the navy suit worn on her engagement day. The Princess of Wales wore a very smart black and white check wool jacket by Blair during her five-day visit to Germany in November.

The German visit unveiled a number of exciting new garments. On the first day in Berlin the Princess employed a now familiar ruse of paying tribute to the host country. In this instance the Princess wore a new primrose yellow and black wool coat by the German design house Escada. The coat was worn with a turban-style hat by Philip Somerville.

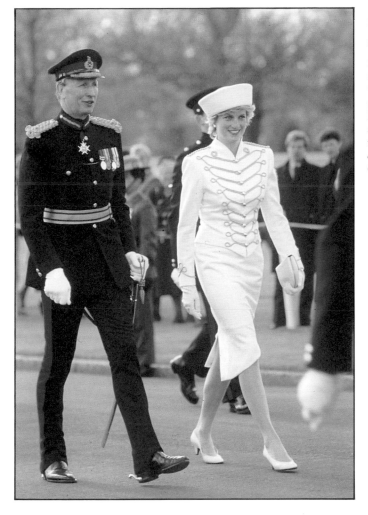

On parade at the Sandhurst Military Academy in April 1987. The Princess wears a rather unusual two piece suit in cream wool by Catherine Walker. It has a short fitted jacket with heavy gold braiding across the front and on the shoulders. The high crowned straw hat is by Graham Smith at Kangol.

Catherine Walker designed most of the clothes worn on this German visit, including the luxurious deep purple taffeta and velvet gown with a flamenco-style skirt which was worn to the Munich Opera House. In Hamburg the Princess was wrapped up against the cold autumn weather in a new loose beige coat by Arabella Pollen. The collar and cuffs were in a dark brown mock fur, as was the beret-style hat. Mock fur was steadily becoming popular with the Princess; various interpretations would become evident during 1988.

The Princess leaves Wetherby school in London in January 1987 in a casual red woollen skirt and sweater. The collar and cuffs of the navy woollen jacket by Mondi are in a colourful elastic shirring. The skirt and sweater are by Jasper Conran.

Portugal, February 1987 and the Princess looks very slender in this fitted two-piece suit by Victor Edelstein. The dark green woollen jacket has pointed stepped lapels and a velvet collar. The skirt illustrates the new shorter length of that season.

The Princess covers her Victor Edelstein lace dress with a black crushed velvet cape when she arrived at London's Festival Hall in 1987. A long strand of costume pearls are wound around her neck and hang in a knot.

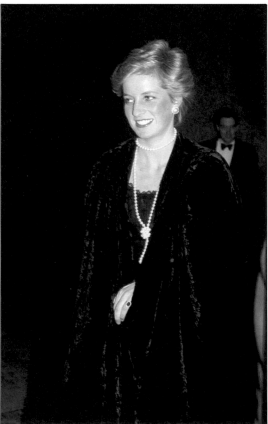

This three-quarter-length coat is worn over a matching pleated skirt in Lisbon, Portugal in February 1987. The suit, by Catherine Walker, is worn with an air hostess-style hat decorated with a large bow.

This pale blue lace gown by Catherine Walker, chosen for a banquet in Portugal in 1986, contrasts dramatically with the deep red ceremonial cloaks worn by her fellow Portugese guests.

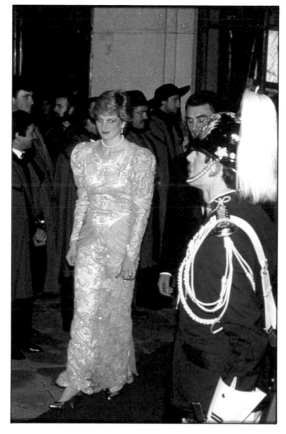

At a lavish banquet held in Lisbon, Portugal the Princess wore her off-the-shoulder crushed velvet gown by Bruce Oldfield. The Spencer family tiara and dropped ear-rings are stunning accessories even without an elaborate necklace.

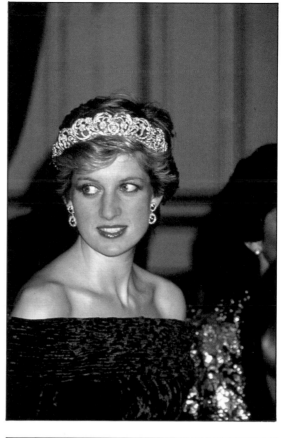

Sheltering from the rain in Portugal the Princess wears a camel-coloured wool coat dress by Catherine Walker. Black accessories match the wide patent belt. The blouse in a patterned satin has a high cowl neckline.

Arriving at London's Hippodrome night club in March 1987 to attend a charity event, the Princess looks terrific in a black tuxedo with a bright pink silk bow tie and cummerbund. She wears *diamanté* clips on her satin shoes. The suit is by Catherine Walker.

The coat dress seen previously in Portugal is worn here a month later in Wokingham but this time without the belt. The same blouse has been selected plus baggy black suede boots.

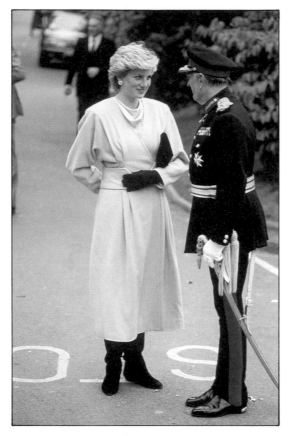

This white 'majorette' suit by Catherine Walker drew critical comment when the Princess elected to wear it to Sandhurst Military Academy in April 1987. The hat is by Graham Smith at Kangol.

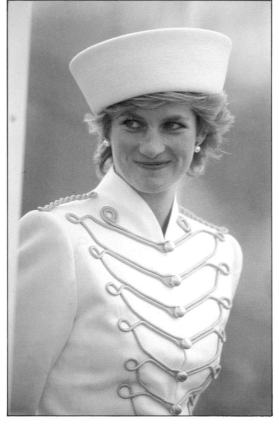

In Madrid in April 1987 the Princess wore the emerald green dress by Catherine Walker which was first seen on the Gulf tour, but this time it is worn without a camisole top. A matching hat by Philip Somerville with a large brim finished off the outfit with characteristic elegance.

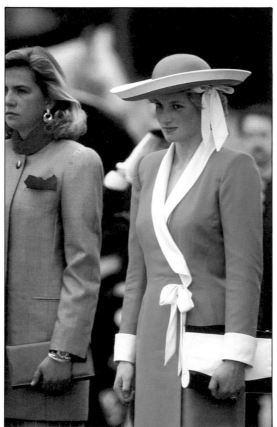

At a banquet held by King Juan Carlos in Madrid in April 1987 the Princess wears a royal blue gown with bright pink polka dots. The dress by Bruce Oldfield has a deep 'V' neck and is ruched at the front.

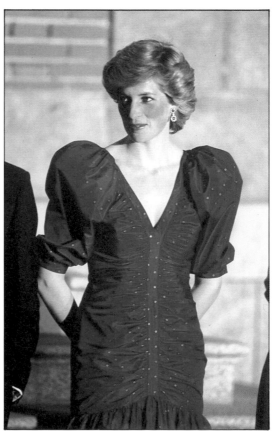

Looking dazzling in a turquoise blue moiré taffeta peplum suit by Rifat Ozbek in Spain in April 1987, the Princess upstaged many of the models at the fashion show. The suit has ornate gold appliqué designs on the jacket.

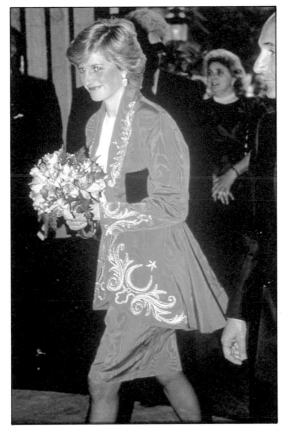

A gallant student drapes a traditional cloak around the Princess in a gesture of welcome when she arrived at Salamanca, Spain in 1987. A bright red and white suit is worn under the cloak with matching two-tone shoes.

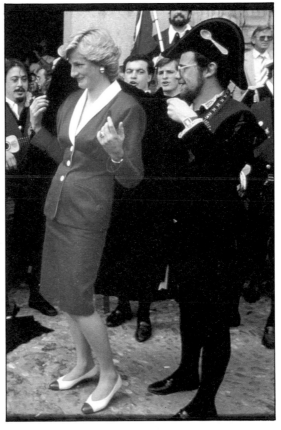

The return of the pinstripes, but this time bolder in grey and white. The double-breasted suit by Catherine Walker is collarless and worn over a plain silk blouse during a visit to Toledo in Spain.

This figure-hugging pink dress is gathered quite tightly across the hips. The dress, by Victor Edelstein, has a button fastening on the shoulders; it was chosen for the Lionel Ritchie concert in London in April 1987.

One of the two puff-ball dresses worn by the Princess; they are by Catherine Walker and both in navy and white stripes. This dress seen in 1987 is in a dominant navy and worn under a double-breasted jacket.

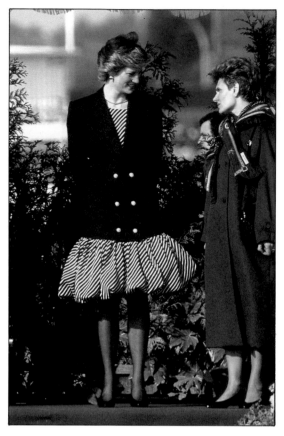

This casual lemon cotton suit by Bruce Oldfield was worn to a polo match at Smith's Lawn in May 1987. The blouse, by Jasper Conran, is in a turquoise and mauve spotted silk.

This pretty pink and white suit has been a popular choice on numerous public occasions. Seen here at the Epsom Derby in June 1987, the floral patterned blouse cuts a dash with its decorative hanging sash. The especially wide hat is enhanced by a decorative bow.

This delicate lace dress by Zandra Rhodes was worn to the London Palladium in June 1987. The hand-beaded dress has also been spotted adorning Lady Sarah Armstrong-Jones, daughter of Princess Margaret.

This particularly bold floral printed suit was spotted at the Ascot races in June 1987. The jacket, in bright lemon, fastens to a bow at the front. Note the unusual draped sleeves. The skirt is well above the knee. A very wide flat-brimmed hat complements the blue flowers in the fabric.

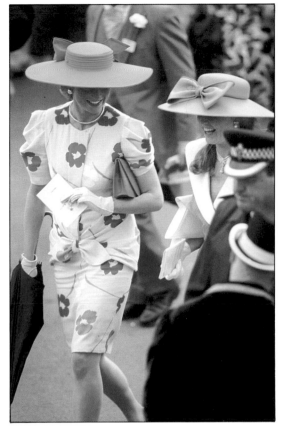

Arriving in London's Leicester Square to attend a 'Bond' premiere in June 1987 the Princess looked extremely glamorous in her low-cut gown by the Emanuels. Evening gloves are not worn on this occasion and jewellery is kept to a minimum.

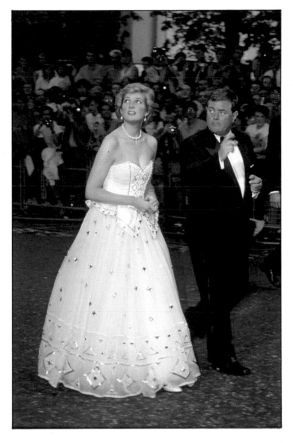

This double-breasted summer coat in a lightweight pastel-blue wool is identical to coats made for Prince William and Prince Harry by Catherine Walker. The coat has pearlized buttons and is seen here in Huddersfield in 1987.

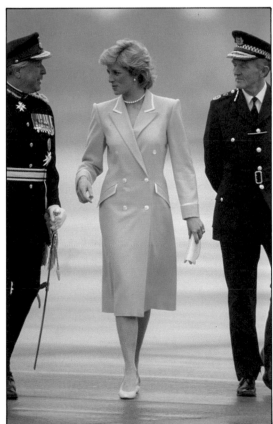

A sunny afternoon at polo in July 1987, and the Princess wears her beige pleated skirt with a cream tie-neck blouse. The wide black belt has an exaggerated buckle.

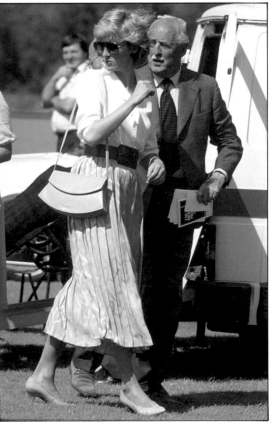

Jewellery
Priceless ... or just for fun

The Princess of Wales has the enviable option of being able to wear exquisite priceless gems or fun paste costume jewellery. With access to the Queen's jewellery vaults at Buckingham Palace, the Princess has plenty of opportunity to display a dazzling array of jewels at her many public appointments. The Princess, however, is very discreet and does not make a habit of borrowing from the Queen.

The trademark of the young Lady Diana Spencer was the three-strand pearl choker worn so frequently during the 1981/82 period. The choker was from the Spencer family collection that also contained the dainty diamond tiara that was worn on her wedding day, and so often since then.

Chokers have remained a favourite item of jewellery and the Princess has experimented with great effect to create an impact far beyond that achieved by those simple pearl adornments. At a ball in Melbourne, in 1985, the Princess appeared in a glittering headband. It would have drawn interesting comment from one of its previous owners, Queen Mary. The emerald and diamond choker was attached to a ribbon to create the memorable 'headband'. The Queen had inherited the choker from her grandmother, Queen Mary, and had given it as a personal gift to the Princess shortly after her marriage. The choker had been seen on two occasions previously, but both times was worn in the more conventional style.

A headband of similar design was seen a year later at a

Right
At the America's Cup Ball in London in 1986 the Princess wore this black-ribboned choker with a small brooch pinned to the front. The drop ear-rings are from her paste collection and are cut in coloured crystal.

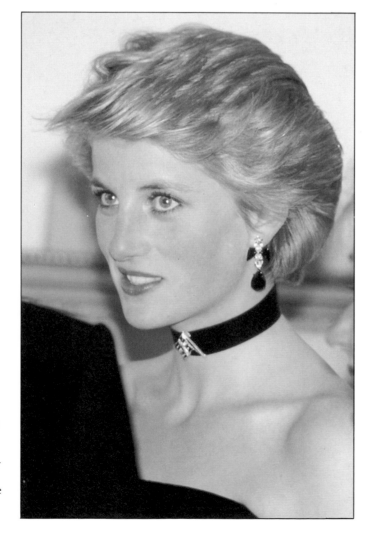

Far right
This is one of many pairs of heart-shaped ear-rings in the Princess's collection. This particular pair, with a small central heart surrounded by paste diamonds, was worn in Spain in 1987.

Above
These drop diamond ear-rings in the shape of a star and half moon were reported to be one of many gifts presented to the Princess during her visit to the Gulf States in 1986. The Princess wore this particular pair at the desert picnic in Saudi Arabia.

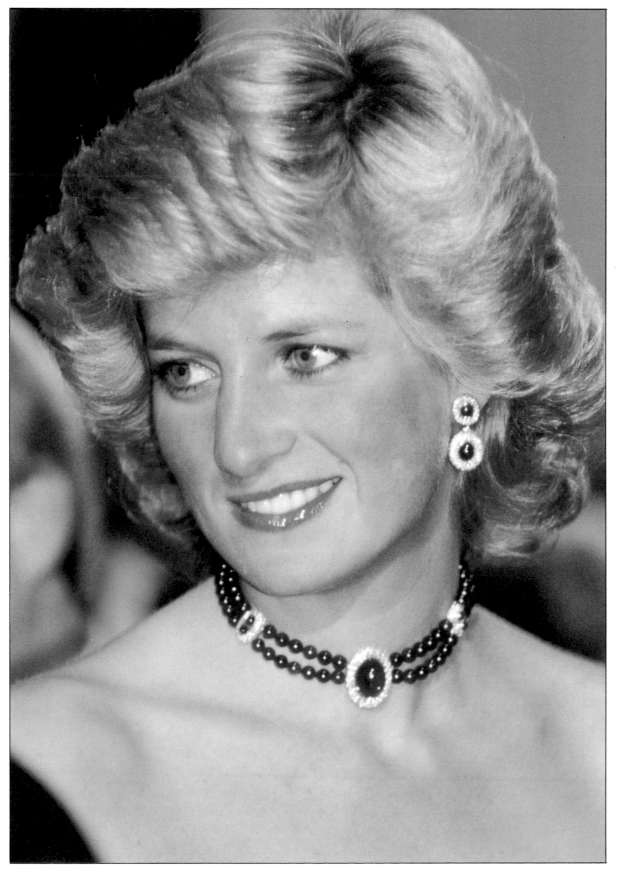

Left
These diamond and amethyst ear-rings beautifully complement the two-strand choker worn to the opera in Munich in 1987.

Right
An unusually styled pair of large 'star' ear-rings in *diamanté* and pearl worn with one of the Princess's simple pearl necklaces to a reception in Adelaide, Australia in 1988.

Far right
Costume jewellery at its best. This gold and *diamanté* necklet and matching half-hoop ear-rings is the perfect choice to complement a dress with a plain neckline. This striking pink creation was chosen for the Lionel Ritchie concert in 1987.

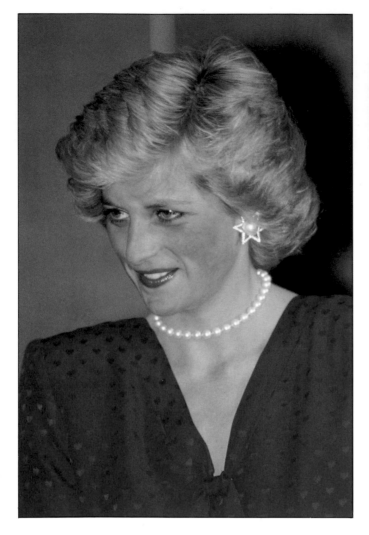

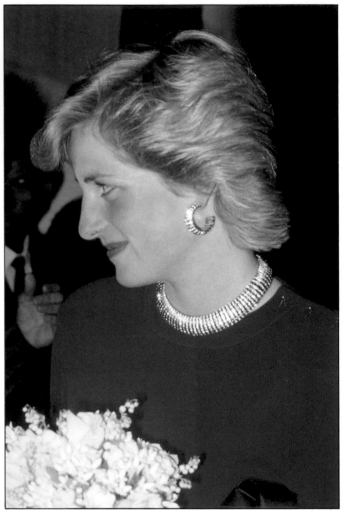

banquet held by the late Emperor Hirohito in Japan. It was made from diamonds and sapphires that were originally part of a watch – one item from the magnificent jewels given to the Princess by the Saudi Royal Family as a wedding gift.

For formal or state occasions a headband would not be appropriate; this is when the Princess's two personal tiaras, the Spencer tiara or the more decorative 'Queen Mary' tiara, come into their own. The latter was another wedding gift, this time from the Queen. This tiara is in the shape of lovers' knots in which hang nineteen drop pearls.

For less ceremonial occasions, such as a film premiere, a dinner or a night at the opera, the Princess can choose from her collection of real diamonds and pearls. Alternatively, she can adopt the informal approach and experiment with fake paste jewels. Among the real collection is a diamond necklace with a pendant in the design of the Prince of Wales Feathers, a diamond and sapphire necklet and a multi-stranded pearl choker. In the Princess's paste jewel box favourite items are a long rope of fake pearls and jet and glass ear-rings.

In addition to jewels given as gifts or those which were inherited, the Princess wears valuable items mostly from the small group of royal warrant holders to the Prince of Wales. They are Asprey's of Bond Street; Garrard, the Crown jewellers; Collingswoods or the West End-based Wartski. The Prince has purchased many items for his wife as personal gifts from these suppliers. The huge sapphire and diamond engagement ring costing £28,500 was among the items to be seen in Garrard's brochure in 1981.

The Prince has marked important occasions in his marriage with gifts such as the antique emerald and diamond bracelet bought as a wedding gift, a gold and pearl heart-shaped necklet that marked the birth of Prince William and the gold charm bracelet to which he adds a new charm regularly.

It was reported that the Prince wanted to buy his wife the diamond Prince of Wales Feathers brooch that belonged to the late Duchess of Windsor. It was a gift from the Duke and was among the items for auction in Switzerland in 1987. On the day, Elizabeth Taylor successfully bid for the stunning piece of jewellery.

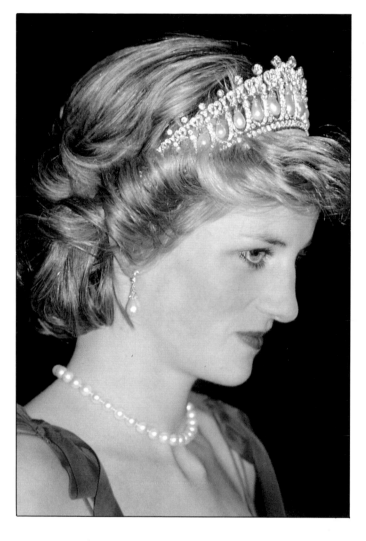

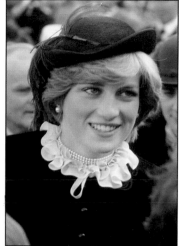

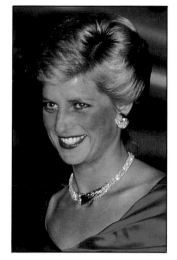

Left centre
The original 'Lady Diana' three-strand pearl choker seen here in Wales in 1981. The ear-rings, a single pearl and diamond clasp, are deliberately understated.

Left
This extravagant set of matching necklace and ear-rings in diamonds and jet was a gift from the Sultan of Oman in 1986 during the Gulf tour. The set, which also includes a matching bracelet, is seen here at a fashion show in Sydney 1988.

Left
This is the 'Queen Mary' diamond tiara given by the present Queen to the Princess of Wales in 1981. It is seen on many formal occasions and here the Princess is wearing it, accompanied by single drop diamond and pearl ear-rings and necklace, to La Scala opera house in Milan in 1985.

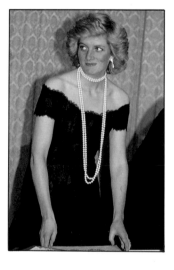

Left
These two strands of long 'fun' pearls have been seen on a number of occasions and have been worn in a variety of ways. For this reception in Hamburg in 1987 the Princess preferred to wind the pearls lightly around her neck, to hang loose to her waist.

During their 1986 tour of the Gulf, the Princess of Wales was reported to have received a stunning necklace, ear-rings and a bracelet of diamonds and jet from the Sultan of Oman. This was not confirmed at the time and it was not until November 1987, that the Princess wore this splendid set at a dinner held in Bonn, West Germany. This was not the first time that the Princess had received diamonds and gems from the generous Arabian royal families and heads of state. The Saudi Royal Family presented two suites of jewels to the Princess as a wedding gift. One of the sets includes many of the sapphire and diamond pieces we see so often being worn in the form of necklaces, ear-rings and bracelets.

The Princess's taste for jewellery is not limited to priceless diamonds and sapphires. She obviously gets great pleasure out of wearing daring items of costume jewellery. Butler and Wilson of London's Fulham Road and South Molton Street is a favourite source of paste items of jewellery. The shop has a wide range of ear-rings, brooches and necklaces in mock gold, *diamanté* and crystal. The Princess has been wearing their 'bow and heart' ear-rings for some years and has a number of pairs in gold and some in coloured glass. Another Butler and Wilson piece is the *diamanté* and jet snake brooch which has been seen pinned on the lapel of the Princess's evening tuxedo.

No one expects a royal princess to wear fake jewellery – it would have been unheard of in Queen Mary's day. The Princess of Wales, however, enjoys wearing a wide range of modern costume designs and although fake gems will not fill a casket of family heirlooms for future royal princesses, the collection of paste jewels befits the young, vibrant personality of Princess Diana.

The Queen's personal and state collection of jewels contains numerous pieces that have never been worn in public and include many heirlooms passed down through the Royal Family, particularly from the Queens Alexandra, Victoria and Mary. Many of these priceless pieces will be worn by the Princess of Wales when she becomes Queen of England. It will be interesting to see if she defies tradition and continues to wear the costume jewellery of which she is obviously so fond.

The Princess looks fresh and suitably seasonal in this red and white silk dress worn to a cricket match in Cardiff, Wales in July 1987. The dress has an insert of lace in the neckline.

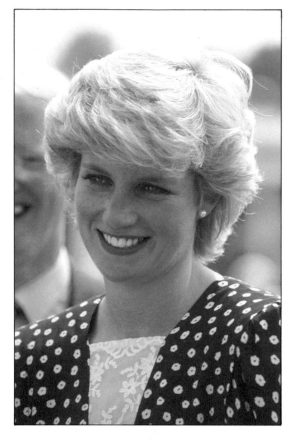

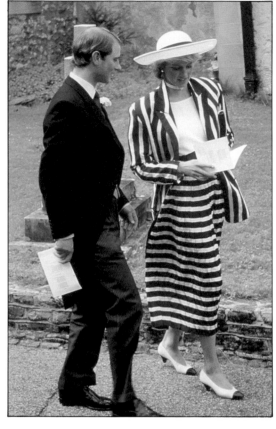

As a guest at a friend's wedding the Princess wears a new navy and white silk suit by Roland Klein. In the jacket the bold stripes run vertically, but the same stripes go horizontally in the pleated skirt. The hat is by Philip Somerville.

At the film premiere of *Superman* in London in July 1987 the Princess showed off her impressive suntan against a pastel-blue strapless gown by Catherine Walker. The dress, which was first seen in Cannes earlier in the year, is in fine silk chiffon, a separate trailing scarf hangs from the Princess's neck.

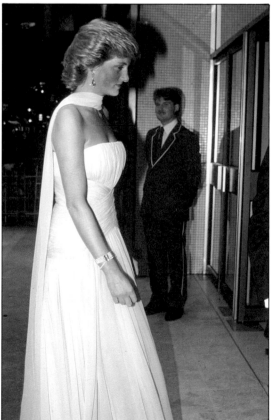

On the Queen Mother's birthday in August 1987 the Princess attended a family lunch at Clarence House in a new navy and white cotton dress by Catherine Walker. The dress fastens with brass buttons at the front.

During a holiday in Majorca in August 1987 the Princess and her family posed for photographers. The Princess wears a cool lemon cotton blouse and trousers with a gold belt and flat shoes.

This very pretty tartan wool dress is by Bellville Sassoon and has been a popular choice for many Scottish visits. Here we see it being worn in Bute in August 1987. The dress has a feminine lace collar and cuffs and fastens with brass buttons at the front.

This cream dress, seen during a visit to Liverpool, is very fitted – especially around the waist. Victor Edelstein created the dress that has a button fastening up the back and a high slit.

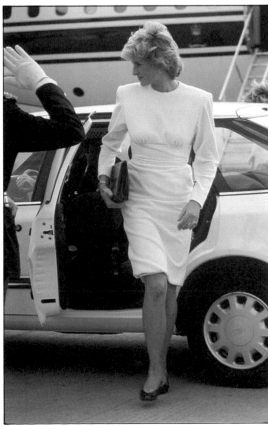

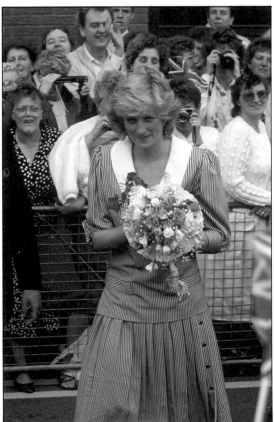

In Worksop the Princess wore a new two-piece suit in grey and white striped silk. The top has a deep neckline with a wide white collar, the skirt is pleated and fastens to one side with buttons.

This unusual beret-style hat with a long feather plume made an appearance at the Braemar Gathering in September 1987. The plum and navy check suit is by Catherine Walker.

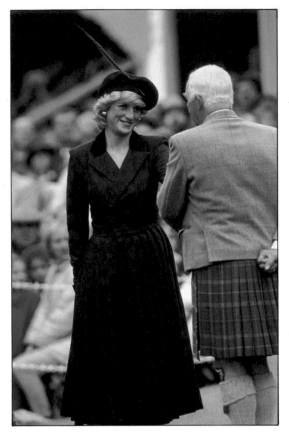

To impress the French in Caen in September 1987 the Princess wore a new red woollen suit by Rifat Ozbek. The suit has stepped lapels and is finished off with knotted brass buttons; two-tone shoes and a large hat by Philip Somerville are the preferred accessories.

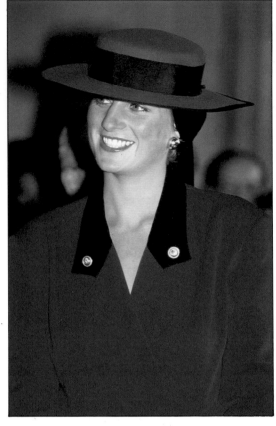

A short and rather unusual scalloped hemline for this skirt worn in Winchester in October 1987. The two-piece suit by Arabella Pollen has a short boxy jacket and is worn over a high black blouse; the hat with a decorative rosette is by Graham Smith at Kangol.

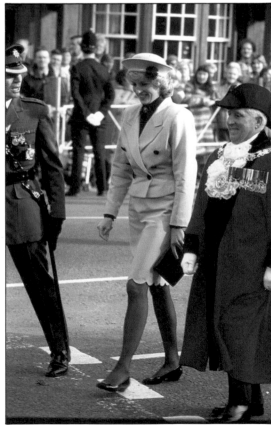

The Princess cut a very dramatic figure in a new velvet and satin gown by Catherine Walker when she attended a charity function in London in October 1987. The dress was obviously inspired by the Elizabethan period, with its high standing collar and full cuffs. A long rope of pearls with a heavy cross completed the stunning effect.

Arriving in West Germany in November 1987 the Princess wore a yellow and black woollen coat from the German fashion house, Escada. The coat is worn with a wide suede belt, black gloves and baggy flat boots to a reception in Berlin. The turban hat is by Philip Somerville.

An evening at the ballet in Berlin in 1987 and the Princess wears a new gown in a heavy duchess satin by Catherine Walker. The pink dress has a wide collar off the shoulders, the waistline is dropped to the hips and the skirt is very full.

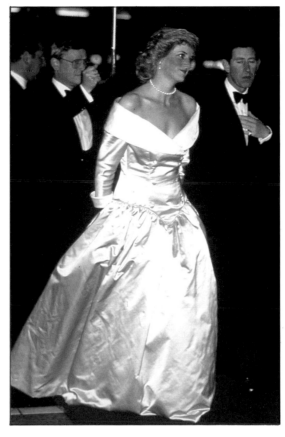

The Princess shows off her shapely legs in Bonn, West Germany in November 1987 in this black and red creation by Arabella Pollen The grosgrain jacket is fastened to the neck with large buttons, the short skirt has a scalloped hem. The beret is by Graham Smith at Kangol.

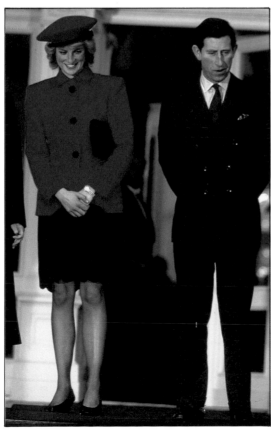

Dramatic evening glamour for a special dinner held in Bonn in November. To complement her deep blue Edelstein dress, the Princess wears, for the first time in public, the matching set of jewels presented to her by the Sultan of Oman in 1986. The Spencer family tiara adds an extra touch of sophistication.

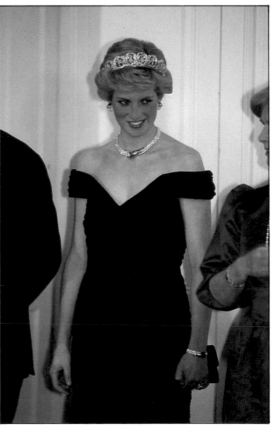

The first Alistair Blair creation to be worn in public by the Princess is this smart black and white check jacket that made its debut in Munich in November 1987. The jacket is belted and worn with a calf-length black skirt and white blouse. The large black hat is by Philip Somerville.

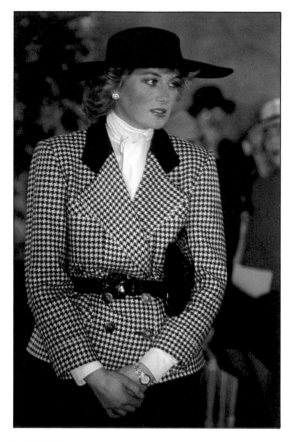

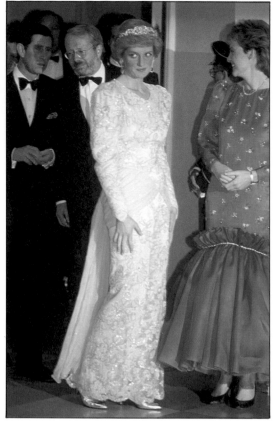

In Munich in November 1987 the Princess chose a firm favourite to wear to a dinner. The blue-beaded Catherine Walker creation looked as lovely as ever; the Spencer tiara is again a delightful accessory.

The Munich opera house provided a fitting occasion for a new Catherine Walker gown in wonderfully rich deep purple velvet and taffeta. The Princess looked stunning in the fitted dress, the trailing taffeta skirt tapering at the front to reveal her slender legs. The long taffeta evening gloves match the skirt.

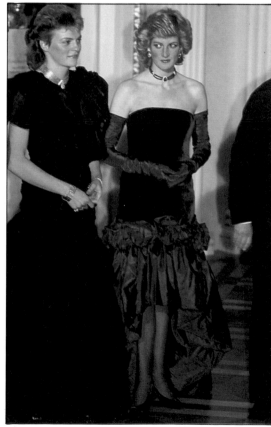

Keeping warm in Hamburg, Germany in November 1987 was relatively easy for the Princess who wore a new light beige cashmere and wool coat by Arabella Pollen. The coat is trimmed in wide fake beaver collar and cuffs; the floppy beret, by Gilly Forge, is in the same fake fur.

Revealing her shoulders once again, the Princess wears a cocktail dress by Victor Edelstein in Hamburg in November 1987. Black lace covers a pink silk lining to create a particularly subtle effect. Two long ropes of costume pearls are well-chosen accessories.

This smart red suit always brightens up a dull wintery day and this occasion in November in Celle, Germany is no exception. Catherine Walker designed the suit, which had a fashionably shorter skirt.

A star spangled strapless evening gown is the perfect choice for the Royal Opera House, Covent Garden in December 1987. The dress has a frothy net skirt which flows out from a fitted bodice. The Omani jewels are worn again to magnificent effect.

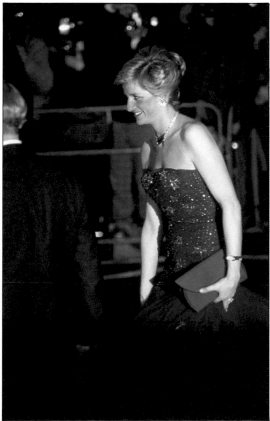

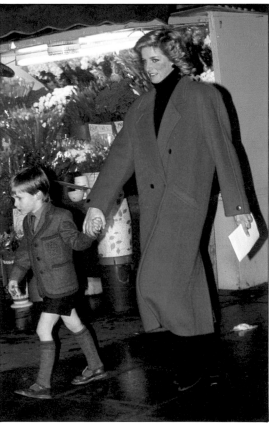

For taking Prince William to a school carol concert in December 1987 the Princess wears a baggy double-breasted bright blue woollen coat. She wears a simple black polo-neck sweater under the coat.

Australia celebrates … France applauds

The Prince and Princess barely had time to digest their Christmas lunch and recover from their New Year celebrations when they had to start packing for a visit to Australia. 1988 was the Australian Bicentennial year and celebrations included a number of royal visitors: the Prince and Princess were the first to arrive in January.

Heading 'down under' into late summer conditions required that the Princess take a mixture of clothes to allow for variations in temperature from hot sticky days in Sydney and Adelaide to the cooler days of Melbourne. A short visit to Thailand on the return journey to England was also planned and this meant that even more clothes had to be packed.

As the Princess stepped off the plane at Sydney airport in the blinding morning sunlight, it was evident that she was going to choose hats that would allow her some shade on her face and protect her pale skin from the harmful rays of the sun. Many large-brimmed hats were seen on this tour, including the new navy and white hat she wore for the arrival at the airport. These large hats were worn quite far back on the Princess's head, thus deviating from the usual style of having the brim well forward.

Many new outfits were seen but the Princess continued to silence her critics as two dresses from the 1985 Australian tour were worn again this time round.

Luxurious satin was popular with the Princess in 1988, it was used in a wide variety of items such as cocktail suits, blouses, hats and even shoes. In Australia we saw two stunning satin creations, one in ivory by Victor Edelstein, and one by Bruce Oldfield in a bright blue.

Catherine Walker was again well represented and one new gown in particular was a great success. It was a shell-pink figure-hugging long dress with bursts of bright blue floral patterns. The dress had a high slit to the thigh on one side and the bodice was boned and strapless. It was an ideal choice to wear to the Hyatt Hotel in Melbourne to a dinner and dance. As the band struck up the tune, *In the Mood*, the Princess swirled around the dance floor with her husband, her dress elegantly trailing in her wake.

Floral-patterned garments were popular in 1988 and in Australia a particularly bright dress by Bellville Sassoon, in blue, pink and yellow silk, was a great success.

Paul Costelloe always seems to dress the Princess on very hot days. Back in Oman in 1986, the Princess wore one of his hand-painted linen dresses in pink and white; it was a very similar dress in lemon and white that the Princess chose to wear for a visit to the Surf Carnival at Terrigal Beach on this Australian tour.

The Princess had a chance to catch up with fashion gossip when she met a number of British designers at the Bicentenary Fashion Show held at the famous Sydney Opera House. Bruce Oldfield was highly delighted not only to meet the Princess but to see that she was wearing one of his creations – a dazzling, satin cocktail suit. A number of Alistair Blair dresses, tops and skirts, featured in the Australian and Thailand wardrobe. All of his designs were characterized by very short cap sleeves, which were extremely practical in the very sticky heat of Thailand.

King Bhumibol of Thailand invited the Prince and Princess to visit Bangkok and Chiang Mai as part of his sixtieth birthday celebrations. It was a chance for the Princess to sample the exotic Far East for the first time.

Exotic was certainly the right word for the Princess's appearance as she attended the formal dinner held in Bangkok by the Crown Prince. Catherine Walker had created yet another stunning evening dress in shining chiffon. This dress was in two vivid colours – fuchsia pink and deep purple. The boned bodice had a strip of mauve fabric entwined across the front and sweeping up over one shoulder to fall in a romantic train behind. The Princess's hair style, which was swept up and pinned with a burst of silk flowers, provided the finishing flourish to a spectacular outfit.

The Princess kept to crisp, cool fabrics in Thailand, for clothes can look creased and damp due to the humidity. Alistair Blair's navy and white silk dress was particularly appropriate as the Princess stood under the shade of a ceremonial sun umbrella at Bangkok airport, watching the Prince inspecting the guard of honour. Two skirts made by Blair had an unusual dropped waistline that incorporated a belt. The skirts were short, in keeping with her new image, ending just above the knee.

During 1988 we saw a lot of the Princess's legs, largely due to her obvious liking for above-the-knee hemlines. The brightly coloured tights that were once so popular were now replaced by sheer black or natural colours or, whenever temperatures permitted, bare tanned legs. Her shoes were now considerably higher and her collection included a number of open, sling-backed styles and two-tone coloured court shoes. The bow tie was still worn but, in Glasgow in May, she wore a man's tie that looked incredibly like one of her husband's with a plain white

blouse and blue coat. Ruffles hardly appeared. The favourite style for blouses this season was a plain white satin blouse with a high neckline.

Towards the end of the year the Prince and Princess made a five-day visit to France. Fashion pundits were again holding their breath in anticipation of the Princess's choice of clothes for a tour to the hub of international fashion: they were not disappointed. On her arrival at Orly airport in Paris the Princess was dressed from head to toe by Chanel. It was the first time she had worn French clothes on an official engagement and her French hosts loved it.

Each day in France we saw a new outfit appear; black and white coat dresses were particularly popular. But it was the evening gowns which drew gasps of admiration. Victor Edelstein's ivory satin dress with matching bolero jacket could not have been a more perfect choice for the formal dinner at the Elysée Palace. In the imposing surroundings of the magnificent chateau at Chambord, the Princess's statuesque figure was emphasized in a long white heavily embroidered dress by Catherine Walker. The light coloured dress worn by the Princess complemented the deep gold of the gown worn by Princess Caroline of Monaco: the two most photographed women in the world were at last together and both looked stunning dressed in their own inimitable style.

On her last day in Paris the Princess wore a long, elegant tailored black coat by Jasper Conran. The coat, with its double-breasted cut and brass buttons, kept the Princess snug as she watched the Armistice ceremony at the Arc de Triomphe.

As the Princess departed from Paris after an immensely successful tour, the French fashion industry could not deny the strength and talent of the British designers to whom the Princess has drawn international attention in recent years. But foremost in the memory of the French people was the image of the Princess herself.

As the year came to a close Princess Diana and her family spent Christmas at the Queen's Norfolk estate, Sandringham. On Christmas Day she attended a family service at the small church on the estate. The weather was unseasonably warm, although very dull, and it gave the Princess a chance to wear her new fitted two-piece suit. The suit, in black, had lapels and cuffs that provided a colourful splash of turquoise blue. The hat, also newly acquired, continued the theme with a long turquoise plume threaded through the crown.

Throughout 1988, in public and in private, the Princess of Wales exuded the poise, grace and elegance that one would expect of a royal princess, and she frequently showed the world why hers is the fashion story of the decade.

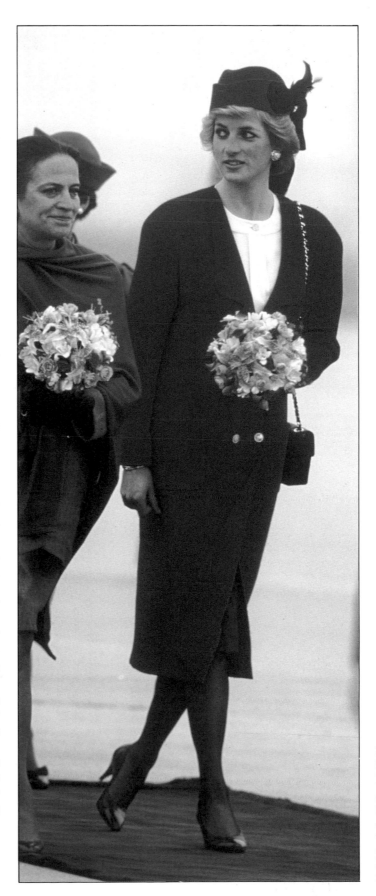

Arriving in Paris in November 1988 the Princess pays great tribute to her hosts for she is dressed from head to toe by Chanel. Karl Lagerfeld designed the coat which is worn over a silk blouse and skirt. The jaunty high hat with large decorative feathers is also by Chanel.

Back to velvet for a dress in deep navy for a concert held at St John's Smith Square in January 1988. The long rolled collar in white silk fastens to one hip.

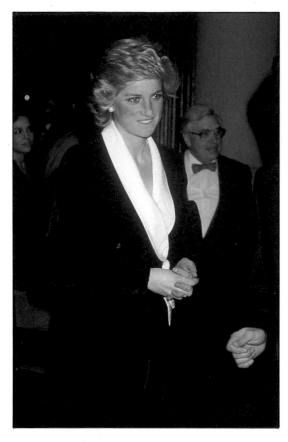

Arriving at Sydney airport Australia in January 1988 the Princess looks delightful in a new Catherine Walker dress in white with a tie shawl neckline in navy and white striped silk. The large 'halo' hat in matching colours is by Philip Somerville.

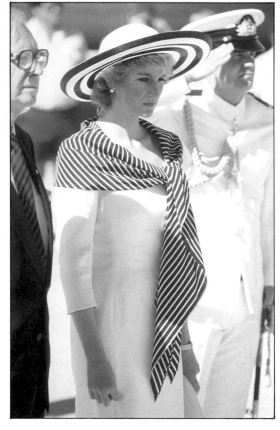

The Princess receives a posy at a variety show held in Sydney in January 1988. Victor Edelstein designed this two-piece suit in satin and lace. The jacket has a scooped out neckline.

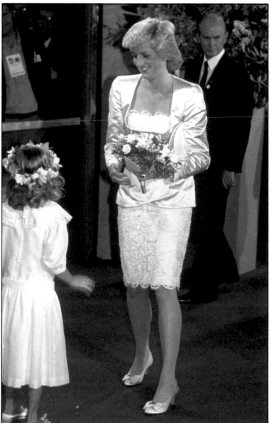

At the Australia Day celebrations in Sydney the Princess wore her emerald green coat dress with a white shawl collar by Catherine Walker. The wide-brimmed hat is by Philip Somerville.

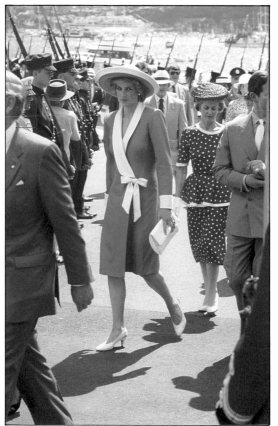

Footscray Park, Melbourne in January 1988 and the Princess is dressed in a pastel-pink fitted dress by Victor Edelstein with a deep neckline and a striped silk decorative bow.

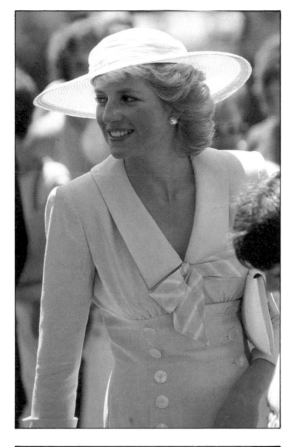

Dancing the night away in Melbourne in January 1988 in a pink and blue Catherine Walker dress. The strapless gown has a large bow flaring from one hip. The Princess has her hair pinned up and this style emphasizes the magnificent diamond and sapphire jewels.

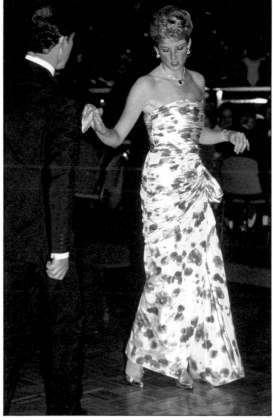

For a visit to the Melbourne School of Music in January 1988, the Princess chose this navy and white silk suit by Roland Klein.

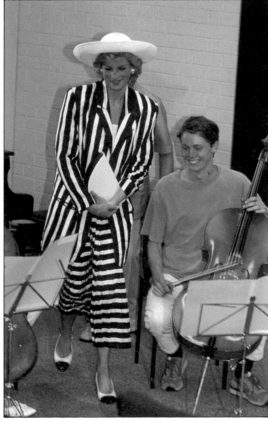

This purple silk dress is particularly appropriate for late afternoon receptions, such as this one in Adelaide in January 1988. Victor Edelstein designed the dress that has a collarless V-shaped neckline and pleated skirt. The sling-back shoes are made in black satin.

This floral silk blouse is usually concealed by the pink linen jacket of the suit. However, it proved to be a cool choice for a hot visit to the suburbs of Sydney in January; a sash belt is incorporated into the blouse.

The Princess faces up to extreme temperatures in Goolwa, Australia in January 1988 but she copes well in a cool short-sleeved dress by Alistair Blair. This cheerful bright red dress has a crisp white collar and is belted with a dropped waistline.

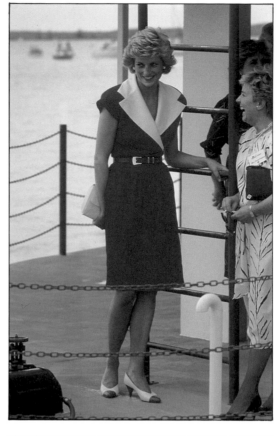

We witnessed the return of the small hat in Sydney when the Princess attended a Sunday morning church service. The hat by John Boyd is in satin and matches the shade of blue in the patterned dress.

No fussy jewels are worn with this Edelstein dress as the twisted neckline provides sufficient effect. The dress is seen here in Sydney in January 1988 but it was originally worn as part of the 1986 Australian tour wardrobe.

A comfortable hand-painted linen dress by Paul Costelloe was worn to the surf carnival at Terrigal Beach in Australia in January. The dress is designed with a loose dropped waist and front box pleats.

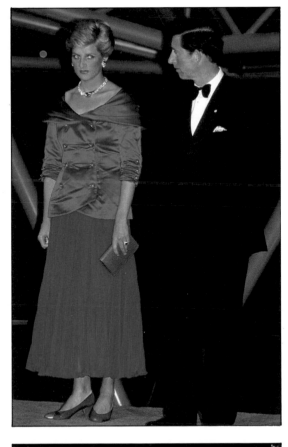

The Bicentennial fashion show held at Sydney's famous opera house gave the Princess the chance to wear a new royal blue double-breasted jacket with a wide neck. The skirt, in the same shade of blue, is in silk chiffon – both are designed by Bruce Oldfield. Blue and pink spotted shoes match the clutch bag.

The cream Catherine Walker coat dress is still popular two years after it first appeared in Italy. Here the Princess wears it to Darling Harbour, Sydney in January 1988.

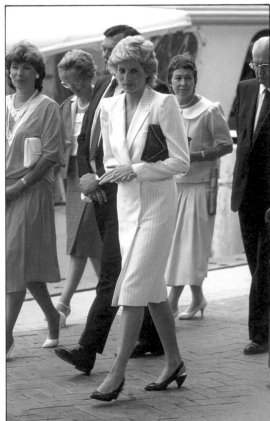

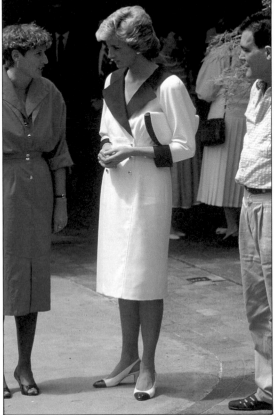

Navy and white are always a smart combination. On the final day of the 1988 Australian tour the Princess wore this cotton dress by Catherine Walker to Auburn. Two-tone shoes matched the dress.

Necklines to be noticed

High-necked Victorian-style blouses and dresses became extremely fashionable in 1981, probably due to the influence of the new romantic look inspired by the young Lady Diana Spencer. As time passed the wardrobe of the new royal bride was carefully scrutinized, and it became clear that the Princess was particularly fond of elaborate necklines.

Over the years her tastes have changed, but she has never forgotten, and still frequently chooses to wear, a ruffle neckline. This style of blouse has proved an indispensable item for wearing under all styles of suits, dresses and coats.

Just after her engagement, the Princess was seen wearing a particular style of blouse in cream. Again and again we have seen it re-emerge, teamed up with such garments as the red and white silk suit seen in Tetbury in 1981 or peeking out from under the red Cossack-style coat worn in Northampton in 1987. The style is timeless and will, no doubt, continue to feature in her wardrobe for years to come.

Another style of neckline that became synonymous with the young Princess was the square or V-shaped sailor collar. Bellville Sassoon designed many outfits for the Princess that incorporated this style of neckline, including the white organza collar on the peach honeymoon suit worn in 1981.

Large flat collars have featured almost as often as the famous ruffles. Jan Van Velden designed a number of

Right
A John Wayne-style neck scarf gives this blouse an unusual finish. The plain turquoise blouse combined well with the printed skirt and bolero jacket when worn to a reception at Grocer's Hall in London in 1982. Donald Campbell designed this outfit.

Far right
The Princess delighted the Italian crowds in her waiter-style bow tie and white wool suit by Jasper Conran, worn during a walkabout in Florence in 1985. This black bow tie has been seen frequently with various suits and coats.

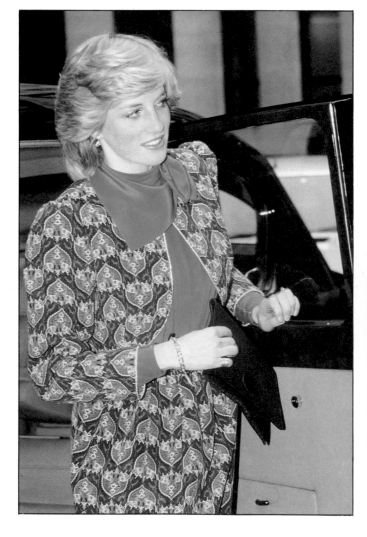

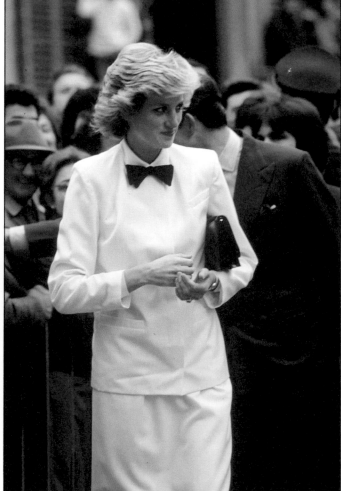

Above
Another tie worn during an Italian tour in 1985. This long slim tie matched the emerald green suit – the wing-tipped collar was by Jan Van Velden.

Left
An evening spent at the Wembley Greyhound Stadium in 1988 seems hardly the place for a black tuxedo and bow tie. The evening, however, was a special charity event and so the Princess dressed accordingly.

Right
This red and white Andy Pandy suit by Bellville Sassoon was finished off with a large bow on the neckline. Originally worn to Ascot races in 1981, the Princess packed the suit in her Australian tour wardrobe in 1983 and is seen here wearing it on a visit to Hobart, Tasmania.

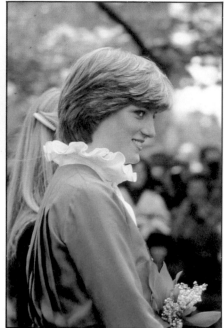

Centre
One of the early cream ruffled blouses so popular with the young Lady Diana Spencer. The Princess wore this green silk suit with the blouse to visit the late Lord Mountbatten's home, Broadlands, in 1981.

Far right
This high-necked blouse comes with a separate tie which is secure in a loose bow. The bright blue and white fabric stands out boldly against the cobalt-blue coat during a visit to Oxford.

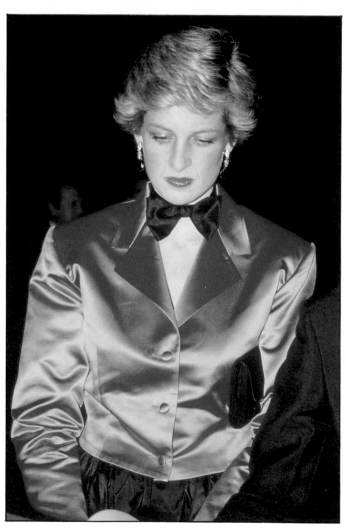

Right
This bow tie was worn in place of any jewellery when the Princess attended the ballet in Lisbon, Portugal, in February 1987.

Far right
This white Van Velden blouse and separate black ribbon tie has been seen under many outfits, including this red wool suit worn in Cirencester in 1985.

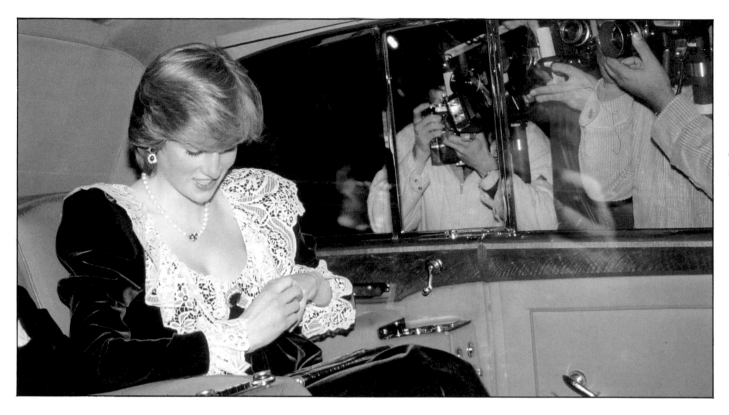

A more daring neckline for the Princess on this midnight-blue velvet evening gown by Bellville Sassoon. The plunging shape revealed a hint of cleavage when worn during the Princess's first pregnancy to a dinner in Downing Street in 1982. The neckline is edged in delicate lace.

Puritan-style blouses with the characteristic severe pointed collars. When worn under a suit or dress the effect was dramatic. Van Velden also created the white wing-tipped collar shirts – these shirts are particularly effective when worn with variations on the tie theme. In Italy in 1985, the Princess wore a thin emerald-green tie to match her suit; a similar style was worn during a visit to Glasgow in 1988, and the Princess has also shown a penchant for bow ties.

The first time we saw the black bow tie was in Birmingham when it was worn with a white tuxedo and black trousers to a rock concert. In Florence, Italy, in 1985, the Princess wore the bow tie with various day-wear outfits – the Italians loved her keen sense of style. Since then, however, the bow tie has only been seen at evening functions. The Van Velden wing-tipped collar also contrasts well with the long black ribbon often tied loosely in a bow to complement an outfit.

The Princess's neckline for evening wear has gone up and down over the years. After that dangerously low-cut black Emanuel gown in 1981, the Princess preferred more demure styles for a time, but during her first pregnancy she wore a gown in a deep navy velvet with a very low, scooped neckline edged in antique lace. The Princess now appears confident in a wide variety of styles – some daring, others more restrained. Many of her latest evening dresses are strapless with a boned or fitted top that shows just a hint of cleavage.

Over the past couple of years the Princess has enjoyed wearing a high-necked blouse with a hunting-style cravat tie. These blouses come in silk and cotton, in a range of colours and patterns from mauve Paisley silk to plain classic white. They are extremely smart when worn with a tailored peplum jacket.

The Princess rarely wears real fur, thus avoiding the inevitable controversy, but she does have a number of garments with necklines edged in mock fur. In Paris, in 1988, a black coat dress by Catherine Walker displayed a white collar made from synthetic fur. Another alternative to fur for edging a neckline is leather or suede; Arabella Pollen has designed a number of coat dresses that incorporate this idea.

After the edging of the early high-necked blouses, ruffles were incorporated in some of the Princess's day and evening dresses. On her wedding day her dress showed a deep, ruffled neckline. A variation on the usual round-style ruffle neckline can be seen on an Oldfield dress worn to the Guildhall in 1982. This unusual one-shoulder design with a deep ruffle edging, proved to be quite eye catching.

Three more dresses have been seen with the one-shoulder look, but the ruffle edging has been dropped. One of these, again an Oldfield creation, in an aquamarine organza and silk, was worn to the Dragon Ball in London in 1982. The other two also expose the right arm and shoulder: one by Hachi in a glamorous silver-beaded silk and the other, seen in Paris in November 1988, is a red and black taffeta gown by Catherine Walker.

Under the protection of the ceremonial sun umbrella at Bangkok airport, the Princess strides out with confidence in a new navy and white silk dress by Alistair Blair. The lattice-brimmed hat is by Philip Somerville.

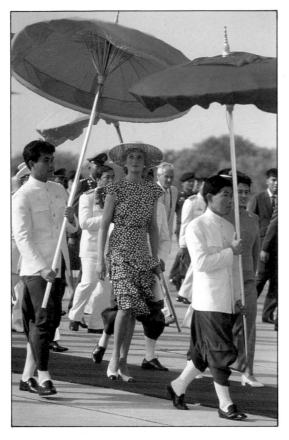

Alistair Blair's new silk suit consists of a straight white skirt with an emerald green cummerbund. The printed sleeveless blouse has a simple neckline. White leather accessories include a large shoulder bag.

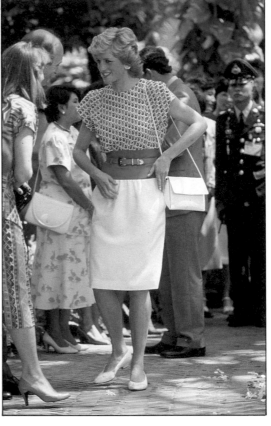

In Bangkok the Princess looked stunning in a fuchsia pink silk chiffon dress with a ruched bodice that incorporated a purple border falling into a train over the shoulder. She wore silk flowers in her hair to match this Catherine Walker gown.

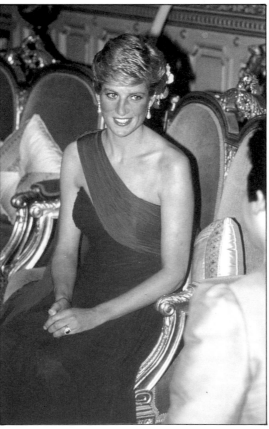

In Chiang Mai, Thailand in February 1988 the Princess wears another Alistair Blair cool, two-piece suit. The ivory and blue check blouse is worn with a linen skirt, again with a dropped waist seam. The shoes have 'skin' inserts.

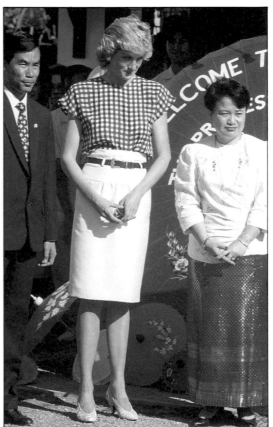

This classically smart two-piece suit was worn for a tree-planting ceremony in Kensington Park, London in February 1988. It consists of a simple wool flannel jacket with large brass buttons and a pinstripe skirt that is worn above the knee.

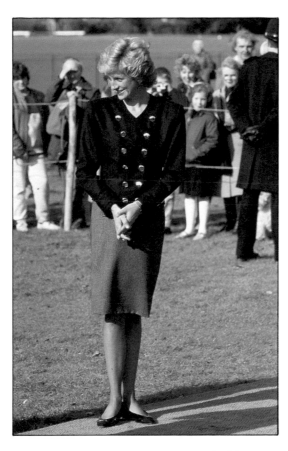

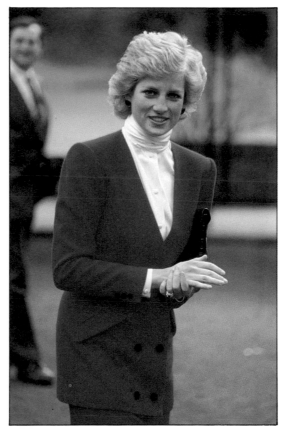

Catherine Walker's red woollen suit is worn here in Rugby in March 1988 over a high-necked white silk blouse. The jacket buttons are covered in black velvet.

At a ballet gala in London in March 1988 the Princess looked divine in a new dress by Catherine Walker. The gown, which is in white silk, has a wide shawl collar with a particularly feminine cut.

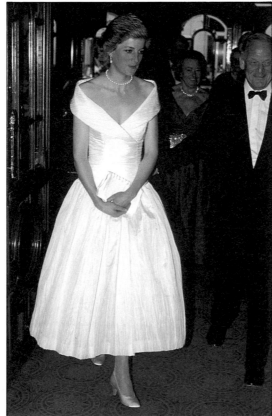

In the snow at Zurich airport in February 1988 the Princess arrives casually dressed at the start of her skiing holiday. She wears a calf-length suede skirt with a black woollen jacket and woollen scarf.

This black and cream suit is worn without a blouse for a visit to the National Gallery in London in March 1988. The jacket has a black velvet collar that contrasts with the stepped lapels and the buttons are also velvet covered. The suit is by Jasper Conran.

The various garments that make up this evening ensemble were personally chosen by the Princess. The jacket is by Catherine Walker and the emerald green silk waistcoat is from the London men's shop Hackett. The outfit is worn here to the Wembley Greyhound Stadium in London in April 1988.

Early one Sunday morning in April 1988 the Princess started the London marathon. She arrived dressed casually in a pale primrose yellow suit worn over a knitted sweater.

Practical but elegant is a particularly apt description of this rich blue velvet dress that kept the Princess warm during a concert in Newbury in April 1988. The dress has a stand-up collar and a full, gathered skirt. She also wears blue satin evening shoes.

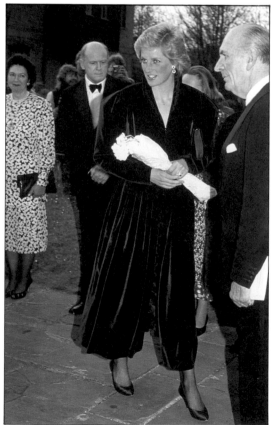

Nautical colours were the order of the day for a boat trip down the River Thames in May 1988. The double-breasted jacket has pinstripe lapels and cuffs that match the skirt. Bellville Sassoon was the designer responsible for the eye-catching outfit.

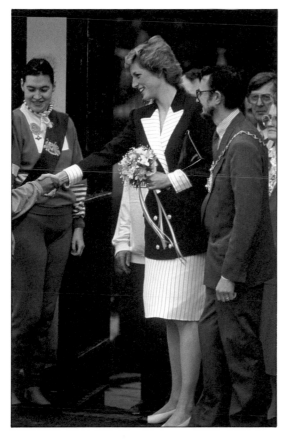

For a trip to the Moscow State Circus in Battersea Park, London in May 1988 the Princess wore a smart dark grey pinstripe coat dress by Catherine Walker. The high-necked blouse worn under the dress is fastened at the neck.

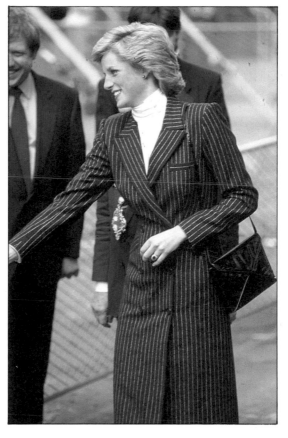

While strolling through the paddock at the Ascot races in June 1988 the breeze catches the Princess's pearl grey top coat worn over a white linen dress by Catherine Walker. A wide-brimmed hat complements the outfit.

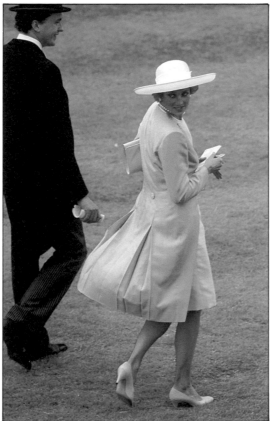

Still popular for racing is the black and white polka dot dress by Victor Edelstein, and again it is worn with a wide flat-brimmed hat and two-tone shoes.

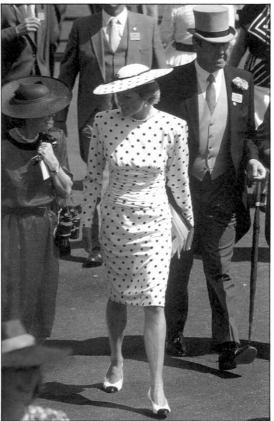

This vividly coloured floral dress by Bellville Sassoon is very figure hugging and particularly unforgiving! This time the peplum has been removed to create a cleaner line. The wide waistline is ruched. The Princess is seen here wearing the dress to a polo match at Smith's Lawn, Windsor in June 1988.

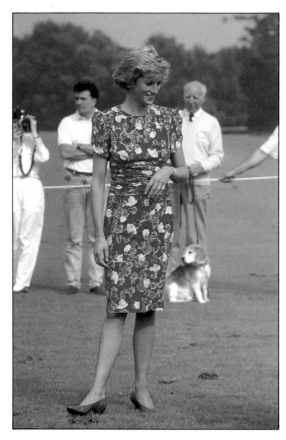

Bellville Sassoon's navy and white jacket was teamed with a long pleated skirt when the Princess started the Windsor Pentathlon in July 1988. Navy leather accessories enhance the elegant look.

This red and white patterned silk dress has been deemed appropriate for all types of occasions, from formal dinners to polo matches. The deep 'V' neckline has lace inserts and a bow. The Princess also carries a white cashmere jacket to this polo match in July 1988.

This new apricot and white polka dot coat dress by Catherine Walker was worn to the Garter Ceremony at Windsor in June 1988. The knee-length coat is fastened with large pearl buttons. A cheeky straw hat is particularly effective.

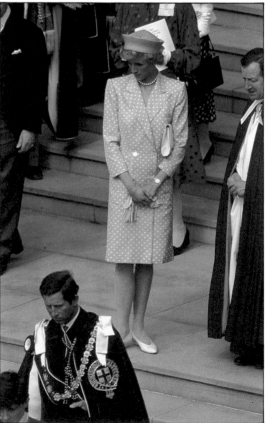

When the Prince met Michael Jackson at his concert in London in July 1988 the Princess positively shimmered in a gold satin suit worn over a black camisole top. In the Princess's arms she carries a leather jacket that she had just been given by the pop star. Again Catherine Walker designed the suit.

While on holiday with her two sons in Majorca in August 1988 the Princess shows off her tanned legs in a short, fitted orange skirt. A casual white cotton blouse is worn tucked into the skirt.

This gay, coloured jacket by Catherine Walker illustrated the Princess's adventurous spirit when it comes to choosing clothes. She delighted the people of Middlesborough in October 1988.

In Crawley in September 1988 the Princess wears a new woollen suit by Catherine Walker. The jacket has a cape top incorporated into the design and is fastened with brass buttons. The skirt falls just below the knee. Purple leather shoes and clutch bag match the shade of the suit.

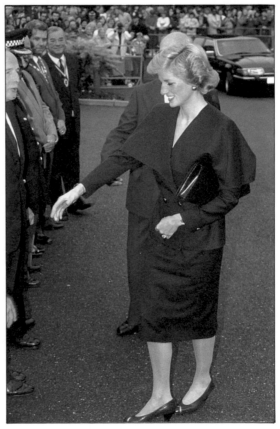

Stepping out in style

The Princess's fondness for bright and vibrant colours in her choice of clothes is mirrored in her choice of hosiery and footwear. During the early eighties the Princess was still wearing the ultra conservative cream tights and soft ballerina pumps that had become popular at that time, but a bolder taste in colour became firmly apparent from 1984 onwards. The Princess started to wear her tights teamed up with a suit and shoes of the same shade. We also saw the beginning of a more elaborate decorative style of hosiery.

A frequent choice of the Princess in 1984 and 1985 was seamed tights and stockings, which were enjoying a great revival at the time. A wide range of variations on the seamed style theme was available; she was particuarly fond of wearing different coloured seams.

The flat pumps worn previously by the Princess were often decorated with shoe bows, but in 1985 we saw the Princess appearing in a very decorative pair of black seamed tights with a black net bow attached at the end of the back seams. These net bows even had small red polka dots embroidered on the fabric. Tights with embroidered spots were very popular, but one trend that really emphasized that legs were an extra fashion asset was the deluge of lacy tights that started to fill most hosiery departments. The Princess was seen in black lacy tights and also a pair of dark fish-net tights. These elaborate tights were worn for both formal and informal occasions, combined with a smart suit or a casual leather skirt.

Right
The Princess shows off her decorative heels as she steps out for a reception in Canberra in 1985. These sheer black tights have a back seam and pretty net bows complete with polka dots attached to the heel.

Far right
The Princess keeps warm on a snowy evening in a pair of thick, black, lacy tights in January 1987. The tights, in a lattice lace, have a back seam and should be worn with a simple shoe, as shown here.

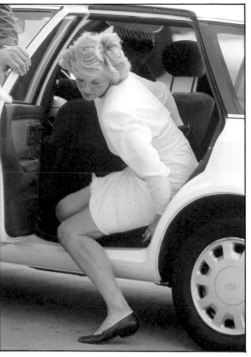

Above
The Princess reveals her shapely, tanned legs as she alights from a car during a visit to Liverpool in 1987. She is wearing a very low pair of soft leather shoes in navy.

Left
Sitting prettily in Australia in 1988 the Princess enjoys the warm afternoon sun on her bare legs. Bright pink leather court shoes are worn to complement the suit.

Right
The Princess still wore pale creamy coloured tights in 1988 but not so frequently as when she first made the headlines. Here we see the opaque tights worn with a navy and white suit in Greenwich. The leather shoes are also in crisp nautical colours – they have only the smallest of heels.

Far right
The Princess has favoured many red fashion items over the years, including a number of pairs of bright tomato-red tights. During a visit to Florence, Italy, in 1985, the Princess wore a red two-piece suit by Jasper Conran with red tights and red leather court shoes.

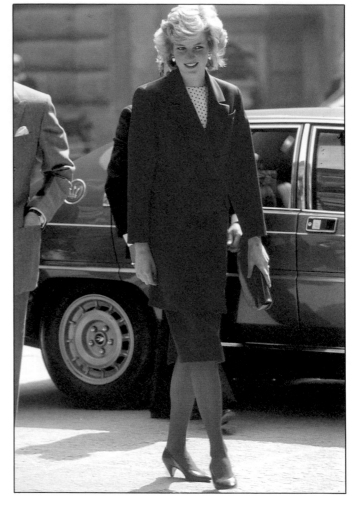

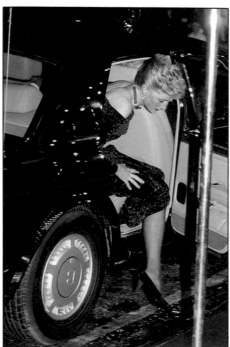

The Princess follows a colour theme through from her velvet dress to her tights and shoes. The evening shoes are also in purple velvet and have satin heels.

Two-tone court shoes in black and dark taupe are worn with a very smart dark grey coat dress when the Princess undertook an afternoon engagement in May 1987. The afternoon was sufficiently warm for the Princess to favour the bare-legs look.

Far left
Another example of following a colour theme. On this occasion shocking pink is the chosen shade for the Princess's check wool suit, tights and shoes.

Left
At the Melbourne Gold Cup in 1985 the Princess wore black-seamed tights with a Bruce Oldfield suit. The tights were finished off with an embroidered bow on the heel of each leg.

During the warm summer months, or for foreign tours to hot climates, the Princess prefers to keep her legs bare. Her long slim legs seem to maintain a good honey-coloured tan for most of the year and, of course, they are in perfect shape, probably as a result of frequent exercising, such as dancing and swimming in the palace pool.

The Princess has also been known to bare her legs for formal events such as Ascot or Buckingham Palace garden parties. In past generations it would have been unthinkable for a lady, let alone a royal princess, to attend without stockings!

As the hems climbed towards the late eighties, the Princess had virtually dispensed with many of her older, long dirndl skirts and developed a confident liking for wearing skirts that were cut above the knee. The flat shoes were replaced by soft leather classic court shoes with a maximum heel of about one and a half inches. They come in all colours from black to red. Patent leathers also feature highly in the Princess's choice of shoes, whether in shiny

black or in more daring colours. Shops such as Rayne and Bertie provide a range of shoes that are suitable for the footwear-conscious Princess but for that extra special pair of shoes the Princess often chooses footwear from the chic cobbler Manolo Blanick. The Duchess of York also numbers among Blanick's royal customers.

During the winter months the Princess likes to keep warm in boots. These boots are usually 'riding boot' style with very flat heels and generous baggy legs. The Princess often chooses boots in a supple black or brown leather or suede, and, occasionally, in a shiny, wet-look patent.

For summer months, and for the more adventurous engagements the Princess chooses soft, canvas, rubber-bottomed shoes such as the pretty pink lace-ups worn while driving an armoured vehicle at the Tidworth army ranges in 1988. During 1988 we also saw the Princess tucking her jeans very casually into a pair of fancy cowboy boots.

Shoeless again! On this occasion the Princess has removed her shoes to throw a wood at the Luton Bowling Club in October 1988. She wears a deep blue woollen suit over a blouse with a collar of delicate lace.

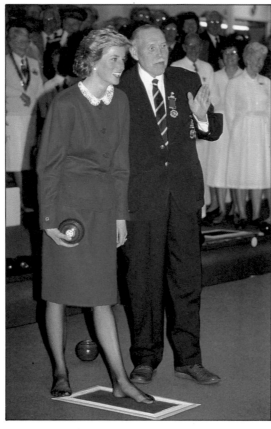

As a tribute to her hosts, the Princess is dressed for the first time on official duty entirely in French-designed clothes. For her arrival at Orly airport she wears a deep-red wool coat over a skirt and blouse – all by Chanel. The hat and bag are also from this famous Parisian fashion house.

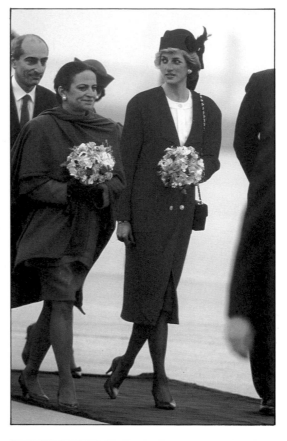

Dinner at the Elysée Palace in Paris in November 1988. The Princess arrives in her new gown by Victor Edelstein in heavy duchess satin. The bodice of the dress and the small bolero jacket are encrusted with shimmering beads.

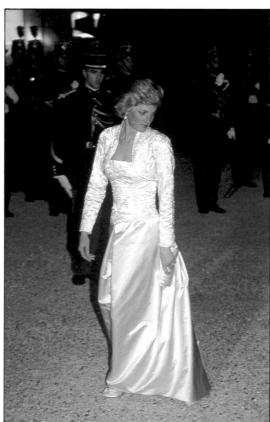

Yet another new coat dress by Catherine Walker. This one was first seen in Paris in 1988 and has long black velvet sleeves and covered buttons.

The full-length coat dress worn to a glittering dinner at the chateau in Chambord, France in November 1988 fastened on to one hip and has a rolled collar. The dress, by Catherine Walker, is covered in beads and sequins.

This warm check woollen coat was chosen by the Princess to visit some of the magnificent châteaux in France in 1988. It is worn with a smart white cravat-tie blouse. Catherine Walker was, once again, the designer.

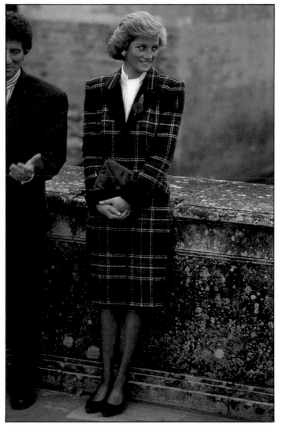

This off-the-shoulder cocktail dress in black silk by Victor Edelstein was worn to a dinner and river cruise during the Paris visit in November 1988. The dress fastens with large gold buttons and is cut just above the knee.

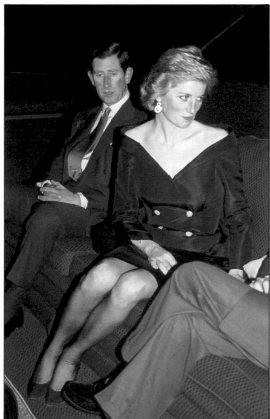

Another Catherine Walker design to have its debut in France in November 1988 was this red and black evening gown worn to the British Embassy dinner in Paris. The dress has only one sleeve and a full skirt falling from a dropped waistline. The bodice is ruched.

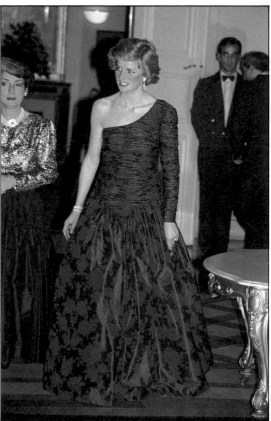

The Prince and Princess visited the Paris branch of Marks and Spencer in November 1988. For the occasion the Princess chose a new black coat dress by Catherine Walker. The dress has a wide collar in synthetic white fur.

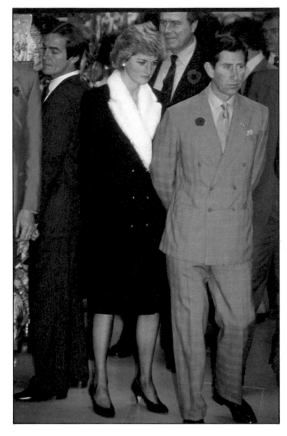

At the Armistice service in Paris in November the Princess looked exceptionally smart in a black woollen coat by Jasper Conran. The double-breasted coat was almost ankle length. The elegant hat is by Viv Knowlands.

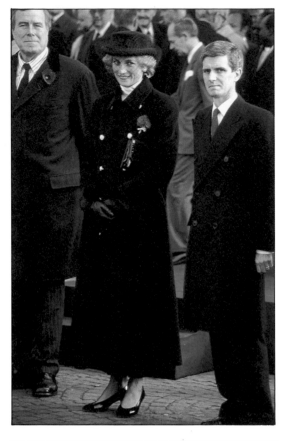

The shapely short jacket of this pale blue suit has large pearl buttons. It is worn over a high satin-necked blouse to visit Chester in May 1988. The skirt is fitted and just above the knee in length. The suit is by Arabella Pollen.

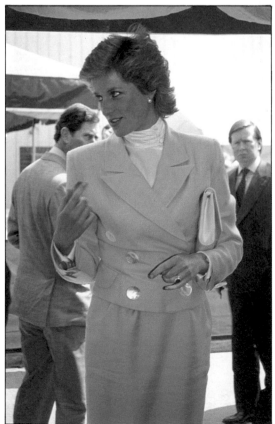

Bruce Oldfield's woollen coat is seen here during a windy visit to HMS *Cornwall* in Falmouth, Cornwall in April 1988. The wool suit is matched with a high pillbox hat. The favourite cream ruffle blouse peeps out from under the coat.

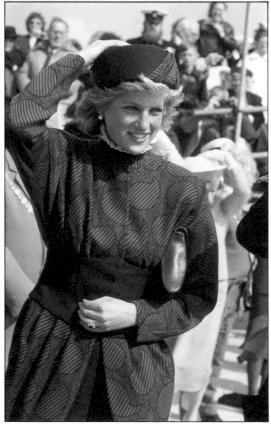

Despite heavy rain the Princess is not wearing a coat over her red woollen suit during a visit to Little London in Hampshire in May 1988. The suit, with a short, fitted jacket, is by Catherine Walker. Two rows of bold brass buttons fasten the jacket.

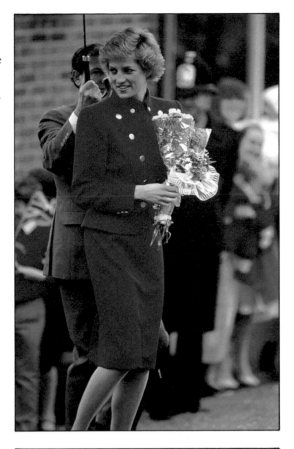

Very definitely 'off duty' clothes seen here at a polo match at Windsor in May 1988. The Princess wears her drain-pipe jeans tucked into cowboy boots. She wears a baggy tweed jacket over a cotton sweat-shirt. The blue baseball cap is unlikely to be deemed suitable for her public duties!

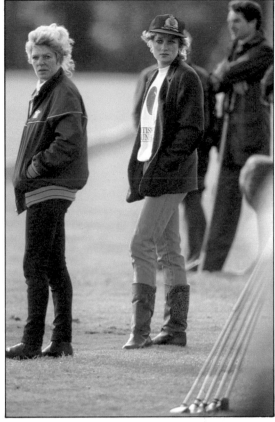

This shiny candy-striped silk blouse is teamed up with a simple black wool skirt for a reception held in London in July 1988 for 'Help the Aged'. The blouse has a double row of black buttons to complement the skirt.

This new suit made its debut at Sandringham at the traditional Family Service on Christmas Day in 1988. The two-piece suit in a deep navy wool has a bright turquoise collar and cuffs. The striking hat sports a long slim feather, dyed to the same turquoise shade that features in the jacket.

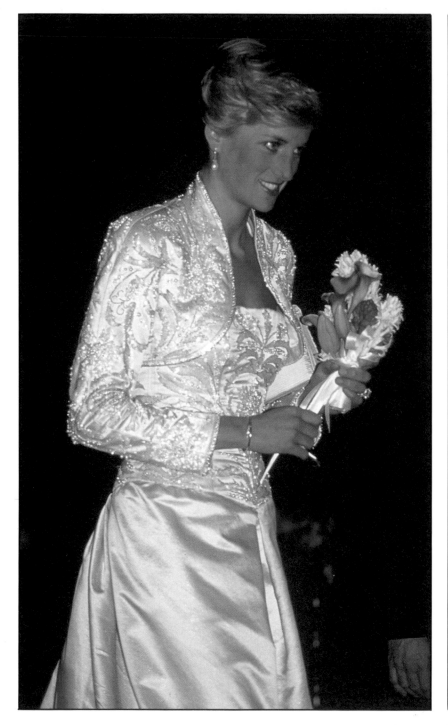

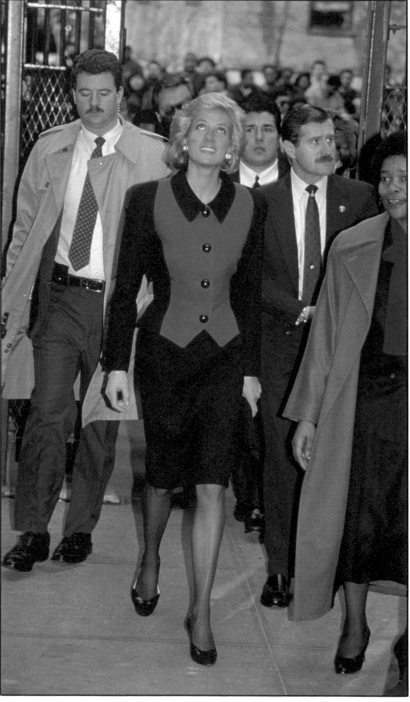

New York – February 1989

In February 1989 the Princess is seen here arriving at New York's 'Wintergarden' to attend a lavish dinner. The heavy satin gown by Victor Edelstein is worn with a short bolero jacket. It was seen previously a few months before in Paris.

The Princess looked particularly smart in a new wool suit when she visited the Henry Street Settlement in New York in February 1989. The two-coloured suit by Catherine Walker sports a short, fitted jacket with inserted shocking-pink panels; it fastens high to the neckline.

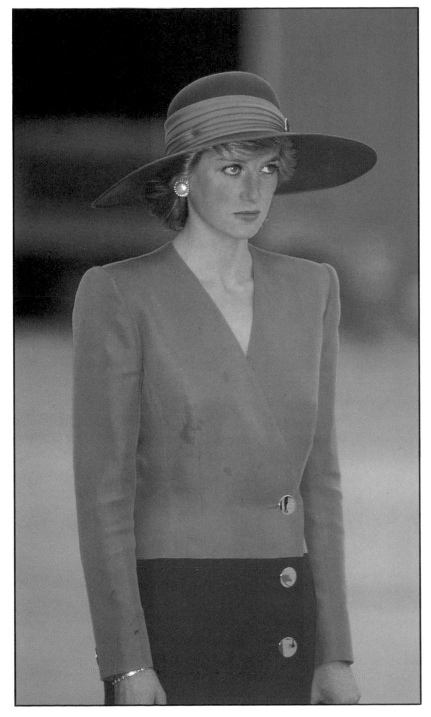

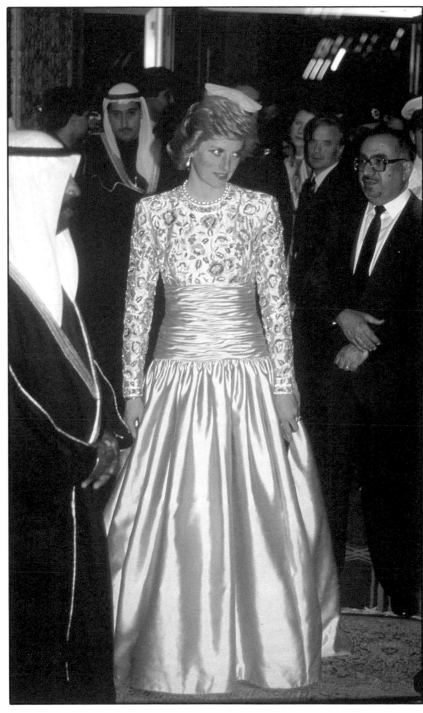

Gulf Tour – March 1989

The Princess of Wales arrives in Dubai in the United Arab Emirates in March 1989 dressed in an unusual combination of colours. She is wearing a bright tomato-red dress under a short pink jacket. Both garments, in silk, are by Catherine Walker. The large-brimmed hat echoes the colours of the garments and compliments them well.

Another new creation by Catherine Walker for the Gulf Tour of 1989. This splendid lilac silk gown is worn to a dinner at the Crown Prince's palace in Kuwait. The bodice is delicately embroidered with flowers and beads.

Acknowledgements

We would like to thank the following for all their help, it is greatly appreciated:

Jim Brown; all the designers and milliners mentioned in the book and their respective public relations departments; Alan and June for their patience and support.

PICTURE CREDITS

Page 16, top right, Rex Features
Page 17, bottom right, The Keystone Collection
Page 97, top right, Glenn Harvey
Page 130, top left, Lionel Cherrault
Page 138, bottom right, Lionel Cherrault